Afterimages

Afterimages

Photography and U.S. Foreign Policy

LIAM KENNEDY

The University of Chicago Press Chicago and London

LIAM KENNEDY is professor of American studies and director of the
Clinton Institute for American Studies at University College Dublin.

The University of Chicago Press, Chicago 60637
The University of Chicago Press, Ltd., London
© 2016 by The University of Chicago
All rights reserved. Published 2016.
Printed in the United States of America

25 24 23 22 21 20 19 18 17 16 1 2 3 4 5

ISBN-13: 978-0-226-33726-5 (cloth)
ISBN-13: 978-0-226-33743-2 (e-book)
DOI: 10.7208/chicago/9780226337432.001.0001

Library of Congress Cataloging-in-Publication Data

Kennedy, Liam, 1961– author.
 Afterimages: photography and U.S. foreign policy / Liam Kennedy.
 pages: illustrations; cm
 Includes bibliographical references and index.
 ISBN 978-0-226-33726-5 (cloth: alk. paper) — ISBN 978-0-226-33743-2
(ebook) 1. Photojournalism—United States—History—20th
century. 2. Photojournalism—Europe—History—20th century.
3. War photography—United States—History—20th century. 4. War
photography—Europe—History—20th century. 5. United States—
History, Military—20th century—Pictorial works. 6. United States—
Foreign relations—20th century—Pictorial works. I. Title.
 TR820.K4295 2016
 779—dc23
 2015020156

♾ This paper meets the requirements of ANSI/NISO Z39.48-1992
(Permanence of Paper).

Contents

Acknowledgments

I am grateful to the Irish Council for Humanities and Social Sciences for the award of a grant that helped me research and write this book. I am also grateful to University College Dublin for the provision of study leave to complete it.

I owe intellectual and personal debts to many people who helped me with this project. Particular thanks to Justin Carville and Caitlin Patrick who helped me develop the research and ideas. And thanks to Hamilton Carroll, Robert Hariman, Steven Hoelscher, Wendy Kozol, Paul Lowe, Scott Lucas, Donald Pease, and David Ryan, who provided comment and support along the way. At the University of Chicago Press, I thank Doug Mitchell for his wise and warm editorial support and Yvonne Zipfer for her careful attention to the book.

I have been fortunate to work in a stimulating environment at the Clinton Institute at University College Dublin and I have valued the interactions with colleagues and students during the making of this book. A huge thank you is due to Catherine Carey for helping me forge time to work on this project. I am also grateful to the postdoctoral and graduate students who have shaped my thinking in classrooms and other engagements with matters of media and conflict.

Finally, I thank my family for their patience with my disappearances during the course of research and writing. Thanks to Jake for sourcing images. This book is dedicated to Nancy, whose forbearance was heroic and whose encouragement carried me across the line.

Illustrations

"Follow the Americans"

In a lecture he delivered in London in 2007, the photojournalist Philip Jones Griffiths addressed a younger generation of conflict photographers: "We're living in a time that's so important for photojournalism. You've got to do it, no matter how trivial the magazines are, no matter how little money is in it. Find a way. This is such a historic period—this is the American Empire on the rampage. It hasn't happened since the Roman Empire was on the rampage and there weren't photographs then. Follow the Americans—that's what's important right now."[1] The statement is vintage Griffiths, bespeaking several elements of his philosophy as a photojournalist. First, there is his passion to promote photojournalism as a critical mirror that must be held up to power; second, his sense that imperial American power was the lightening rod of international conflicts during his lifetime; and third, his belief in the agency of the photographer as a witness and advocate, impelled by ethical and political imperatives to report truth and illuminate injustice. Across his career, from the late 1950s until his death in 2008, Griffiths was remarkably consistent in expressing and working to this philosophy and, at times, obdurate in this expression and impatient with alternative visions. As such, he was a particularly uncompromising example of the "concerned photographer."[2]

While Griffiths's missionary zeal may be viewed as quixotic, his exhortation to "follow the Americans" is a willful articulation of what the political economy of photojournalism has been set up to do since the mid-twentieth century. This is to say that photojournalism's focus on global conflicts (like much other news media but in a distinctive way) has

long been in a symptomatic relationship with American power enacted as "foreign policy." To be sure, Griffiths intends to question and politicize that relationship. While few photographers take such a stringent ideological approach, many find their work follows the contours of the geopolitical imperatives of the United States. For most, this is a necessity of their working lives as professional photographers documenting and commenting on the most significant global events with a view to publication in mainstream media.[3] For some, it is a more loaded association, compelling them to introduce some form of critical perspective in their work. At the very least, as Robin Anderson has noted, "many war photographers consider themselves the eyes of America's conscience."[4]

This is not to say that photographers always act as theorists and critics of U.S. foreign policy any more than they are overt cheerleaders or apologists for that policy or that they are consistent opponents of it—the ideologies of practice, representation, and production are rarely so clearly or starkly exercised. Rather, photographers work within political and symbolic economies of representation and balance professional and personal imperatives as they document war and violence. This balancing act is often evident in the work produced if we look carefully at the frames of representation and production that shape the meanings of the imagery. In particular, we can often discern something of the relationship between formal and institutional frames and how these lend ideological inflections to the imagery. The dialectics of geopolitical power and knowledge that shadow the making and showing of imagery of war and violent conflict are not always immediately evident yet are inevitably present, not least in the them-and-us schema that is at the root of much documentary practice. This schema is especially charged in the representation of violence and suffering at a distance.

The relationship between photography and U.S. foreign policy explored in this book is understood in terms of the above concerns. The aim is not to claim and evidence a direct influence on policy—that is, that photojournalism creates a "CNN effect." To be sure, there are instances when particular images appear to have had direct impact on policy thought and action, and we will consider examples. When photographers are asked, as they often are, if they believe their work has effected policy changes or had some notable impact on public opinion, they offer a range of responses. On the one hand, there is the excitement of Ron Haviv reflecting on his first foreign story, in Panama in 1989, when he photographed the bloody beating of Panama's vice-presidential candidate Guillermo Ford: "Six months later, I found out just how big an impact this shot was going to have—when President Bush used it in his TV speech to the nation to

justify the U.S. invasion. For me it was a monumental moment: I suddenly understood the power of photojournalism."[5] On the other hand, there is the frustration of Susan Meiselas who, reflecting on the lack of action in response to the photographs she took in January 1982 of the massacre at El Mozote in El Salvador, questions the power of photography to frame injustice and suffering: "The larger sense of an 'image' has been defined elsewhere—in Washington, in the press, by the powers that be. I can't, we can't, somehow reframe it."[6] More recently, the photographer Ashley Gilbertson has despaired of any positive impact of the intense photographic coverage of the wars in Iraq and Afghanistan: "Photographs of a thousand more bloody soldiers won't change anything. I can't make [the public] care about the war by bashing them over the head with it."[7] Of his own work in Iraq he says he came to "feel like I am documenting a demise . . . a historian archiving this foreign policy disaster that isn't working."[8] All these comments indicate the intensity of the photographer's investments in having an impact on policy or opinion, a desire that their work has an import beyond the moment of representation. More often than not, they are exercised by the controlling frames of political and media elites or frustrated by the seeming apathy or indifference of publics. The drive not only to document but also to change the conditions of what is documented, often articulated as a demand to "bear witness," remains significant, though, and a key indicator of the troubled relations between responsibility and action, between seeing and believing, that we will return to in this study.

The claims for and against "effect" or "impact" have value as statements of the photographer's intent or, if we look at the contexts of reception, as registers of the ways in which politicians and broader publics interpreted them. But intent and reception provide limited understanding of the relationship between photography and foreign policy and tend toward reductive visual determinism.[9] Such claims are not the focus of this book; rather, the focus is on ways in which selected photographers have sought to frame the activities and effects of U.S. foreign policy, often though not always with a critical perspective, and how their work engages the dialectics of power and knowledge that attend the American worldview. What is at issue here is understanding relations between the geopolitical conditions of visuality and the particulars of the image.

The American worldview, a belated ideological category associated with geopolitical paradigms of discursive knowledge formation in international relations or forms of area studies, has a fresh critical valence understood as a scopic regime. Geopolitics is itself a category of perspective, a visualized knowledge of global interactions. It has long valorized a per-

spectivism that operates through assumptions about the faculty of sight to cognitively map the territoriality of global politics. The metaphorics of vision in modern geopolitical thought is often associated with the concept of a worldview, connoting the strategic politics of global diplomacy and governmentality as issues of visual power and control.[10] Beyond this, the concept of a worldview refers us to the hegemony of certain ways of seeing the world beyond one's own nation state. That hegemony is legitimated by foreign policy, which is a privileged arbiter of power and knowledge that frames national cognition of foreign dangers and challenges. As David Campbell notes, "Foreign policy is a discourse of power that is global in scope yet national in its legitimation."[11] All geopolitical issues and events require legitimating frameworks in order to be apprehended.[12] Such dominant geopolitical frames as the Cold War and the War on Terror (but also supplementary frames such as humanitarianism and national security) transform cultural and political codes to produce legitimizing accounts of foreign policy realities and interests. What I shall refer to here as conditions of visuality are the ideological conditions that determine certain ways of seeing, that support practices and representations that establish (in)visibilities and police the relationship between seeing and believing in the American worldview.

Documentary photography has been instrumentally involved in the visualization of U.S. foreign policy and more broadly the representation of America's geopolitical visions (and their impacts) from the mid-nineteenth century onward. In part, this is due to the historical connection between the evolution of photography and the development of a young nation. The origins of photography in the United States are tied up with the documenting of westward expansion and with internal and external conflicts that defined the boundaries of the nation and the role of the state.[13] As it documented the growth of the nation, photography developed conventions and frames, a way of seeing that conjoined the democratic and imperial impulses of an emergent American worldview.

By the end of the nineteenth century, the foundations of American photojournalism were well established even as new technologies emerged to reshape its international coverage.[14] In the twentieth century, the triumph of American modernity on a global scale ushered in an increasingly confident perspective on international affairs, framed by domestic ideals and ideologies. The "golden age" of American photojournalism, from the mid-1920s to the mid-1960s, was a period in which picture magazines and

news magazines (drawing inspiration and personnel from European examples) came to the fore as the premier conveyors of photojournalistic imagery. Henry Luce, the founder of *Time* and *Life* magazines, articulated the prominence of this visual interest when he stated the prospectus for *Life* magazine in the mid-1930s. The purpose of the magazine, Luce proclaimed, was

to see life; to see the world; to eyewitness great events; to watch the faces of the poor and the gestures of the proud; to see strange things—machines, armies, multitudes, shadows in the jungle and on the moon; to see man's work—his paintings, towers and discoveries; to see things thousands of miles away, things hidden behind walls and within rooms, things dangerous to come to; the women that men love and many children; to see and to take pleasure in seeing; to see and be amazed; to see and be instructed; thus to see, and to be shown, is now the will and new expectancy of half mankind.[15]

What Luce celebrated and *Life* so brilliantly illustrated midcentury was an American way of seeing—that is, a way of seeing the world that is visually codified and thematized by the national concerns of the United States. As picture magazines such as *Life* articulated narratives of national identity, photojournalism took on a leading role in representing the intersections of national and international affairs.[16]

America's "rise to globalism" in the twentieth century denoted a will to power that conjoined the democratic and imperial impulses of an increasingly confident worldview. It promoted a rationality of perception that bound values and security together in visualization of the nation's foreign affairs—the will to power was sublimated in a will to see—and bore with it an epistemology of American geopolitical thinking. This projection of American exceptionalism proved well suited to the core development of photojournalism as essentially humanist and driven by a democratic ethos that rendered reality transparent through documentary realism. It established a relation between American culture and the rest of the world founded on the promotion of photography as a universal language. This promotion reached its apogee in the 1950s, most famously with the Family of Man exhibition, but also shadowed the perspectives of a postwar internationalism that was shaped by the ideological currents of the time as a new world order was envisaged that would not repeat the mistakes that had led to world wars. The creation of Magnum photo agency in 1947 epitomizes this, for, as Michael Ignatieff notes, "Magnum's task was providing the iconography of a liberal moral universalism."[17] A key tenet of the visual philosophy of midcentury photojournalism was

its commitment to a democratizing vision of human affiliations and an imaginary globalization of conscience: it posited a culture of humanity as a universal ideal and human empathy as a compensatory response to global threats—particularly to the threat of nuclear annihilation—and promoted compassion as a commensurate response to the suffering of distant others. The idealism of that vision would be severely challenged before the century was over, yet its moral currency remains a vital part of photojournalism's DNA.[18]

By midcentury, in the wake of World War II and the onset of the Cold War, the ideological formation of the American worldview was a powerful frame in media and geopolitical realms, and humanist perspectives were often readily aligned with it. Yet even as the Cold War framework conditioned the visualization of U.S. foreign affairs, it also exacerbated anxieties about the international role of the United States. With the Korean War and more overtly the Vietnam War, these anxieties were reflected in visual representation.[19] The ambivalence registered in Korean War imagery became a more deep-seated disillusionment with the onset of the Vietnam War, coverage of which is often cited as photojournalism's last great historical moment of record and relevance. During the war, photojournalists moved into a more adversary relationship with the military, as they questioned the management of the war, and in the work of many photographers the tensions held within the conjunction of democratic and imperial impulses in the American worldview began to visually erupt. This is the starting point of this book's detailed analysis of photojournalistic coverage of the United States' engagement in foreign conflicts.

Chapter 1 of *Afterimages* examines Vietnam War imagery. While news photography from Vietnam produced imagery that challenged the ideology and course of the American mission, a great deal of the work was produced as spot news imagery within a conventionalized form of professional practice. The result over time was that the published imagery repeatedly presented similar scenarios, motifs, tropes, and points of view. There were notable exceptions, though—photographers who developed a fresh visual awareness about war and its representations, especially those who stayed for long periods or who came with investigative intent. This chapter focuses on the work of two such photographers. The first is Larry Burrows, whose work constitutes a remarkable documentary chronicle of the war's shifting contours and his sensitivities to this and reflects his development of a "compassionate vision" that reflected the moral ambiguities of his role. The second photographer is Philip Jones Griffiths, whose body of work boldly illustrates and indicts the destructive military and cultural presence of the United States in Southeast Asia both during and

after the war. Griffiths put together his book *Vietnam Inc.* in 1971, a benchmark of war reporting, and returned regularly to Vietnam for many years after the war and published two further books, one on the effects of Agent Orange and another on socioeconomic changes in the country. Taken together these books form his Vietnam Trilogy, one of the most extensive documentations of a war and its aftermath by one photographer.

Chapter 2 focuses on the visual reportage of international affairs in the later 1970s and 1980s. With the golden age of photojournalism ending, a tougher style becomes apparent in the work of the post–Vietnam War generation of photojournalists, marked by a more subjective and self-conscious approach to the practices and values of the genre. Some sought to reinvigorate the genre through experimenting with technique, form, and color, disrupting the conventions of composition of the journalistic image and heightening tensions between aesthetic and reportorial concerns. This "new photojournalism" was innovative and at times controversial. It constructed a new visual grammar for looking at war and conflict, focused on conflicts in the Middle East and Central America that were geopolitically framed by Cold War imperatives of the United States. In chapter 2, I will look at a range of examples, with particular attention to the work of David Burnett, Abbas, and Gilles Peress in coverage of the Iranian Revolution and the hostage crisis and of Susan Meiselas in Central America. The section on the Iranian Revolution will focus most closely on the innovative work of Gilles Peress, whose imagery is a record of his confused perceptions and emotions during the weeks he spent traveling through Iran. There is, in his work, a distinctive challenge to the eye—to make visual sense of what is being looked at—and to particular ways of seeing international conflict. With regard to Central America, I will look most closely at the work of Susan Meiselas whose work in Nicaragua was a lightning rod for debates about the use of color in conflict photography, the lines between documentary and artistic practice, and the role of the photographer as witness.

With the endings of the Cold War in the late 1980s and early 1990s there emerged conditions of visuality that were significantly shaped by the effects of new media technologies on global communications and by the geopolitics of liberal capitalist expansionism and, in particular, by the imperatives of humanitarianism. Chapter 3 considers the work of selected photographers documenting the practices and effects of U.S. foreign policy in post–Cold War contexts—the Gulf War, the intervention in Somalia, and the Balkans wars—mapping the new geographies of threat and the new technologies of violence. The first Gulf War, in 1991, was a war in which visual production and representation was tightly controlled

and choreographed by the American military. Notwithstanding the re-strictions, a number of photographers produced challenging documen-tations of the "event" and its aftermath, and we will look here at work by David Turnley and Kenneth Jarecke among others. In the Balkans, the conditions of visuality were complexly affected by humanitarian frames and discourses. The Balkan wars, as much as the falling of the Berlin Wall, marked a watershed in mainstream Western photojournalism's role as an architect and agent of the postwar liberal humanist imagination. In the conflicts of the former Yugoslavia the narratives and ideals of liberation and freedom that accompanied the endings of the Cold War broke down violently and comprehensively, as Europe looked into the abyss of its own making. This is illustrated in the work of many photographers. I will look closely here at the work of Ron Haviv, Gary Knight, and Gilles Peress, all involved in "forensic" approaches to the aftermaths of violence and pro-ducing forms of documentation that can support legal testimony on war crimes and acts of genocide.

In the post-9/11 era, the geopolitical imperatives of the American worldview operate through assumptions of omnipresence and transpar-ency that attend the visualizations of interventions enacted in foreign lands. This worldview reflects and refracts the conditions of the perpetual wars of terror and securitization that sustain it. Chapter 4 examines visu-alizations of these perpetual wars. The primary frame to be considered in examining photographic documentation of the wars in Afghanistan and Iraq is that formed and regulated by the embed system of reporting. While embedded photographers are not happily complicit with the system, it nonetheless produces a frame that regulates their visual productions. For all the constraints, though, many photographers have been producing imaginative work, some of them pushing at the boundaries of the frame even as they work within it. This chapter will look at examples, includ-ing the work of Chris Hondros and Ashley Gilbertson in Iraq. It will also examine the emergence of a digitalized soldier photography—another form of embedded image making—that offers compelling, real-time per-spectives on the American soldier at war and suggestively supplements professional photojournalist representations of the conflicts in Iraq and Afghanistan. The chapter will also look at the role of photojournalism in documenting the realities of the "homeland security" state. This focus takes on a fresh urgency in the context of a war on terror that is both an external event and threat and an internalized condition of everyday life in the United States and that has made the workings of power more resis-tant than ever to the evidentiary truth claims of visual and news media. This perpetual war presents particular challenges to visual representation,

especially to photojournalism, which has long been predicated on the re-lationalities of foreign and domestic spheres. With this context in mind, I comment on the work of three contemporary photographers who work with a politicized sense of purpose and a belief in the values of social documentary practice. All three—Nina Berman, Anthony Suau, and Ashley Gilbertson—seek to represent the war on terror by looking inward at a time when much documentary attention is focused on Afghanistan and Iraq, in order to ask questions about the conditions of war at home.

––––––––

What is the role of photojournalism in relation to the ideological conditions of visuality surrounding U.S. foreign policy? In the broadest yet historically discrete terms, it is to reflect and illuminate the landscapes and actions of the United States in international conflicts in meaningful ways to an interested public. This is to say, it adopts and adapts the traditional role of photojournalism as a public news medium that re-presents democratic life to its participants. Robert Hariman and John Louis Lucaites have argued that "photojournalism is an important technology of liberal-democratic citizenship," the functions of which include "reproducing ideology, communicating social knowledge, shaping collective memory, modeling citizenship, and providing figural resources for communicative action."[20] As such, it both mirrors and shapes relations between liberalism and democracy, between public and private spheres, and between the individual and the state. In the context of international affairs, it also mirrors and shapes relations between domestic and foreign realms.

Photojournalism conventionally frames worlds of conflict and violence beyond the nation state, thereby shaping the composition of differential norms—such as humanity and otherness—that are crucial to the understanding of ethical and political relations in international affairs. In doing so, it provides visualized and often embodied form to significant abstractions in the discourses of foreign policy media—abstractions such as human rights or collateral damage. This is to say that it plays a significant role in depicting human relationality, defining and redefining relations between "them" and "us." A key aspect of this shifting dynamic is the ways in which perceptions of space and time reshape frames of representation, for a sense of distance is crucial to the (non)identifications with others and to perceptions of humanity and inhumanity.

The more direct, biopolitical question that springs from so much representation of war, conflict, and human rights abuses is: who counts as human?[21] As we shall see, this is a question that goes to the crux of doc-

umentary representation of U.S. foreign policy for it entails ethical and political considerations of the values and assumptions that underlie the American worldview. For photographers, the question is rarely so baldly posed, but none are unfamiliar with the devaluations of human life in the representation of war and conflict in foreign lands. A complex interplay of formal conventions and ethical considerations characterizes the production, display and reception of photojournalistic images of war and conflict, more particularly when these images, as they so often do, focus on bodies that are subjugated or/and in pain. The imagery can function to demonize and dehumanize, rationalizing perceptions of the enemy or aggressor, but it can also function to humanize, rationalizing perceptions of the friend or victim. It is the focus on the human that is the locus of a range of affective responses to such imagery, from horror to pity. And so, photojournalistic imagery of war and conflict both valorizes and parses humanity; it reminds us both of our common humanity and that our sense of what it means to be human is at issue under conditions of war and conflict, but it also screens who or what counts as human.

Such tensions continue to mark the work of photographers and are a consequence of the role photojournalism has performed in promoting and sustaining a humanistic perspective on the violence of war and human rights abuses—most particularly by positing compassion as a framing device for the representation of the suffering or subjugated bodies of distant others—while operating within a political economy of media production skewed to represent the values and interests of dominant Western powers. Often, under these conditions of representation, compassion becomes the default frame that simultaneously invites viewers to engage the horrors via affective responses to agony, yet disengages them by eliding the geopolitical realities of power and violence that underlie the horrors. As such it registers the multiple professional and ideological demands on the photographer and the multiple tensions the framing of the photograph signifies even as it works to create a stable image.

Photojournalism bears a complex relationship to the visual production of American national identity and of foreign policy. It can function to support a geopolitical way of seeing—an American worldview—that frames domestic perspectives of international conflicts, yet can also question the rationality of perception that binds values and security in this worldview, to apprehend the relations of power and knowledge that structure it. In this book, I consider some of the ways in which photojournalism critically engages the American worldview, particularly with regard to the framing of violence carried out by the state. In line with the sense of agency Philip Jones Griffiths articulates above, *Afterimages* focuses on photographers

who have worked to push the boundaries of photographic practice and to critically reflect on the contexts and scenery of war. While these photographers have varied motivations and were often constrained by media and state frames, they developed the genre of photojournalism, adapting it to new conditions of warfare and technological production. They have produced a more meditative form of photojournalism, an *afterimagery* of conflicts and contexts, bound not to spot news reporting but to a more investigative framing of events. As such, their work is attentive not only to the moment of the event and its representation within news frames but also to broader and deeper forms of documentation that engage cultural and political contexts. Many are also attentive to the afterlives of their images beyond the moments of making and first publication. As Max Kozloff notes, "The afterlife of images is the beginning of their effective life—when news value has evaporated, the photographer repossesses the visual material."[22] The reproduction of images in books, exhibitions, and in online and other forms has been a significant element in the dissemination of conflict photography since the early 1970s.

The emphasis on "afterimagery" here also refers us to the reflexivity of much of the work under analysis and its relation to the development of the genre. These photographers are attuned to the traditions and conventions of photojournalism, and several are vocal commentators on this. Many seek to spur critical reflection on American foreign policy by utilizing the critical and reflective elements of photographic representation. This takes diverse forms in visual practice, though as we shall see a common concern is to open critical spaces for thought, to give the viewer pause. In this the photographers may be said to practice a form of "postreportage," a posthumous yet searching visualization of the event, its environs, and its legacies. This is also to say they recognize the limitations of the genre and help us understand that photojournalism is greatly constrained if understood only as a form of news coverage. Their complex, self-aware visual practice reminds us of the shortcomings of paradigms of journalism or media to explain the nature of photojournalism as a public art form. It also suggests that the endless jeremiads about the death of photojournalism—no media genre has ever been so repeatedly and publicly pronounced dead, exhausted, or irrelevant—may be viewed as perverse reflections of its propulsive life force and critical qualities.

For these reasons, this book foregrounds the work of individual photographers yet is neither an auteur study nor led by biographical concerns. Taking the work of selected photographers as points of focus allows us to map the evolving relations between the American way of war and photographic coverage of it. And so, the chapters are organized in the first

instance around key U.S. military actions over the last fifty years, and then move to examine how photographers have engaged these conflicts and how the forms of visual reportage they produce comment not only on the conflicts but also on wider ethical and political matters and on the genre of photojournalism. As suggested above, mid-twentieth-century photojournalism's liberal humanist principles provide both a rich history and troublesome burden for the genre's practitioners, not least because of the entanglements of these principles with American imperialism. Photographers have been innovative in working within that entanglement and at times controversial in trying to work out of it. The key point is that they have been working out answers to problems that remain compelling in relation to American power enacted as foreign policy. Running throughout *Afterimages* is an inquiry into the high value (ethical, sociopolitical, legalistic) that continues to be placed on the power of the still image to bear witness and to stimulate action. It presages a number of questions that echo across the chapters. How has the role of the image maker as witness evolved? What capacities for critique do images maintain? What new visual vocabularies are emerging to represent new forms of war and violence?

Compassion and Critique: Vietnam

The collapse of French colonial power in Vietnam in the mid-1950s held only fitful interest for American news media but it did attract the attention of a number of photojournalists looking for the next big international story. The emergence of photo agencies such as Magnum and the competition for stories of conflict meant that a number of photographers were roaming the globe for such imagery. Two of the most famous war photographers of the period made their way to Vietnam. In May 1953, David Douglas Duncan photographed the French cause unsympathetically, showing lazing French officers and an army mostly made up of foreign mercenaries. In his text, he derided "inept French colonialism" and wrote: "It was now nearly over. The cause was bankrupt from the start."[1] When Duncan's report appeared in *Life*, it annoyed the U.S. State Department and enraged the editor of the magazine, Henry Luce.[2] Robert Capa went to Vietnam a year later, partly because he was responding to the challenge of competition with Duncan, and he died there on May 25, 1954 when he stepped on a landmine while accompanying a column of French and Vietnamese infantry in the Red River Delta.[3] Duncan and Capa's imagery empathized with the Vietnamese but did little to clarify what was at issue for Americans or to secure strong public interest in the U.S. role in the region.

With increased aid to Vietnam at the end of 1961, including the assignment of combat support units, the media became interested in Vietnam as a war story and increased

their coverage and their resources accordingly. The increased investment demanded much more intensive coverage, not only analysis of trends and conditions but also and especially spot news, focused on events. The key sources for much of the news content were the American mission in Saigon and South Vietnamese officials representing President Diem's views, but journalists very soon saw the disparities between these statements and the evidence around them. As has been well documented, they began to draw on other sources, especially lower-level U.S. advisers and military personnel who were frustrated with the conduct of the war. The *New York Times*'s David Halberstam wrote that "the closer one gets to the actual contact level of this war, the farther one gets from official optimism."[4] The relationship between the American mission and the American press began to disintegrate as the latter questioned the merits of the Diem regime, the quality of South Vietnamese military forces, and even the American mission's efforts at news management.[5]

This was the beginning of what has been commonly described as the "adversarial" relationship between the military and the press in Vietnam. Richard Nixon would later claim that "this was the first war in our history during which our media were more friendly to our enemies than to our allies."[6] Such claims have taken on the aura of historical truth and have helped perpetuate a powerful myth—that the American media undermined American morale and contributed to the loss of the Vietnam War. The work of several historians shows that this is a half-truth at best, as the great majority of American press supported the war and were committed to the national security consensus.[7] However, there were differences within the journalistic ranks, with younger journalists in particular more likely to question the management of the war even as they supported more general aims (and continued to frame their dissent within an American point of view). While few of them were politicized by the war, many became disillusioned, and this was reflected in their coverage. There was considerable freedom for such questioning as there was only very limited censorship for much of the war and the press had unprecedented access to the military and the theaters of conflict. The result was "a goldfish bowl atmosphere" that gave a general impression of transparency (and illusion of insight) and attracted Western correspondents in great numbers.[8]

And yet, for all the open access, there was a general incoherence in the organization and progress of the war that tested journalistic talents and conventions to interpret its meanings and contributed to the shakiness of its framing. Flows of images reinforced the perception of a war without clear battle lines or coherent strategy, while military and political claims of a justifiable and winnable war were slowly undermined by imagery that

shaped public knowledge if not understanding about the war. The idea that the war was resistant to conventional forms of journalistic interpretation has been voiced by many commentators during the war and since. Malcolm Browne, who reported on the war for the *New York Times*, noted: "Viet Nam does not lend itself well to numerical reporting, or even to the kind of simple, narrative statement required of the average newspaper lead. There are too many uncertainties, too many shades of gray, too many dangers of applying English-language clichés to a situation that cannot be described by clichés."[9] The media historian Phillip Knightley describes the Vietnam conflict as "a war with no identifiable enemy, no simply explained cause, no clearly designated villain, no front line . . . a war with complicated political issues and in which the correspondent had regularly to try to make sense out of a whirl of experience and ghastly sights. . . . No one correspondent could hope to get a broad, general experience of it all; all that most correspondents succeeded in doing was obtaining a limited, spotty experience. It was a complex war, equally difficult to understand and convey in all its ramifications."[10] The ramifications of these difficulties have been commented on for print journalism, and the emergence of "new journalism" has been identified as a response to this crisis of interpretation.[11] How did photojournalism respond?

If we consider the broader contours of the media coverage of the Vietnam War, it would appear that news photography had an increasingly retrograde role as it was overtaken by television in the depiction of the war. The Korean War was the last major conflict that most Americans viewed primarily through photographs in print; by 1962 over 80 percent of American homes had television and, by 1968, over 60 percent of Americans looked to television for news on the war. Vietnam would come to be thought of as the first "television war," and there are many who argued that in bringing the war to American living rooms it was instrumental in turning American public opinion against the war.[12] However, the statistics do not tell us about the conditions of visual news production and its effects. Photojournalism did not quite cede the ground of news representation to television. Rather, these mediums existed in a relationship of mutual influence. Together, they constructed a visual grammar for looking at Vietnam. At the same time, and partly in response to the challenge of television, photojournalism evolved certain techniques that emphasized its capacity to document decisive moments and that were commensurate to the nature of the conflict in Vietnam.

Photography played a key role in framing the war for the American public not least because for much of the conflict the technology of the still camera was much better suited to the terrain and the style of warfare

being conducted. Television equipment in the field remained large and cumbersome until the early 1970s. As with other forms of media coverage, the volume and focus of photographic coverage was largely determined by the particular conditions of this war—the technologies, the tactics, and the territory—and by the shifting course of the war in relation to American public opinion. The numbers of photographers fluctuated, from only two in 1962—Horst Faas and Larry Burrows—to more than one hundred by 1969, and then fell away dramatically in the early 1970s. Some photographers were full-time staffers with news agencies such as Associated Press and United Press International and news magazines such as *Life*, *Time*, and *Newsweek*, but many more were freelancers who turned up in Vietnam hoping to have their work taken up by one of the major agencies or papers. Not all were professionally trained, yet press passes were easy to obtain, and with a pass the photographer would receive support from the American military to move relatively safely as he or she covered the war. The large numbers of photographers and the relative autonomy they enjoyed contributed to a new political economy of war imagery that emerged in relation to the Vietnam War, one that was very immediately responsive to and regulated by the American and other Western markets' large appetites for steady diets of war imagery.[13]

A great deal of this imagery focused on spot news and dramatic action, prerequisites to meet the demand and deadlines from the daily and weekly papers and magazines. This material was not without aesthetic or documentary merit. Rather, these were tailored to the representation of distinctive forms of combat activities and terrains and to the technologies of movement and violence. The result over time was that the published imagery repeatedly presented similar scenarios, motifs, tropes, and points of view: helicopters taking off or landing; troops springing from helicopters and fanning out on foot; troops on patrol through paddy fields and wading across rivers. The helicopter became a key icon in this imagery, with point of view shots of terrain from helicopters being common. Indeed, the cameras rendered the helicopter (on which the photographers were very often dependent for their own movements and war coverage) the ubiquitous motif of the war, one adapted by cinema at war's end. The result was an increasingly stylized and often distanced perspective on the war, finding its mise-en-scène in the framing of American men and machinery against inhospitable terrain. The absence of the North Vietnamese in so much of this photography was a fitting visual reflection of a war of insurgency, with no clearly defined frontline or enemy.[14]

The effects of photography on public opinion remain as difficult to determine as those of written journalism and television.[15] To the extent that

it played a role in turning public opinion against the war, this should be seen as an incremental effect of the flows of daily photographic coverage over the long term of the war. Military and political claims of a justifiable and winnable war were slowly undermined by imagery that shaped public skepticism if not understanding about the war. It may be that the cumulative effects of such imagery over twelve years had a more profound impact on the American public than it is possible to measure. Just as significant was the impact of photography in reinforcing and making graphic particular moments of the war that fed the growing disillusionment of the American public (fig. 1.1). Barry Zorthian, who was in charge of media relations in the U.S. Embassy in Saigon from 1964 to 1968, later reflected on the impact of news photography on policy and opinion:

I would note the impact on the first day of Tet, with perhaps as much effect in Washington as T.V., of the front page of *The Washington Post*, which was dominated by photos of the brand new American embassy attacked and semi-destroyed, as well as the impact of the continuation of that fighting in Saigon and in Hue—the two points at which the press was most visible and most active. The impact of the one such as the shooting of a Vietnamese prisoner by a Vietnamese general, and the incredibly bloody and gory cover of *Life* showing a tank carrier covered with dead American marines which circulated approximately ten million copies throughout the United States,

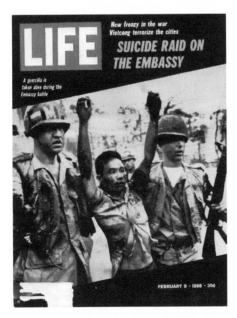

1.1 "Suicide Raid on the Embassy," cover, *Life*, February 9, 1968.

was immense. The anxiety, desire, and intensity of the media focusing on the most dramatic, seeking the greatest impact, dismissing the subtleties, the qualifications, and the limitations required, gave what was essentially a distorted impression and a misreading of Tet. That situation finally led to deterioration of public support and to an impact on President Johnson and others that affected their political decisions.[16]

Zorthian's judgment on the coverage of Tet notwithstanding, his comments suggest that still news imagery of the Vietnam War played a significant role in visually dramatizing the failings of the American mission in Vietnam.

A corollary of this is that photojournalism not only complemented television coverage of the war but also served distinctive documentary functions, especially as it maintained a power to frame decisive moments. In a war of confusing patterns and resistant to conventional forms of interpretation, it often proved to be the still photograph rather than the moving image that framed and defined moments of insight and brought some clarity to the scenery of confusion. Often, it did so by turning the moments into symbols, transcending the local context to address more universal human concerns. This was the case with the most iconic images of the war, and it is striking how potent these were and remain, displacing written and televisual journalism in popular memory of the war. Malcolm Browne, a reporter for the Associated Press, who took the iconic image of the Buddhist monk Quang Duc fatally setting himself on fire on a Saigon street in 1963, notes that "millions of words had been written about the Buddhist crisis, but the pictures carried an incomparable impact."[17]

While collectively news photography from Vietnam constituted a potent archive of a new kind of photography suited to a new kind of war and produced imagery that challenged the ideology and course of the American mission, a great deal of the work was produced as spot news imagery within a conventionalized form of professional practice. There were notable exceptions though—photographers who worked more self-consciously to push the boundaries of photojournalistic practice. George Russell has suggested that this more adventurous photojournalism represented the mainstream of news photography coverage of Vietnam: "News photography surrendered its pre-eminent place as a mover of mass public opinion in Vietnam. It also discovered—or rediscovered—a different kind of emotional intensity, based on what television could not do. Television did not linger well, nor could it amplify an emotional effect by passing and repassing across the same subject from subtly different angles. That kind of television news was simply boring. In Vietnam, therefore, photography took on a kind of meditative authority, in lengthy, often ferociously

pointed essays on the devastation and pointlessness of the conflict."[18] Russell overstates the case: most news photographers had neither the time nor the inclination to produce meditative visual essays on the conflict, particularly not those meeting daily deadlines. In Malcolm Browne's view, "No newsman can afford to think about history. He has to have something to put on the wire machine." Browne adds: "Journalistic photographs certainly have no point of view in them because there is no time or energy for point of view in this kind of photography."[19] Browne's view was shared by many news photographers covering Vietnam; it was a component of their sense of professionalism. Photographers, like all accredited press in Vietnam, worked with a consciousness of professional commitments and pressures that delimited reflective or critical perspectives on the war effort. They knew the expectations of their editors and beyond that of media executives and owners and of the public, all of which contributed to the framing of the war in broader terms.

However, there were a number of photographers who did move to produce a more "meditative" form of photojournalism, an afterimagery of conflicts and contexts. I am thinking here of photographers such as Larry Burrows, Philip Jones Griffiths, Don McCullin, Catherine Leroy, Kyoichi Sawada, and Henri Huet. In Vietnam, photographers had opportunities to develop a fresh visual awareness about war and its representations, especially those who stayed for long periods or who came with investigative intent. Within the mass visual coverage of this war were examples of this new awareness, the work of photographers reflexively attuned to the style and ethos of their work as a subjective register of their relation to the war. I will focus here on the work of two such photographers, Larry Burrows and Philip Jones Griffiths, who differ greatly in style and motivation, yet have each produced remarkable documentary chronicles of the conflict and influential templates for future photojournalistic treatments of the United States at war.

"A Compassionate Vision": Larry Burrows

Very few Western photographers spent as much time working in Vietnam during the war as Larry Burrows. He first arrived in 1962 and continued to cover the conflict until his death in 1971, when the helicopter carrying him and three other photographers crashed over Laos. Already lionized as a fearless professional, Burrows's untimely death hastened his mythologization as the greatest combat photographer of his generation. *Life* magazine, for which he worked for twenty-nine years, published a book of his

work in 1972, titled *Larry Burrows: Compassionate Photographer*. Since then, his work has been widely exhibited and a book devoted exclusively to his Vietnam images, *Larry Burrows: Vietnam,* was published in 2002, with an introduction by David Halberstam. Halberstam writes: "Because of . . . his talent, his courage, and his particular feel for the Vietnamese people, [Burrows] became the signature photographer of that war, a man whose journalism, in the opinion of his colleagues and editors, reached the level of art."[20] Such statements are not especially instructive in trying to understand the significance of Burrows's work as a photojournalist, especially as it suggests this work transcends the contexts of its making, but they do signify the esteem in which it is held within his profession. In 2008, his mythic status was symbolically enshrined in American journalistic history when some of the remains found at the crash site of Burrows's death were interred within the Newseum in Washington, DC, as part of its opening ceremony.

My purpose is not to seek the real Larry Burrows beyond the mythologizing. Burrows was indeed a dedicated and exacting professional, striving to push the boundaries of his medium and genre, and the technical quality of his work sets it apart from many. But so do the particular circumstances afforded him as feature photographer for *Life* magazine, not least the time and support he had in order to produce more reflective work than many of his colleagues. The significance of Burrows's work in Vietnam resides in the genius of his technical and formal abilities but also in the remarkable documentary chronicle he produced across ten years. The trajectory of this work is instructive as it evolves in several ways. First, we see a strong experimental impetus, stretching the genre—evident in the use of color, striking compositions, and incongruent points of view. Second, his photographs document the escalation of American involvement in Vietnam, from the presence of military advisers in the early 1960s through the quagmire of key battles of the late 1960s to the extended war in Cambodia and Laos in the early 1970s. Third, Burrows's perspective on the war shifts, from that of a "hawk" to one of "disillusionment" with American involvement in Vietnam. In the interrelations of these evolving techniques and perspectives we find Burrows working to strike a balance— between document and aesthetics, between objectivity and subjectivity— that will make the war meaningful to Western viewers, and to himself.

Burrows first worked for the London bureau of *Life* magazine in 1942 at the age of sixteen. His association with *Life* grew as he worked his way into the profession, from errand boy to darkroom technician—he developed multiple stills of the war in Europe—to a freelance photographer in the 1950s, to a staff photographer in 1961. During this long apprenticeship as

a photojournalist, Burrows worked mostly in London, covering British political and celebrity life, yet developed multiple skills that would become more and more evident in his Vietnam work. Perhaps most importantly, he learned much about the use of color when *Life* tasked him to photograph celebrated paintings across Europe.[21] Burrows's imagination was increasingly sparked by assignments to cover foreign conflicts, including the Suez Canal dispute between Egypt and the United Kingdom in 1956, the civil wars in Cyprus and in Lebanon in 1958, and the uprising in colonial Congo in 1960. In 1961, he was appointed a staff photographer for *Life* and stationed in Hong Kong as a base to cover Southeast Asia. From there he covered not only the conflicts in Vietnam but also took up many assignments in other parts of the region, including the temples at Angkor Wat, Ashanti tribesmen in Ghana, New Guinea wildlife, and the Taj Mahal. Burrows's foreign commissions were an admixture of tourism and conflict sites, reflecting *Life*'s visual exoticization of the world beyond the United States, and represented a terrain in which he most productively advanced his color photography. This conjunction of subjects and sites also mapped out a late colonial perspective that shadowed the imperialist ambitions (and uncertainties) of the United States in this period.

"This Formless War"

Burrows's first major Vietnam War story, published in *Life* on January 25, 1963, was an exceptional publication, presenting the conflict in Vietnam to the American public in a way that had not been seen before. The fourteen-page photo spread, titled "We Wade Deeper into Jungle War" and subtitled "Stark Color of the Vicious Struggle in Vietnam," accompanies a report by Milton Orshefsky titled "Despite Battlefield Setbacks There Is Hope—with Caution." There are twelve photographs by Burrows, all in color. It took him almost six months to cover the material and prepare the story, which depicts the operations of South Vietnamese forces and their American advisers in the Mekong Delta. The most extensive photographic coverage of the conflict at that time in the American press, it was Burrows's images that made it stand out. This was the first color imagery of the war in a major magazine, and it changed the ground rules for photojournalistic coverage of the war.

Stylistically, the photo spread followed the best design traditions of *Life*, producing not only a collection of striking images but, as well, a narrative stitched together by the layout of the spread, the echoing stylistic and thematic motifs in the imagery, and the accompanying text: all work together to narrativize and dramatize the events depicted. What was new

in this presentation were the vibrant colors used by Burrows to enhance physical and emotional aspects of the imagery and his use of jarring compositions to shape the viewer's point of view on the action and personnel. At the same time, the spread challenged contemporary conventions in American media about what should be represented in imagery of American foreign policy in action. There are depictions of dead bodies of the Vietcong and of torture, while other images show evidence of U.S. military involvement at a time when this was little discussed—we see American H-21 helicopters supporting the Vietnamese troops, a U.S. pilot instructor watching a Vietnamese napalm strike by a T-28 fighter-bomber, and the figures of American military advisers at the scene of a conflict. Overall, the effect of "We Wade Deeper into Jungle War" is to generate a sense of a brutal conflict taking place in an inhospitable landscape and to introduce an undertone of unease about growing U.S. involvement in what the text terms "this formless war."[22]

It is the formlessness of the war that is most powerfully connoted by Burrows's imagery. The final image—set across two full pages—shows a group of dead Vietcong soldiers by the river (fig. 1.2). It stands out as a document and artifact, reflecting Burrows's sharp sense of the nature of the conflict in this period and his attempt to translate this visually for the viewer. The caption for this image reads: "Vietcong soldiers, trapped and shot down in the Delta, lie dead on a nearby shore."[23] The dead bodies fill the center and lower part of the frame. They are scattered in ungainly poses, mostly with arms flung out; all are barefoot and some are only partially clothed. There are few signs of injury apart from a red patch on the head of the man lying in the central foreground and blood beneath the face of the man beside him. At the background stand two U.S. advisers, seemingly relaxed as they survey the scene. To their right are huddled a group of Vietcong prisoners. We also see a pile of captured guns and a Vietcong flag. The scene is framed as a suggestive tableau, freezing in place many elements of the conflict as it was then enacted and inviting us to connect them meaningfully.

The power of the image is due in part to the striking composition, focusing our eyes on the dead bodies at center but providing more and more information about context as our eye travels around the border of the scene. For all the formal weight the dead bodies have at the center of the image, we gain a sense that the horror of their display is for our eyes as none of the living in the picture show interest or concern. The eyes of the American advisers appear to be averted, while all the South Vietnamese soldiers in the scene either have their backs to the dead or look away from them. The most striking example is the soldier whose profile fills the full

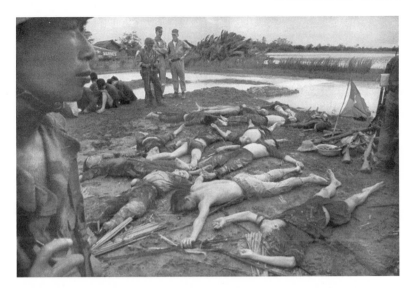

1.2 South Vietnamese forces and their American advisers in the Mekong Delta, Vietnam, 1962. (Larry Burrows, photographer.)

left side of the frame as he stares into the distant right—the soldier's profile is dramatically cropped by Burrows and barely in focus. Point of view is difficult to determine with this image precisely because it offers so many different viewpoints, but the dead bodies hold the center and our eyes return there. Color is used in a muted fashion, as the dominant greens and browns reflect the monochromatic palette of the muddied Vietnamese landscape. Supporting the composition, the effect is dispassionate; there is no glamour in victory, no dignity in death in war.

From 1963 to 1965, Burrows followed the evolving political and military conflicts in Vietnam, including the Buddhist revolt and the coup that overthrew Diem, the increasing activity of U.S. advisers, and the arrival of U.S. combat troops in March 1965. He spent many weeks traveling with helicopter crews, keen to do an in-depth story on one of them, showing the cycle of their work at base and in the field. One such mission produced one of the most famous picture narratives of warfare. On March 31, 1965, following the work of U.S. Marines Helicopter Squadron 163, Burrows flew with Yankee Papa 13, which was airlifting Vietnamese troops to an enemy area near Da Nang. On one trip, they landed close to another helicopter that had been shot down and rescued two of its crew but were unable to also rescue its pilot due to heavy ground fire. One of the rescued men, Lieutenant Magel, died during the flight back to base. Burrows constructed a photo essay that centered on this mission. *One Ride with*

Yankee Papa 13 was published in *Life* on April 16, 1965—a fourteen-page essay with twenty-five black-and-white photographs by Burrrows and his own accompanying text.[24]

The photo spread was constructed as a "day in the life" of Corp. James Farley, a fresh-faced twenty-one-year-old helicopter gunner, and so developed a narrative arc about his experience—more symbolically, his loss of innocence—that accentuates his shock and distress as the key emotional contours of the action. With Farley as the fulcrum, the photo story combines shots of action and intimacy. The cover image (fig. 1.3) is drawn from the dramatic center of the action, showing Farley in his gunner position looking shocked as he shouts and gesticulates to another crew member, with the slumped body of Magel beside him and empty shells at his feet. Overall, the photo story chronicles the mission, from the preparations in Da Nang, to the rescue mission and Magel's death, and the return to base and Farley's breakdown. It opens with juxtaposed images of the group and the individual. The group shot is of a briefing of the Marine helicopter squad in Da Nang as they prepare for the mission. The individual shot is a full-body image of a smiling Farley confidently striding toward his helicopter carrying two M60 machine guns. The juxtaposition sets a key element of the frame, focusing on one life among many, and as the sequence develops, images of Farley's actions and expressions receive focal significance (they dominate all the larger prints in the layout) while counterpointed with activities of the helicopter's team. Farley's role as a mirror of emotional responses to the scene comes to the fore most powerfully in his shocked responses to the dying Magel on the return flight and in the closing image, of Farley weeping alone in a supply shack. Burrows risks pressing the symbolism at this point as we note the open doors behind Farley through which pours a potentially redemptive sunlight.

The narrative arc of *One Ride with Yankee Papa 13* has been reprised by many photojournalists and echoed in many war movies. By narrativizing the events he photographed as a coming-of-age story, Burrows reached into a mythical terrain of war representation that drew on many literary and visual antecedents. At the same time, he innovated and extended the conventions through his technological acumen, providing action shots that were rarely attempted by an earlier generation of photographers and creating an admixture of intimacy and high adventure that many photographers would seek to mimic.[25] While the inference of a loss of innocence can be abstracted to American involvement in Vietnam, Burrows does not intend a critique of U.S. policy or strategy. Rather, his focus, as with so much of his work, is on the human component—the individual—and on

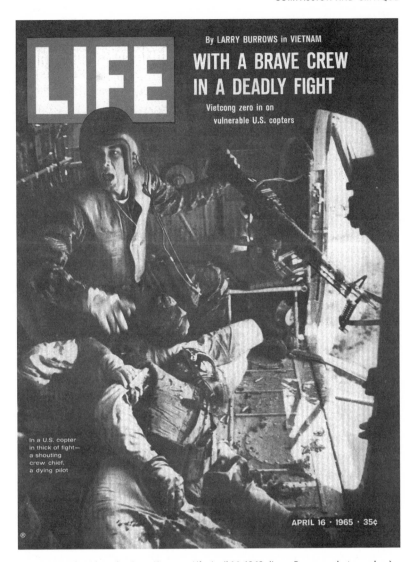

By LARRY BURROWS in VIETNAM

WITH A BRAVE CREW
IN A DEADLY FIGHT

Vietcong zero in on
vulnerable U.S. copters

In a U.S. copter
in thick of fight—
a shouting
crew chief,
a dying pilot

APRIL 16 · 1965 · 35¢

1.3 *One Ride with Yankee Papa 13*, cover, *Life*, April 16, 1965. (Larry Burrows, photographer.)

more general emotional themes surrounding death and suffering. Once again, though, he alludes to the formlessness of the conflict. For all the symbolic focus on Farley and the closure on his private grief, the death, confusion, and shock of the mission—and Farley's sense of guilt—all signify a much messier conflict in which the individual American's role in

Vietnam remains uncertain. The images appeared only one month after the U.S. committed its combat troops to Vietnam.

With the United States now fully committed to combat, Burrows sought out stories that would inform his audience about the particular features of this war. On September 9, 1966, he published a photo essay titled "The Air War," a companion essay to that on Yankee Papa 13 in its focus on American use of advanced technology but very different in use of color, composition, and point of view. Unlike the earlier essay, Burrows did not focus on an individual or even on a group but on the technology itself. He made use of color to express the speed and spectacle of high technology directed for use in war. America's technological superiority was most devastatingly evident through its airpower, yet there was little reporting of this aspect of the war. Aware of this, Burrows worked closely with the Air Force for nine months. They were keen to have the coverage and even removed the door from a plane so Burrows could strap himself in the doorway and photograph the guns inside and outside. This kind of support was not available to every photographer, and it suggests both how keen the military were to have coverage for certain aspects of the war and how they trusted Burrows to represent their perspective.[26]

The resulting imagery is spectacular and renders the technology and its violence disturbingly beautiful. Eschewing focus on individuals, Burrows uses form and color to accentuate the power of the technology. We see the burst of orange fire from the Gatling guns fitted to a C-47, photographed from the doorway by Burrows; we also see the men inside the plane covered in a reddish glow as they operate the guns. This is not only a technically innovative image but also one that attempts to stretch conventional representations of air fire that links the human technicians with the lethal weapons. We also see action shots of an F-4C Phantom swooping toward a riverside village and firing rockets into it and images of an A-1 Skyraider dropping phosphorous bombs on village huts in Ban De—the explosions and afterburning are spectacularly colorful. Eschewing the intimacy of the Papa Yankee 13 essay, this essay is markedly dispassionate in its presentation of violence and its aftermath. There is no focus on human drama, and while the power and impact of the machines on the landscape is shocking, the human destruction is distant and invisible. This in itself is suggestive of some element of critique by Burrows—how impersonal and removed war is for some American soldiers—but the more striking overall effect of the images is that aesthetic elements have overwhelmed the documentary. The bombing runs, aligning the pilot's point of view with the colorful destruction of villages, and the imagery of planes flying side by side in the sunset would become visual clichés in Vietnam War

films, usually accompanied by a musical soundtrack. There is horror in Burrows's images of the air war but it is distanced, beautified; there are no signs of humanity, just efficient machines.

Throughout 1966–68, Burrows closely followed several key operations and battles as ground fighting intensified across strategic sites in Vietnam. The most significant photo essays he produced covered the battle for hills in the Demilitarized Zone in the autumn of 1966, the growth of U.S. activity in the Mekong Delta at the beginning of 1967, and the siege of Khe Sahn in the spring of 1968. These images produced some of his most intimate and dramatic images of American soldiers involved in ground war—the sort of combat and combat photography not seen since World War II. The enemy remained invisible for the most part, but Burrows was intent on taking his viewer in close to the action and the physical and emotional suffering of American soldiers in the midst of battle. Color is to the fore again and the inhospitable terrain—water, mud, and jungle—is again accentuated. The close-ups of tired, shocked faces of active soldiers recall the work of the photographers W. Eugene Smith in Saipan in World War II and David Douglas Duncan in the Korean War and reflect Burrows view: "You can't photograph bullets flying through the air. So it must be the wounded or people running loaded with ammunition, and the expressions on their faces."[27]

The most dramatic sequence of images shot by Burrows focuses on the battle for the Nui Cay Tri ridge during Operation Prairie. Three of these, including the cover image, were published in *Life* on October 28, 1966; a fourth image was later published in the February 26, 1971 issue of *Life*, in a memorial article on Burrows. The sequence details the marine battalion's struggle to take two of the hills from entrenched Vietcong forces, with much of the imagery focused on wounded American soldiers. There are several shots of a black gunnery sergeant, Jeremiah Purdie, who had been wounded in the leg and head and was being directed to an evacuation helicopter. Burrows described Purdie's movements: "Purdy [sic] lurched past me, slipping and sliding through the mud to get away from the crest of the hill and find a dugout, blood was streaming down his face and he was screaming mortar attack. He had been hit by shell fragments from the first of three shells. Shortly after he wanted to return to his post but was restrained for medical treatment and refused to be carried but walked to the top of the hill for helicopter evacuation."[28] One of these images depicts Purdie at center reaching toward a wounded white marine who lies sprawled before him (fig. 1.4). The sprawled man, covered in mud and bandaged on both legs, is propped against a tree stump, his left arm cast toward the viewer, gripping another tree stump. They are surrounded by

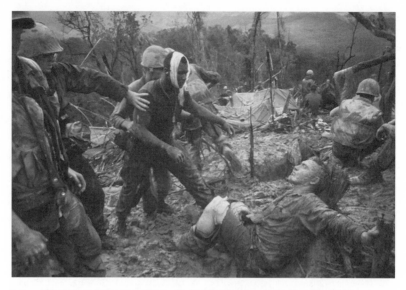

1.4 U.S. marines during the battle for the Nui Cay Tri ridge during Operation Prairie,
 Vietnam, 1966. (Larry Burrows, photographer.)

several soldiers and the muddy landscape of the hill, with the lush jungle
hills in the far background. The tableau-like effect of the image is power-
ful, conjuring symbolic references that transcend the immediacy of the
scene. The central expression of human interrelations here, based on the
intensely intimate moment of a shared gaze between the two wounded
soldiers, is one of compassion—of Purdie for his colleague—but beyond
this the Christlike pose of the man on the ground summons up a more en-
compassing message of humanity at the center of violent conflict. While
the moment of recognition shared in their gaze is elemental and univer-
sal, it also has more specifically American connotations as black and white
soldiers symbolically connect in a moment of interracial brotherhood.

 Of all Burrows's images, this is the one that has come closest to achiev-
ing iconic status, as it has been reproduced on many occasions in books,
magazines, and documentary films commenting on the Vietnam War or
on war photography more generally. It is commonly titled *Reaching Out*.
This is the image that wasn't published in the original *Life* story on Op-
eration Prairie but that instead appeared in the February 26, 1971 issue of
Life as one of fifteen images illustrating Burrows's work, a memorial ar-
ticle that appeared a few weeks after his death. By 1971, the photograph
could be viewed afresh and now take on significance in relation to the
broader disillusionment about the war shared by the American media and

public. By 1971 and thereafter, it was an emblematic illustration of the "quagmire" that the Vietnam War had become in American perceptions.[29]

"A Degree of Disillusion"

Quite when Burrows's own sense of disillusion settled in is unclear but it seems in line with the more general disillusion of the American public from 1968 onward, in the wake of the Tet Offensive. Between 1968 and 1970, Burrows's major stories were focused less on American operations or even on the American soldier than on South Vietnamese civilians and their sufferings. In 1968, he photographed Nguyen Thi Tron, a twelve-year-old South Vietnamese girl who had lost a leg following an attack by a U.S. helicopter in a free-fire zone. Burrows recalls: "I was walking the streets of Saigon as I've been doing for six years, thinking I'd never really told of the misery and suffering. Round a corner in a Red Cross compound, two Vietnamese children were rocking back and forth in a swing. . . . They were not the same as any other two youngsters, for they had only one leg between them and it was Tron who propelled the swing."[30] Burrows befriended Tron and documented her recovery as she learned to use an artificial leg and readjust to home and village life. A photo essay focused on Tron was published in *Life* on November 8, 1968 (fig. 1.5), with text by Don Moser that commented on the move toward peace in Vietnam. Tron was not the first poster child of injured innocence during wartime but she was the most famous instance in the Vietnam War, not least because of the profile Burrows's piece in *Life* could provide. The *Life* story used her images and story both to conjure compassion among readers—the images prompted some readers to send donations of aid for Tron and her family—and to suggest the war was taking a new direction, moving toward peaceful resolution. As such, Tron's painful rehabilitation stood in for the national rebuilding then required of the country.[31]

For Burrows, Tron was a more personally troubling symbol of his responses to the war and to the Vietnamese people. His growing sense of disillusion is partially displaced onto the suffering-yet-stoical figure of Tron. At the same time, he was concerned about his own relationship to her as a photographer and benevolent other.[32] This complexity of relations and feelings would affect Burrows again in 1970 when he photographed the homecoming of Nguyen Lau, a ten-year-old Vietnamese boy who had been paralyzed by a mortar fragment and received medical treatment for two years in the United States. Lau was unable to integrate back into family and village life and Burrows documented the estrangement. For Burrows, Lau's difficulties were emblematic of the war: "Lau's is not the greatest

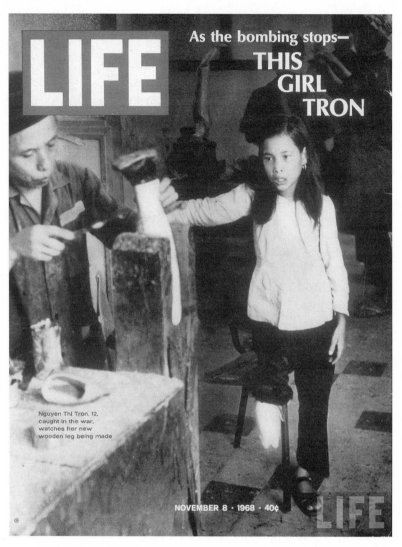

As the bombing stops—
THIS
GIRL
TRON

Nguyen Thi Tron, 12,
caught in the war,
watches her new
wooden leg being made

NOVEMBER 8 · 1968 · 40¢

1.5 "As the Bombing Stops—This Girl Tron," cover, *Life*, November 8, 1968. (Larry Burrows, photographer.)

tragedy in Vietnam. But as one looks at the picture of this courageous little chap, one has to wonder whether the ultimate agony of this war is not to be seen in his eyes."[33] Burrows's close attention to these stories of injured children both announces and deflects his own growing unease about the meaning and impact of the war. Unwilling or unable to decry American

involvement in Vietnam, he picks out and underlines the human suffering of the South Vietnamese.[34]

Burrows's efforts to provide a more considered statement on his evolving perspective culminates in his *Life* essay titled "Vietnam: A Degree of Disillusion," published on September 19, 1969. The photo spread consists of four separate stories, different perspectives on South Vietnamese soldiers and civilians. Burrows introduces the article with a statement:

All over Vietnam you see the faces—more inscrutable and more tired now than I have ever known them to be. Their eyes do not meet yours, because they are aware that the enemy is still, even today, all around them, watching. They are in the middle. The pressure on them is terrible and has existed for some thirty years.

I have been rather a hawk. As a British subject I could perhaps be more objective than the Americans, but I generally accepted the aims of the U.S. and Saigon, and the official version of how things were going. This spring, impressed by government statistics showing that conditions were improving, I set out to do a story on a turn for the better. In the following three months I indeed found some cause for optimism— better training and equipment in the South Vietnamese Army, more roads open and safe—but I also found a degree of disillusion and demoralization in the army and the population that surprised and shocked me.[35]

This announcement of his own position—"I have been rather a hawk"—is the most direct comment Burrows makes in print about his ideological views of the war. Yet, he does not directly address his own sense of disillusion, nor does he question the American mission in Vietnam. Instead, he focuses on what he perceives to be the disillusion of the South Vietnamese people.[36] The scales falling from his eyes revealed not a failure of American values but of Vietnamese will.

As he photographed South Vietnamese people throughout 1968 and 1969 (partly in an effort to move beyond conventional imagery of the war), Burrows's growing sense of the destruction of the fabric of their lives disturbed him. He noted that "the story is hard to tell in pictures. The people are simple and hard-working and bear pain in silence. You look into their placid faces and think of the torment going through their minds. I remember one woman in a village we went into—a mother sewing, with a dead VC [Vietcong] at her feet. A Vietnamese officer asked her if she knew him. She said no, and went on sewing. He searched the hut and found a family picture. The VC was her son."[37] It is the loss of humanity that most affects Burrows and that he wants to transmit to viewers. Yet he never really manages to produce a coherent story of Vietnamese

life that illuminates the causes and consequences of this. Notably, the most obvious linking element in the photo story on disillusion is the imagery of injured or suffering women and children, framed as stories of compassion—the very quality the Vietnamese appear to lack according to Burrows's anecdote.

The South Vietnamese remain "inscrutable," beyond Burrows's reach visually and ideologically, their unknowability a register of the formlessness of this war and a mirror of the damage done to an idea of humanity that is also revalidated as the compassionate ethos of the photographer-as-witness. There is a tension in much of this imagery that registers Burrows's perturbation about how to visually express what he sees and about his role as witness. One image depicts a U.S. soldier watching a young South Vietnamese mother suckle a child in the village of Rach Kien in 1967 (fig. 1.6). The caption informs us that the soldier is acting as a guard as the woman proved to be an assistant to her father who was "a Vietcong 'tax collector.'"[38] The strong composition accentuates the borders and relations between war and domesticity. The woman is seated in profile in the doorway to what appears to be a domestic dwelling with the photographer shooting from inside the building; beyond the woman and dominating the center of the frame is a soldier languidly holding a rifle by his side while he stares at the nursing woman. The ambiguities of the photograph exceed the captioning, registering the shifting connotations of domination and care in the relations among the subjects, the photographer, and the viewer. As such, it indicates the complexity of the moral economy that informs Burrows's "compassionate" point of view.[39]

Burrows's photo essay of Lau (published in *Life* in January 1971) was his last major publication on the war in Vietnam. His editors, keen to have him take time away from the conflict but also because of waning American media interest and the consensus it was moving to an end, had him cover other stories in the region—the temples of Angkor Wat in Cambodia and street life in Calcutta, as well as the cyclone in Pakistan. While in Calcutta, Burrows pressed to cover the U.S. incursion into Laos in early 1971. On February 10 he boarded a South Vietnamese helicopter with three other photographers—Henri Huet, Keisaburo Shimamoto, and Kent Potter—and flew into Laos. The helicopter was hit by antiaircraft fire and crashed. There were no survivors and remains were never found, although a search in 1998 did establish the crash site.[40]

Since his death, Burrows has been mythologized as the prototype of the fearless professional and the compassionate photographer, witnessing on behalf of others. It is a compelling myth and one that has influenced many young photographers. However, it glosses what are the real—creative and

1.6 U.S. soldier and Vietnamese woman and child in Rach Kien, Vietnam, 1966. (Larry
 Burrows, photographer.)

professional—qualities of his work just as it ignores the limitations of his
"compassionate vision." Burrows played a significant role in creating a
fresh visual awareness about war that resonated throughout his medium
during the Vietnam War and since. His technical prowess and his use of
color significantly advanced the stylistic possibilities of photojournalism,
while the subjectivity of his approach also opened up opportunities for a
more expressive form of documentary representation. Burrows influenced
the style if not the ideology of a new generation of photojournalists who

emerged to prominence in the 1970s and 1980s; many acknowledged his influence as they sought to establish a fresh visual vocabulary for the photojournalistic coverage of war and conflict.

"Obliterating Distance": Philip Jones Griffiths

Griffiths is the one who showed us Viet Nam as a country, not as a war.
JOHN PILGER

Unlike many American journalists Griffiths was not "disillusioned" by the war in Vietnam—he was a skeptic before he arrived to cover the conflict and very deliberately set about producing a body of work that boldly illustrates and indicts the destructive military and cultural presence of the United States in Southeast Asia. While he denied political motives or partisanship, he readily acknowledges a driving moral passion, an empathy with the "have-nots," shaped by his Welsh rural upbringing and his photographic apprenticeship documenting postwar Britain. Of his moral impetus, he says: "Journalism is about obliterating distances, bringing far away things closer [to] home and impressing it on people's senses. You excite your humanity every time you take a photo; lose your humanity and you stop being able to judge, to know, to see."[41] His Vietnam photography does indeed obliterate distance by taking the viewer into the cultures of the Vietnamese and the Americans. It is a form of in-depth journalism that focuses on the why of the event, on causes and contexts, and so moves well beyond the military frame to focus on cultural difference and conflict.

With no outlets for such imagery among the mainstream American media, Griffiths put together his book *Vietnam Inc.* (1971), a benchmark of war reporting and an influential marker of the authorial role of the concerned photographer. He returned regularly to Vietnam for many years after the war and published two further books, one on the effects of Agent Orange and another on socioeconomic changes in the country. Taken together these books form his Vietnam Trilogy, one of the most extensive documentations of a war and its aftermath by one photographer. They evidence Griffiths's distinctive perspective as a war photographer: "I'm not a war photographer. I just happened to photograph a war, and if anyone wants any proof as to the fact that I'm not a war photographer—guess what, I've been back to Vietnam 26 times since the war ended. War photographers don't go back to countries once the war's over; they go on to another war."[42] Yet, he remains a war photographer in that he is interested principally in the effects and legacies of war on the cultures and values

of a people and their way of life. His detailed attention to post-conflict scenarios and settings provide a significant example of the way in which photography can both follow and shape the temporality of understanding surrounding a major conflict.

Vietnam Inc.

Traveling extensively in the mid-1960s to cover conflicts across the world, Griffiths decided he wanted to focus his energies on one substantial project rather than racing to cover many for short periods of time. In 1966, the same year he joined Magnum as an associate, he "decided the important thing to do was to get passionate about something, and you didn't have to be a genius in '66 to work out that there was something very important happening in Vietnam."[43] His approach was methodical. He read widely on the history and culture of Vietnam and on the origins of its recent wars. Once in the country he traveled across South Vietnam, visiting every province, and familiarized himself with the cultures of the Vietnamese. Although he often traveled with the American military, he was not a central member of the media packs and had limited contact with other photographers; he worked quietly and unobtrusively, for the most part living with South Vietnamese at little expense. Financing was his biggest headache. Although he planned to publish a book, he also needed to publish images to bring in enough funds to remain in Vietnam, but the leading newspapers and magazines only rarely published his work—he was repeatedly told his photographs were "too harrowing." Later, he would suggest Magnum had not done enough to try to sell his images—a charge in line with his self-aggrandizing commentaries on press coverage of the war: "In general, 95 percent of the press was totally in favor of the war; 4.999 percent was in favor of the war but not the way it was being fought. And then there was me and two Frenchmen."[44]

Griffiths claims he had an immediate affinity with the Vietnamese, likening them to the rural Welsh in terms of community bonds, resourcefulness, and canny defiance of colonists. However romanticized this view may have been, it did draw him close to Vietnamese civilians as his key source of information and perspective and certainly afforded him a very different perspective on the war than that of most journalists. As he learned more about the country and its people, he not only questioned the American narratives about the war and its progress, he also grew angry about the absurdity of the disjunction between these narratives and the realities he observed: "The things we were being told [about the war] didn't make any sense. So I traveled the length of the country for my own

personal selfish reasons, to put together the jigsaw puzzle, and to produce a historical document. I wasn't the person working for the news agencies to make sure there was a picture on the front of *The New York Times* every morning. I worked differently."[45] Working differently meant many things. First, as indicated, it meant working apart from the established media and military frameworks, even as he took advantage of American military transport and befriended U.S. soldiers. It also meant looking for the why of the war where few others were looking. He notes: "Some of the best combat photography in the war came from the battles that took place at the end of 1967 . . . but the pictures are meaningless, because the battles were meaningless."[46] This may be read as a harsh judgment of the work of fellow photojournalists, but it is also a characteristic statement of Griffiths's certitude and method. In other words, his photography rarely follows the event, nor does it indicate a sense of formlessness or incoherence about the war, even as metaphor. Rather, his imagery is marked by his sense of clarity about what is being depicted within the viewfinder—his sense they are historical documents.

The war *was* meaningful, Griffiths believed, and the places to look for this meaning were at the points of cultural contact between the Vietnamese and Americans and at the points of imperial myopia in the activities of the Americans. In the introduction to *Vietnam Inc.* he writes: "I contend that Vietnam is the goldfish bowl where the values of Americans and Vietnamese can be observed, studied, and because of their contrasting nature, more easily appraised."[47] His approach to this work of observation and to putting together his book is suggestive of a social scientist in its rigor and critical method. *Vietnam Inc.* advances a form of cultural critique that operates through demystification, illuminating tensions and contradictions in the American worldview. For Griffiths, a critical role of photography is to reveal what is normatively hidden: "The Vietnamese say that looking and understanding is much more important than caring about the surface. The Americans were completely blind to the subtleties of the Vietnamese language and the fascinating structure of Vietnamese society. All of the elements drew me to the country and strengthened my will to stay on, but what ultimately made me addicted to the place was the desire to find out what was really going on, after peeling away layers and layer of untruths."[48] The key dialectic of his work is that of blindness and insight, and an urge to demystify—to peel away the layers and reveal truths—is evident in individual photographs and in the layout of the book as a whole.

A simple but effective example is a photograph Griffiths spent several days trying to produce. It depicts a busy street scene in Saigon. People are

looking in different directions and our eyes are pulled across the scene looking for the locus of meaning, the point of the image. Then we see it, just off-center, the young girl artfully picking the pocket of the large GI who is peering elsewhere, distracted. The image is suggestively composed. It is not a snapshot. Griffiths had waited for days on a first floor balcony of the Hotel Royale across the street from this scene, and also photographed several similar scenes—four of them appear on one page of *Vietnam Inc.* The methodical preparation was typical of his work, shaped as it was to reveal something he already knew but was rarely visible to Western eyes. This sense of illicit or subversive viewing is replicated in the image. The attempted robbery of the GI is but one point of urban spectacle within the scene—we note the act is being observed by one or more of the people around him. In his caption, Griffiths observes that pickpockets were tolerated by the Saigon public: "Hatred of the Americans was such that no Vietnamese would ever warn one if his wallet was about to be taken. Many people could be seen surreptitiously admiring pickpockets' prowess."[49] For Griffiths, the act of pickpocketing American soldiers clearly symbolizes the more general Vietnamese activities of duping and undermining the colonizer.

This demystifying of the relations between Vietnamese and Americans is the organizing basis of *Vietnam Inc.* The book is made up of over 250 black-and-white photographs, supported by blocks of informative text and spare, often acerbic captions. It opens with a glossary, and the author wryly explains: "A book about the Vietnam War is bound, unfortunately, to need an extensive glossary to guide the reader through the fog of Orwellian 'newspeak' that the United States employs in an attempt to disguise its activities."[50] By drawing immediate attention to what he terms the "lexical war," Griffiths indicates his book aims to reveal what the fog of war has so far concealed. Throughout, he is attentive in his text as well as the images to political and military rhetoric, and he particularly questions the meanings of American discourses of liberation, modernity, and freedom as applied to the U.S. mission in Vietnam. The one-page introduction succinctly presents Griffiths's view that the war in Vietnam is a war "for the minds of men" and that "America is trying to sell a doctrine to the Vietnamese," that of "Americanism." As such, he views the war as a conflict of values and finds horror in the doctrinal myopia of the United States, its "misplaced confidence in the universal goodness of American values."[51]

The image filling the page opposite the introduction depicts a GI with a young Vietnamese girl on his knee (fig. 1.7). Both stare intently into the camera. The GI is unshaven and sunken-eyed, his gaze solemn, perhaps

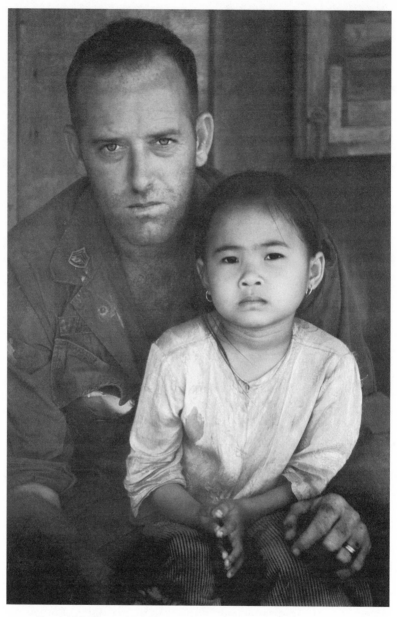

1.7 GI and child, Vietnam, 1967. (Philip Jones Griffiths, photographer.)

even sullen. The girl's clothes are sullied and she presses her hands together between her legs. As he leans forward, she leans into herself. They are frozen together but it is difficult to interpret their relationship. Elsewhere in the book, Griffiths notes that GIs liked to befriend and be photographed with children, an attempt to identify with some form of innocence in the theater of war. That may be happening here—the soldier's wedding ring may hint at an identity other than that of soldier. It also hints at the dialectics of care and domination that shadow America's imperial enterprise in Vietnam. At the same time, their implacable togetherness, in the context of the introduction, suggests they are both victims of forces beyond their control and comprehension.

The book is divided into thematic sections. The first, "The Vietnamese Village," illustrates what Griffiths sees as the essential values of the Vietnamese—wisdom, harmony, and community—tied to the village environment and its culture. For the most part, the imagery imputes a sense of a peaceful rural society, with only allusions to the threat of American despoilment—a reference to an absent mother, for example, gone to "work for" the Americans. The final image of the sequence is jarring by contrast. A two-page spread, uncaptioned, it depicts what appears to be the dead body of a Vietnamese male, his upper torso visible in the top right of the image, a gun on the ground on the left, and what appears to be the shadow of an American soldier taking up the center and foreground of the photograph. For all the graphic directness of his image making, Griffiths does employ symbolism on occasion. The text in this section asserts what the imagery implies: "What American policy has attempted to do is to obliterate the village as a social unit. This, ostensibly, is to deny cover to the guerrillas, but, in reality, the purpose is to reconstruct Vietnamese society in the image of the United States."[52]

The next two sections—"Why We're There" and "The Communication Gap"—begin to show the distance between the Vietnamese and the Americans, a motif that runs through the book. Children figure prominently as they are generally in closer, less aggressive proximity to the soldiers. In one image, we see a Marine hugging a child as the mother looks on anxiously; in another, a child curiously feels the facial hair of a GI; and in another a GI offers a cigarette to a peasant girl in a field. In many of the images there is a sense of corruption surrounding the presence of the GIs—at a "Car Wash" young girls surround a GI to sell goods and themselves. All the while, Griffiths argues in his text, the children smile and accommodate to take advantage of the soldiers.

There are several images of prisoners, composed so that the prisoner is at the center of the image, thereby accentuating their vulnerability. One

of these compositions is famed as one of the finest combat images of the war. It shows GIs giving water to a VC fighter who had fought for three days with a severe stomach wound that had him place his intestines in a bowl and strap it to his body. The GIs admired his bravery, and Griffiths honors this in his sympathetic composition.[53]

The communication gap is rendered more violent in the imagery depicting the frustrations of the American search for enemy combatants in rural areas. Griffiths records the growing resentment of the U.S. soldiers as they take frightened civilian villagers from their homes and burn or direct bombing to the villages. One image, taken on a search-and-destroy operation with a unit of the Americal Division (i.e., the 23rd Infantry) in 1967, shows a woman cradling a child overseen by an American soldier. The caption reads: "Mother and child shortly before being killed . . . this woman's husband, together with the other men left in the village[,] had been killed a few moments earlier because he was hiding in a tunnel. After blowing up all tunnels and bunkers where people could take refuge, GI's withdrew and called in artillery fire on the defenseless inhabitants."[54] The soldier's odd stance is one of detachment, likely also of resentment as we learn from the caption—the pietà of mother and child draws no sympathy, no sense of concern. Griffiths notes that this event occurred about six months before the massacre at My Lai (carried out by Americal soldiers) and implies that the murderous resentment among the soldiers was already apparent.[55]

The next two sections—"Search and Destroy" and "Relocation"— document the forced relocation of several thousand rural people in the Bantangan Peninsula to the model village of Song Tra. Griffiths shows it to be a wretched destruction of a society and its ways of life. He portrays the burning of villages and the forced trek to Song Tra, where peasants are housed in internment camps, surrounded by barbed wire and signs announcing their "freedom." The degradations of the peasants are evidenced in incongruous scenes—one image shows peasant children looking at copies of *Playboy* magazine, distributed by a Psychological Operations officer who forgot to order "indigenous reading material."[56]

The next sections—"Our Vietnamese Friends" and "The Battle for the Cities"—document the degradations of the newly urbanized populace in the large cities, particularly Saigon, and the urban battles that ensued in the wake of the Tet Offensive in early 1968. The fullest sequence of imagery in these sections documents the Vietcong attacks on Saigon and the confusion this caused among the American soldiers and the Vietnamese citizenry, both unaccustomed to being attacked in this urban center. The GIs look scared and bewildered as they take cover when their own artillery

fire is misdirected and kills two of their number. There are several images of dead or wounded civilians on the streets. In one, a woman in blood-ied clothes lies on a stretcher in the foreground while above her a soldier kneels and looks into the distance, and behind them people hurry past with their goods. It is a suggestive tableau, indicating the impotence of the soldiery to protect civilians or deter looting. Overall, the imagery con-notes confusion and loss of control as the city breaks apart and homes are reduced to rubble. The sequence ends with a powerful two-page image that shows a woman at center walking toward the camera carrying many belongings—including stoves, pots, and bowls—across her shoulders (fig. 1.8). On each side of her, soldiers walk in the opposite direction, carry-ing their own accoutrements—guns, backpacks, ammunition belts. They pass silently not looking at each other. The road is churned mud, and they are surrounded by the debris of bombing on all sides. It is as though two worlds have walked right past each other. To be sure, the woman is a civil-ian victim, but she has her belongings and appears to move purposefully, holding what remains of her world together—an individual compressed into limited space—her belongings a metonymy of her shattered world.

In the final section—"Pacification"—Griffiths focuses on the effects of the renewed battle for hearts and minds following the upheavals of 1968 and the further decline of social order in the cities. He later notes that, after Tet, "great disillusionment set in" among the South Vietnamese in

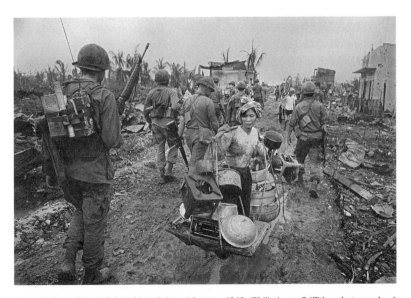

1.8 Refugee from U.S. bombing, Saigon, Vietnam, 1968. (Philip Jones Griffiths, photographer.)

urban centers, and he "found it a very interesting time photographing the discontent and turmoil in the urban enclaves."[57] Images of garbage dumps, of elderly people living in institutions rather than with families, and of young prostitutes on the streets, combine to connote the breakdown of a traditional order. The sequence focused on prostitution is particularly disturbing, depicting girls as young as twelve with American soldiers. At the center of the sequence is a controversial image showing two male navy SEALS on a bed with a Vietnamese woman at the U.S. naval base in Nha Be in 1970. One of the men is leaning over the prostrate woman who is lying on a rug with her dress pulled back to her midriff, while the other soldier crawls toward them on the floor. The woman's head is turned away from the soldier whose face is lowered toward her, her mouth open. It is impossible to tell if the woman is laughing or screaming and the image can and has been read as a depiction of rape.[58]

Throughout this section Griffiths notes the fast developments in what he terms "automated war"—the use of computers and of long-range devices to conduct war. He mocks the absurdities of the use of computers to evaluate the degree of "pacification" of Vietnamese hamlets. In one image, four military operators stare at a computer printing. The caption reads: "The computer that 'proves' the war is being won. . . . Optimistic results on the 'my-wife-is-not-trying-to-poison-me-therefore-she-loves-me' pattern are reliably produced each and every month."[59] However, he also soberly comments on the emergence of a "new warfare" that reduces ground troops and utilizes electronic technologies, "automatic fire control," and aircraft carriers. There are several images of personnel on an aircraft carrier. One caption notes, "The sailors and the pilots on board have never been to Vietnam. They have never seen the faces of their victims, the Vietnamese people."[60] The following image is of four seriously wounded Vietnamese victims of "antipersonnel bombs," laid side by side on stretchers, all of them "classed 'terminal' and sent home to die."[61] There follows several pages juxtaposing images of Vietnamese amputees and victims of napalm bombing, interspersed with images of the American bombs.

The penultimate image in the book is one of the most famous images of the war. It shows a Vietnamese woman holding her hands up to her fully bandaged head (fig. 1.9). The woman has a tag attached to her arm that reads, in part, "VNC FEMALE," meaning Vietnamese civilian.[62] The image has often been reproduced to represent the effects of napalm, but the tag actually states "Extensive high velocity wound to the left forehead and left eye." It is not surprising it should be misinterpreted in this way, as the symbolism of the image is rich and it has iconic qualities that transcend its moment of production. At the very least, it stands as an image

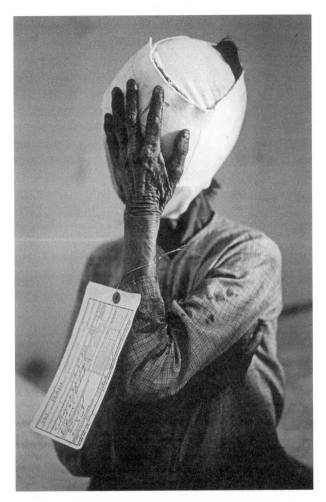

1.9 Civilian victim, Vietnam, 1967. (Philip Jones Griffiths, photographer.)

of dehumanization and so condemns the impact of the war on civilians. The tag accentuates this diminishment of the individual to a cipher in the administration of the war, while the cancellation of her identity can refer to the more general invisibility of civilians in the consciousness and lines of sight of the American military, media, and public.

It is the realities and visibility of the victims' lives that Griffiths most forcefully dedicates himself to documenting in *Vietnam Inc.* and in his following visual studies of postwar Vietnam. With *Vietnam Inc.*, he produced an incendiary documentation of the war that took many by surprise and disturbed the field of photojournalism irrevocably. There was much that

was startlingly fresh and audacious about the book. It moved the camera away from the American soldier to concentrate on the Vietnamese and to document the effects of combat seen through the eyes of civilian victims. The iconic photographs of the war in American public memory are images of victims of U.S. or U.S.-sanctioned violence, but they are snapshots of such. Griffiths provides a detailed, in-depth illustration of the consequences of this violence, not snapshots but carefully composed and sequenced condemnations of the impact of the United States on Vietnamese culture and society.

In doing so, he also took an innovative step in positing the role of the photojournalist as an author. This is evident in his eschewal of objectivity in favor of working with a clear vision and a determination to interrogate the why of the event. In this sense, he took on the role of the photographer as witness already imputed in the Magnum tradition but radicalized it by producing a more engaged, interventionist photography than did his predecessors. He also demonstrated the authorial role of the photojournalist by producing his work on his own terms and publishing it accordingly. He published little of his Vietnam imagery in established news media but turned this to his advantage by transcending the agendas and frames of mainstream media.

It is impossible to measure the impact of the book on public opinion about the war, though many claim it was significant. Noam Chomsky later wrote: "If anybody in Washington had read that book, we wouldn't have had these wars in Iraq and Afghanistan."[63] It received some strong reviews in the very publications Griffiths had difficulty publishing his images in a few years before. In part, this was due to timing, as more graphic material began to appear in the aftermath of the My Lai imagery, but also because his work provided one of the few coherent visual perspectives on the core years of the war. A glowing review in *Time* magazine described the book as "the best work of photo-reportage of war ever published. . . . The book sets entirely new standards for critical judgment of the medium of photo-reportage."[64] The *New York Times* described it as "the closest we are ever going to come to a definitive photo-journalistic essay on the war."[65]

For all the fame of the book, its impact on future photographers is also difficult to measure. Without doubt, it influenced a coming generation— influence in the sense of showing the possibilities of authorship available to the photojournalist and profoundly influential in presenting the photo book as a legitimate and powerful form of photojournalistic expression. Yet it would be difficult to pick out very direct forms of influence in terms of style or approach. Few wanted to work with graphic black-and-white imagery as color became dominant from the later 1970s, and fewer still

had the incentive or financial backing to spend three years on a single project. Out of print for many years (it was finally reprinted in 2001), *Vietnam Inc.* became a monolith and something of a conundrum: a great milestone in photojournalism, it was also almost invisible, a model yet inimitable.[66]

Postconflict

In 1971, Griffiths joined Magnum as a full member. In 1972, on an assignment for *Life*, he attempted to return to Vietnam but was refused entry. He was informed that President Thieu had personally demanded he be banned from entry, reportedly saying: "There are many people I don't want to see back in my country, but I can assure you that Mr. Griffiths' name is at the top of the list."[67] However, Griffiths did return to Vietnam, more than twenty times after 1980 when he first returned, to extensively photograph the legacies of the war and painful reconstruction of the society. Over that period, he built a large body of work that he finally published in the form of two books, *Agent Orange* (2003) and *Vietnam at Peace* (2005). Together, they are important documents of the ongoing effects of the war and the reconstruction of a traumatized society.

Griffiths first heard about Agent Orange—the toxic herbicide used by the American military as a defoliant during the war—in 1967 while in Saigon: "During the war there were these rumours that babies were being born without eyes and it became a quest to find them. I visited as many Catholic orphanages as I could, but I was barred entry from most of them and I became convinced that the Americans had put the word out—don't let any press in."[68] After the war, there was confusion and obfuscation surrounding the effects of Agent Orange on the Vietnamese. In the United States, there had been steadfast resistance by the government to recognize diseases caused by the herbicide, in large part due to fears of litigation, but also due to a residual anxiety about the promotion of chemical warfare by the United States. This resistance was complemented by a cultural reluctance to engage this topic in the United States during a period when the war was "forgotten" even as it was screened widely via popular culture.[69] In Vietnam, at the same time, there were restrictions on visiting hospitals or other institutions where victims were housed, and there was state censorship of commentary on victims in the media. The effects of Agent Orange was an issue rendered barely visible in both countries as it was an unwanted knowledge, haunting the making of public memory about the war. Griffiths is attuned to this haunting element of his subject. He

subtitled his book *"Collateral Damage" in Vietnam* (the quotation marks underscore the knowing use of what he termed "Orwellian 'newspeak'" in *Vietnam Inc.*) and "collateral damage" is an apt term to denote "a calculated discounting of the wounded, the tortured and the dead" who yet haunt the visual culture of warfare.[70]

Agent Orange is conceived as an epilogue to *Vietnam Inc.* as it picks up themes of that book—the American dedication to scientific forms of warfare, the desire to destroy the landscape, the lack of empathy for the Vietnamese people—and shows how these culminate in the ongoing, slow-motion destruction of a people for a generation after the war has formally ended. He understands the effects of Agent Orange as a legacy of the war, in which the poisoned land still damages and kills its inhabitants. The book is an unflinching documentation of the effects of this chemical warfare on the land, the victims, and their offspring. The images, all black and white, confront the viewer with visual horrors that are, as Gloria Emerson notes, "almost unbearable."[71] They accumulate in a dark vision of humanity, lightened only by moments of compassion but also charged by an anger at the conditions depicted.

Like *Vietnam Inc.*, the book is organized to provide the optimal balance of emotion and analysis, providing a narrative sense of cause and effect that indicts the treatment of the victims of Agent Orange as "collateral damage." The cover and inside-cover images are of a U.S. Air Force satellite map showing the "spraying runs" by planes spreading Agent Orange. The abstracted lines of flight suggest the abstracted nature of warfare for those in control of it and their distanced perspective on the sites of impact and the lives of people who dwell there. Griffiths has noted that the map shows many flights over Ba Hao Reservoir and claims that pilots dropped leftover spray in the reservoir, so further poisoning the populace.

The first photographs in the book are five double-page images of defoliation caused by Agent Orange during the war, drawing on Griffiths's work there in the early 1970s. The sections that follow categorize and document the effects. The first focuses on the ecocide that resulted from "poisoning the land" and presents images of efforts to recultivate barren or scrub-covered lands as part of a national program of reforestation. While the landscape images are bleak, they also include several examples of children tending to saplings, which Griffiths captions as "an opportunity to reaffirm the tradition of living symbiocity with nature that defines the people of Vietnam."[72] This may be a deliberate counterpoint with the opening section of *Vietnam Inc.*, where he correlated the relations between the people and the land, preparing us for the severance of

that relationship by the U.S. military. The historical ironies are part of the legacy Griffiths is exploring.

From the scarred and poisoned land, Griffiths moves to the damage done to humans. The section titled "The Bell Jar" is a disquieting sequence of images of the remains of fetuses and stillborns preserved in jars of formaldehyde at Tu Du Hospital in Ho Chi Minh City. The remains are grotesque, deformed exhibits and yet also retain an affective human charge for the viewer. From these "remains" Griffiths moves to "the human toll," the damages experienced by the living. Many of the images are of children held in institutions and in need of constant care. A good number are portrait shots and as disquieting in the close-up gazes of the children as the blank stares from the bell jars. That children are the focus of these images underlines the carryover of the effects of the war into new generations. Again, Griffiths works to humanize his subjects, most obviously by portraying the roles of mothers as primary caregivers. At the same time he draws attention to the haunting trauma surrounding childbirth and rearing for many women who "have come to learn that procreation in their homeland, that most fundamental act of humanity, is now a squalid and terrifying exercise of chance."[73] The compositions of mothers and disabled children inevitably recall iconic imagery of compassion.[74]

Agent Orange presents photography as evidence, making visible what has barely been seen, and asking for a commensurate action to ameliorate the suffering documented in the imagery. The book was well received though largely by readers and reviewers disposed to the issues and to Griffiths's point of view. Yet, it helped lend a visual profile to a debate that had little public traction in the United States. Just as pertinently, it challenged public memories about "Vietnam" and drew attention to the meaning and reality of "collateral damage" at the time of new American wars in Afghanistan and Iraq.[75]

Vietnam at Peace chronicles postwar reconstruction from the economic hardships of the period of American embargo to the embrace of foreign investments and consumer capitalism in the 1990s to the more measured responses to capitalism in the early twenty-first century. Across this period, Griffiths focuses on and illustrates a range of legacies from the war—the boat people, Vietnamese children parented by American soldiers, activists for those missing in action, victims of Agent Orange—and documents the effects of postwar changes on cultural institutions and everyday life in Vietnam. He very deliberately plots and strives for a comprehensive view, a systematic act of documentation based on his view of the key markers of Vietnamese identity in the postwar era. The book consists of over five

hundred black-and-white photographs organized into fourteen chapters, each of which has a short introduction penned by Griffiths. As with *Vietnam Inc.*, he also supplies short, often pithy, captions.

The early sections of the book depict muted victory celebrations in Ho Chi Minh City (formerly Saigon) and the rounds of life in devastated landscapes, now showing signs of regeneration with austere, Soviet-style apartment buildings and impromptu roadside shops. The third section, titled "The Debris of War," is suggestive of the damaging legacy of the war as the "unexploded ordinance" from the American bombing continues to kill Vietnamese people—there are images of children beside unexploded bombs. It is also suggestive of the Vietnamese capacity to pragmatically make use of all "scrap" materials from the war.

There follow several sections that focus on the impact of the war on human relations and bodies. Many images illustrate the legacies and memories of the civil war for a range of individuals and communities. These include former combatants holding up photographs from the war or the dog tags of U.S. soldiers they had killed. One image depicts the widow of the soldier executed on a Saigon street in 1968 during the Tet Offensive—the famous image taken by Eddie Adams. In Griffiths's photograph, the widow holds up a newspaper that contains the Adams image and also holds a military medal, presumably awarded to her husband by the state. Her tearful look adds a new dimension to this already iconic image and reminds the viewer of the very different perspective on the "American War" within Vietnamese society and memory. It also symbolizes the rift within Vietnamese society that has not fully healed and is followed by imagery of people in "reeducation" camps where over one million Vietnamese were detained between 1975 and the late 1980s. The impact of the war on human lives is further explored with images of reform schools for heroin addicts and prostitutes, of Amerasian children fathered by American soldiers, and of people whose bodies have been disfigured by the violence of the war. We see how the fabric of lives and social relations has been damaged by the war, which has deeply disrupted familial and civic ways of life.

There are series of imagery focused on sites of collective memory related to the war, including My Lai, the Ho Chi Minh Trail, and museums. In these sections, Griffiths is concerned both to illustrate infamous sites of the war and to examine how the Vietnamese have remembered the war. The My Lai images are the most haunting as Griffiths photographs groups of children standing in the sites of the atrocity. In one image, a very young girl stands in the center of "the infamous path where hundreds of women and children were murdered," behind her in the middle distance is the blurred figure of a young woman carrying a child on her hip, echoing

similar profiles in the images of the My Lai massacre.[76] The composition is calm and chilling. Elsewhere Griffiths illustrates how My Lai has become "a tourist attraction" and in a section on war museums he notes the "commodification of history" has become widespread in response to tourism and the demands by the government to appease Americans in order to support tourism and other forms of investment.[77]

The turn by Vietnam to foreign investment and consumer capitalism is the focus of the longest section in the book, titled "Doi Moi—a Change in Direction." It covers effects of Vietnam's switch to a market economy in 1986 and the fuller normalization of relations with the West, most significantly signaled by the lifting of the U.S. embargo in 1994. In Griffiths's view, this inaugurated a struggle over values that the Vietnamese have been losing: "America's involvement with Vietnam started with genocide and ecocide. It has now coined a new slogan—culturecide."[78] He illustrates this by depicting incongruities occasioned by uneven development or the contact points of the local and the global. For example, one image shows a billboard advertising Japanese commodities that "casts a shadow" over rice fields.[79] Other images go well beyond the surface visual clichés of incongruity to document underlying structural or systemic elements of global forces and their impacts on human subjects.

The closing section of *Vietnam at Peace* is revealing of Griffiths's critical perspective on the effects of American power understood principally as economic and cultural imperialism (rather than military might) and glossed in the text and in interviews as "globalization." It is a thesis that is clearly in line with his long view of the American role in Vietnam. Reflecting on this, he comments: "I photographed the war because, frankly, in 1966 it was the most interesting story. I soon discovered all was not as it seemed. Viet Nam was full of contradiction and before long I came to see beyond the death and destruction. I argued in my book, *Vietnam Inc.*, that America was trying to impose its consumer capitalist values on the Vietnamese. On returning after the war I came to realize that the country was an effective fish bowl in which to examine the effects of globalization."[80] Again, we sense a marked consistency in his critical perspective—the metaphor of the fish bowl is one he used in *Vietnam Inc.* to describe the opportunity to document and contrast American and Vietnamese values. What he gains in ideological clarity he risks losing in critical acuity for the conflation of varied modes and forms of imperialism, and the presentation of "globalization" as an extension of American power can be a limiting formulation to frame documentation of the Vietnam War and its aftermath. The power of Griffiths's Vietnam Trilogy, though, is that it both delivers and transcends such formulations. It delivers by carefully

documenting the ideological sinews of cause and effect in the making of war both in cultural depth and across time, so that the historicity of the war becomes part of the frame. It also transcends the more constrictive formulations of "imperialism" and "globalization" by producing imagery that is excessive of such frames and acknowledges the agency of those subject to them. In following his own injunction to "follow the Americans," he has produced a singular view of the effects of American power, including the mystifications of that power.

Fred Ritchin has suggested that the nature of the Vietnam War challenged many photographers to reconceive their role: "The photographers had to try to comprehend scenes that elided the more familiar mythology of good and evil. It was the territory of actual war, the microcosm of bullet piercing skin, the universe of crumbling souls. In an attempt to parse landscapes of horror, intellectually confusing and morally ambiguous, photojournalism became a medium that interrogated layers of reality rather than providing simple answers. The photographers had transcended—some might have said 'abdicated'—their traditional role as recorders of a monumental conflict who worked in the service of one side."[81] Larry Burrows never quite abdicated the traditional role, he was "rather a hawk" and remained broadly sympathetic to the U.S. mission in Vietnam. Like so many journalists in the conflict, he was very much "embedded," reliant on and aided by the U.S. military for access and other support to produce his work. However, his work nonetheless registers the mutation in the role of the photojournalist that Ritchin refers to. While Burrows never formulated a coherent narrative of the war, the uneven responses to it reflected in his work are an important documentary chronicle both of the war's shifting contours and of his sensitivities to this. That his efforts to make sense of the war and of his own relation to it drew him to "a new sense of concern for a universal humanity" may suggest a myopia about the geopolitical realities of the conflict but may also suggest the peculiar tensions he experienced in attempting "to parse landscapes of horror" and create a point of view that reflected the moral ambiguities of his own role.[82] Such tensions are evident in his framings. A good case in point is the last Burrows image discussed above, that depicting the U.S. soldier gazing at the nursing Vietnamese woman. With whom is the viewer being asked to empathize and identify in this image? What are we witnessing in this scene? Is this a scene of care or a scene of domination? The dialectics of care and domination emblematize the contradictions of the American mission in

Vietnam and render this a suggestive, primal scene of that corrupted mission. In the ambiguities of this image we sense that the limit of Burrows's "compassionate vision" is also the essence of its documentary truth.

Philip Jones Griffiths posits a different, more directly engaged perspective on the geopolitical realities of the conflict in Vietnam and takes a more ideological approach to his work as a result. His abdication of the traditional role of the war photographer is so overt he could be viewed as simply flipping it over to produce anti-American polemic, but this misses the true power and sophistication of his work as a concerned photographer. There is a charged moral vision in his critique of American power and policy that aims not only to demystify these but also to humanize the Vietnamese people and culture—his work consistently cuts against the more conventional forms of framing the otherness of the place and the people. This is not to say Griffiths eschews compassion as a motivated framing device, for he deploys it in his work, but he does not want the reader's response to be diffused in pity and inaction and so the compassionate framing of individual victims is combined with the more didactic attention to the political and cultural contexts of protest and action.[83] There is an idealism in Griffiths's work that can be quixotic yet is invariably pointed in its focus on the ideological gap between values and security in the enactment of U.S. foreign policy—his achievement has been to hold up a consistently critical mirror to that foreign policy.

Pictures from Revolutions: Iran, Nicaragua, El Salvador

Coverage of the Vietnam War is often cited as photojournalism's last great historical moment of record and relevance. As the war wound to an end, the conditions for the making and publication of war and conflict imagery changed markedly. In part, this was due to the shifting nature of international conflicts and of U.S. foreign policy in relation to the contours of Cold War imperatives. The defeat in Vietnam stymied American military and political appetites for large-scale interventions, while U.S. geopolitical concerns shifted to the Middle East and Central America. It also led the military to review the role of the media in the Vietnam War and to determine to never again permit such freedom of access. The management of news coverage intensified during the overt conflicts involving the United States in the 1980s—there were bans on media access to the military invasions of Grenada in 1983 and Panama in 1989. During the same period, and much less overtly, there were political and ideological pressures on media producers to reflect national security concerns and Cold War frameworks when covering U.S. foreign policy and diplomatic issues.

These pressures intensified in the aftermath of the Sandinista revolution in Nicaragua in 1978–79 and the Israeli invasion of Lebanon in 1982. As the war in El Salvador escalated in the early 1980s, it not only attracted a great volume of media coverage but also drew intense criticism and soul-searching, in part because of a widespread belief that American media had been "soft" in coverage of the Sandini-

sta rebels in Nicaragua. Congruent with this, media coverage of the Israeli invasion of Lebanon ignited criticism within the United States, and itself became one of the most controversial stories of the conflict.[1] Roger Morris noted that the media were "under siege in West Beirut, both literally and figuratively," as "partisans of both sides—and, increasingly, supporters of Israel—attacked the coverage for omission, distortion, or worse. . . . And truth often became a casualty in the domestic war over the front-line reporting."[2] Much of the criticism of particular features of media coverage of these conflicts reflected paranoid yet common Cold War "fears that we are about to 'lose' Central America and the Middle East."[3] Some more pointedly lamented that media coverage compromised the United States' "ability to operate in the real world with the threat of force."[4] It also reflected an intensified politicization of conflict reporting as diverse actors sought to manipulate media attention. One result was a tendentious but narrow debate about the role of the media in relation to the making and enacting of U.S. foreign policy.

The visual reportage of international affairs was also affected by the broad changes in media production in the 1970s and 1980s as the decline and collapse of mass circulation magazines—*Look* closed in 1971 and *Life* closed in 1972—removed a significant forum for photojournalism. Television had come to dominate the visualization of U.S. foreign affairs and the "golden age" of photojournalism was at an end. Documentary and news photography was entering a period when the fracturing of the American worldview during the Vietnam War would be reflected in the fragmenting of media publics and of visual genres and stylings in American media and popular culture more generally. Some commentators pronounced the death of photojournalism in these contexts, arguing it had substantially lost its primacy as a news medium and that the traditional institutional bases and networks for its production and for the consumption of its imagery were being eroded. Concurrent with these challenges to its institutional and professional existence was an intellectual attack on photojournalism's history and ideological principles, particularly its associations with humanist concerns.

There was some weight to these critiques but photojournalism did not wither away in the 1970s and 1980s. Rather, it was reinvented and reenergized by a combination of factors. First, the political economy of the photojournalism industry was changing—while the traditional forums of publication were shrinking, new forums were emerging. The decline of the general-interest magazines, driven by the loss of advertising revenue to television, was terminal for many, including *Life* and *Look*. This decline certainly had an effect on photojournalism as those major news magazines

that continued to publish had diminished resources and were reluctant to employ staff photographers. However, partly in response to this, a number of news-picture syndication agencies emerged in the late 1960s and early 1970s, using freelancers to cover many parts of the world very economically and provide picture rights to global media. French agencies took the lead in this initiative—Gamma, Sygma, and Sipa were the principle agencies—and by the early 1970s they were shaking up the American-based leadership of international news image making and marketing.[5]

The markets for photojournalism were changing too. Throughout the 1970s and into the 1980s, much of the market for magazine journalism moved from the United States to Europe—*Actuel* and *Paris Match* in France, the *Sunday Times Magazine* in the United Kingdom, *Stern* and *Geo* in Germany, and *Epoca* in Italy. In the United States, while there was a notable decline in the magazine market there remained and emerged some significant platforms for photojournalistic imagery. The *New York Times Magazine* became a more significant promoter of high-quality photojournalism and a number of regional papers took strategic initiatives to raise their profiles by supporting photojournalists on extended stories—the *Boston Globe*, the *Philadelphia Inquirer*, the *San Francisco Examiner*, the *Detroit Free Press*, and the *Seattle Times* all produced strong photojournalistic coverage of international events in this period. To be sure, *Time* and *Newsweek* remained the principal buyers in the international news image market and the major news agencies—Reuters, Associated Press, and Agence France-Presse—continued to have a major global role in disseminating news imagery. However, they were having to adapt to the innovative techniques of the smaller agencies that were aggressively competing for coverage. A noteworthy result of this competition, also shaped by market demand, was the emergence of a more dynamic news imagery that placed a premium on action, on the event itself. This helped to bring a new expressivity to news photography, though some worried that it did so at the expense of more investigative forms of image making.

The second major reason that photojournalism did not wither away was that, within the United States as well as beyond, a new generation of photojournalists was emerging who did not want to define their work within the established conventions of the humanistic photojournalism that had been so prominent in the United States since the 1930s. These photographers, as Andy Grundberg notes, were "dissatisfied with the conventions they inherited from such patron-saint figures as Robert Capa and W. Eugene Smith."[6] This generation was not in thrall to humanistic perspectives of their forebears; they presented a cooler and tougher vision. This was a period when the status of the (documentary) photographic

image itself was under much intellectual and critical scrutiny; it was burdened by formal, ethical, and historical questions that contributed to the crumbling authority of its evidentiary forms. Susan Sontag in her mid-1970s writings on photography provided what was probably the most challenging and influential critique, arguing that photographs cannot tell us political truths and that the "humanistic" strain in American photography was exhausted.[7]

This new skepticism about photographic ethics and aesthetics was not just the product of an intellectual critique by influential artists and writers. Rather, it reflected broader anxieties about media saturation and an emergent society of the spectacle (in this regard, Sontag's views are symptomatic). As contemporary experience became increasingly visual and visualized, the documentary role of the photograph was compromised by the postmodern "image world" it sought to record.[8] With the erosion of distinct aesthetic and cultural boundaries, the photograph promiscuously trafficked between documentary and artistic modes of image production. Writing in 1981, Martha Rosler noted that the "confusion between journalism and art and the increasing speed of the conversion from one to the other . . . characterizes our age."[9] For photographers, this was both a potential liberation and a liability and exacerbated the tensions within documentary and artistic traditions that had long existed within photojournalism.

In the context of these concerns, we may refer to the emergence of the post–Vietnam War generation of conflict photographers as the progenitors of a "new photojournalism."[10] This term is not introduced to signify a coherent movement or canon of work; rather, it refers to a broad move to more subjective stylings that pushed the boundaries of the genre in documenting war and conflict. A key feature of the work of the new photojournalists is the foregrounding of their own subjectivity and a concomitant reflexivity in photographic practice. They eschew not only the mythical neutrality of the news photographer but aggrandize the role of the photographer as witness, consciously depoliticizing or repoliticizing it through the use of recognizable conventions that charge or challenge the viewer's point of view. In so doing, they often draw attention to their own limitations and by implication that of their viewers as witnesses, challenging viewers' understanding of a foreign imbroglio and their capacity for empathetic responses to the distant suffering of others. As with many new journalist writers, the photographers express their subjectivity so as to foreground their role as moral actors (not passive witnesses) and their role as producers of the document before the viewer.[11]

This authored approach is also evident in the efforts of photojournal-

ists to take control of the contexts of their work's publication or consumption. Beginning in the 1970s, many photojournalists sought to publish books of their work and to display it in exhibitions. This significant shift in the dissemination of their work was partly a pragmatic response to the demise of the general-interest magazines but also an indication of the new perspectives and energies in the field as photographers sought to display their work in new formats and with greater control over its presentation. Philip Jones Griffiths's *Vietnam Inc.* was an inspiration, if a singular one that few would seek to mimic. Many more wanted to work beyond the conventions of narrative visuals and mainstream press publication. In 1979, Raymond Depardon produced a small book called *Notes*, a diary-like commentary combined with photographs from his work covering conflicts in Lebanon and Afghanistan. Drawing on literary, cinematic, and philosophical references, it is a fragmented and highly subjective travelogue, expressing his anxieties and his thoughts on photography.[12] Gilles Peress and Susan Meiselas, having found difficulties in publishing their images of the Iranian and Nicaraguan revolutions, published books that were experimental and controversial: Meiselas published *Nicaragua* in 1981 and Peress published *Telex Iran* in 1983. For some photographers, book publication became a primary motivation to work. Alex Webb, who produced innovative documentation of revolutionary scenes in the Caribbean in the mid-1980s, remarks: "The photojournalistic vision of narrative picture stories has not been the chief direction of my life. I've always thought in terms of books."[13]

All these experiments with book formats point up the cross-fertilization of documentary and artistic photographies in this period. At the same time, art photographers explored the traditional territories of photojournalism. The French conceptual artist Sophie Ristelhueber, for example, photographed landscapes of Beirut in the early 1980s, with a focus on landscape and ruin rather than conflict or human suffering (a forerunner of the "aftermath" photography of the twenty-first century), and published a book of her imagery, titled *Beirut* (1984). Traces of violent events are documented on buildings and landscapes, reflecting her "obsessions" with "traces, scars, destruction of the human presence, or constructions of all sorts of obstacles to separate one human being from another."[14] Her interest in the architectural and topographic is yet ideological, focused on illuminating the dialectics of construction and destruction in landscapes of war and conflict and connecting these to cultural concerns of trauma and memory. Ristelhueber has also produced a series of aerial views of these landscapes that defamiliarize and underline a sense of distance from conflict that photojournalism often elides.

Exhibitions were also important in displaying the properties of a new photojournalism. As well as individual shows, there were several notable group exhibitions in the 1980s that brought together examples of the work of this emergent generation. These include *On the Line: The New Color Photojournalism*, organized by the Walker Art Center in Minneapolis in 1986, *Contact: Photojournalism since Vietnam*, organized by the Contact agency and first displayed at the International Center for Photography in New York in 1987, and *In Our Time: The World as Seen by Magnum Photographers*, which opened tours of the United States and Europe in 1989. These exhibitions signified the growing maturity of this imagery, promoting it as an elevated form of journalism, worthy of gallery representation and attention.[15] *On the Line* displayed the work of twelve photojournalists from the United States, Iran, Brazil, France, and Belgium, mostly in their thirties and early forties. The title, *On the Line*, refers to the liminal positions and perspectives of these photographers, straddling art and reportage. The exhibition curator Adam Weinberg views them as "hybrid photographers" who "have assimilated the aesthetic lessons of art photography and are well-versed in the visual language of color photographic materials."[16] Yet he notes that few photojournalists are comfortable with the title of artist, and there are tensions in the commentaries by photographers quoted by Weinberg.[17]

On the Line foregrounds a discussion on the role of color in the photographers' work, illustrating some of the gains and losses for conflict photography and recognizing some of the ethical as well as formal tensions it introduces. The use of color by photojournalists focused on war and conflict was an issue that animated and divided many photographers and critics in the period. As we have seen, Larry Burrows was the first war photographer of note to use color extensively, and by the end of the Vietnam War color photography of the conflict was becoming increasingly common. This was not a smooth or speedy transition, however. There were technological constrictions for a time, as color was complicated to use and expensive to develop and print until the later 1960s. The slower speeds and relative unpredictability of responses to natural lighting did not make it readily conducive to action photography. At the same time, many photojournalists distrusted color for a range of reasons, some believing it compromised the formal complexity of composition, while others simply viewed it as debased due to its associations with advertising and commercial image making.[18] Another concern was that drawing on art photography stylings may work to aestheticize the subject being pictured. This was not a new concern, and it still has resonance in the digital age. In the late 1970s and 1980s it was a particularly raw concern, as the use of color and

fresh pictorial conventions drawn from art and commercial photography were transforming the fields of photojournalism. The issue of aestheticization was a ready target for detractors and a point of tension for new photojournalists. Susan Meiselas articulated her concern succinctly: "It's very hard to work against . . . beauty in colour."[19] What was at issue for Meiselas and all photographers interested in using color and experimenting with the genre's conventions is the relationship between aesthetics and reportage—at its heart, this is the issue of the balance of form and content within the image, but it is also what flows from that in terms of the reference points for viewers and the relationship of the image to what lies beyond the frame. As they developed a new vocabulary of color, the photographers acknowledged the tensions between aesthetics and reportage, not by avoiding them but by incorporating them into the work.

At times, color appealed to photographers as the sine qua non of content. This was especially so in Latin and Central America. Alex Webb says of Haiti: "Colours are out there. You go into a country like Haiti. It is poor. Shockingly poor. There's tremendous repression. Yet the walls are bright pink and bright green and it's incredibly beautiful. The complexity of that kind of response that one can have in colour interests me. The colours in Haiti do transform the experience."[20] Similar views are expressed by Jean-Marie Simon working in Guatemala, Susan Meiselas in Nicaragua, and Steve McCurry in Lebanon and Afghanistan. Such emphasis on color heightened the tensions between aesthetics and reportage, not least because it risked exoticizing the subjects being documented and drew attention to imperial and colonial registers of representation. As a result, the work of these photographers was susceptible to critique. Susan Meiselas's work in Nicaragua, for example, was attacked for rendering suffering "exotic" (more on this in the section on Meiselas in this chapter), while Alex Webb's work in Haiti and other countries of the Tropics that were in violent political strife drew criticism as an example of "Third World mystique."[21] The critiques were symptomatic of the critical and cultural debates surrounding the new photojournalism at this time and of a too often simplified understanding of the innovations photographers such as Meiselas and Webb were producing. Webb's books *Hot Light/Half-Made Worlds* (1986) and *Under a Grudging Sun* (1989) were innovative in extending the frames of photojournalism by eschewing "news" and focusing on the environment of oppression, using intensities of light and color to accentuate this—the contrasts and depths of vision can be dizzying (see, e.g., fig. 2.1). Max Kozloff presented a robust rebuttal of such criticism in a 1990 essay in which he argued that Webb uses expressive pictorial form to create an emotional depth that runs counter to the professional

2.1 Street scene, Cité Soleil, Haiti, 1986. (Alex Webb, photographer.) © Alex Webb / Magnum Photos.

"detachment of both conscience and affect from information" in Western photojournalism.[22] He "deprofessionalized his genre," Kozloff argues, by immersing himself in Haitian culture: "Any sense of a larger history can only emerge from his personal circumstances as he lives them at each moment . . . so that the esthetic scaffolding matches the psychic tension of his work."[23]

Webb may seem an extreme case to debate the qualities and values of a new photojournalism in the 1980s, yet he is a significant outlier. As Kozloff notes, Webb's work is in "a media limbo" and "has nowhere social to go except outside the rigidified genre of photojournalism and into books of an ambiguous and troubling cast."[24] Yet, his work illustrates the energies and innovations of a "dissident photojournalism" that sought to align its formal dissidence with critical perspectives on war and conflict.[25] It is within the contexts of image production outlined above that a new generation of photojournalists renewed their medium in the wake of the Vietnam War. In doing so, they established a new visual vocabulary of conflict that promoted a fresh self-consciousness about style and genre but was also attuned to the forms and environments of violent conflict. For this new generation, there were fresh challenges to meet in composing not only aesthetic but also ethical and political responses commensurate to both their subject and the contexts of its production and reception.

This inevitably involved creating visual documentation of post–Vietnam War theaters of U.S. foreign policy activity. I will look closely at several examples here, focusing particularly on the coverage of the revolutions in Iran and Central America.

Iran

The Iranian revolution, including the "hostage crisis" that ran from November 1979 to February 1981, was highly mediated, an unfolding drama that showed up the complicities between the spectacle of revolutionary terror and violence and mass media news making. This drama reached its greatest intensity for American media and publics with the hostage crisis, but well before that drama became a fixture on American television, the revolution was formulating a distinctive visual language (of repression and terror) that was most accurately illustrated by still photographers. In part this was due to the ways in which imagery took on dynamic political and cultural significance in the revolutionary turmoil. As the Iranian-French photojournalist Abbas notes: "Everyone was taking photographs, they were part of the cultural revolution. Photographs, and sometimes poems, were nailed to trees to show the horrors of the regime and make people aware that the action wasn't a revolt—it was a revolution. The revolution wasn't just happening in the streets, it was happening in our minds."[26] The streets and public spaces of Tehran in particular became the stage for the symbolic politics of factional conflicts. The bodies of dead demonstrators were widely exhibited and their funerals and mourning ceremonies became sites of political agitation; those executed by the militants were displayed publicly and their photographs widely published. The challenge for photographers covering the revolution and the hostage crisis was how to read this revolution-in-the-making.

This challenge was also heightened due to media manipulations of the revolution and the hostage crisis, both by Iranian and Western sources. Image wars ensued both internally and externally, not least over the iconology of Islamic revolution and of Ayatollah Khomeini in particular. Once the hostage crisis began, the manipulation and dramatization of events intensified. The students occasionally exhibited blindfolded hostages for the international media; they also photographed the hostages and attempted to place these images in Western media. In the United States, the crisis consumed the media, which created particular frames and narratives to make sense of the events for the American public. The nation was soon transfixed, as the events were turned into a spectacular

drama with an ensemble cast. Certain images became familiar: violent street demonstrations featuring fanatical students and the burning of American flags, an obdurate ayatollah and an impotent American president, ordinary Americans held hostage in Iran and their tearful or angry families at home. Through much of this intensive coverage, the crisis was framed as a human-interest story, only most obviously in the way in which ABC's nightly *America Held Hostage* (later *Nightline*) presented it, focused almost entirely on the hostages and their families.

The media frenzy around the hostage crisis reflected some of the tensions and contradictions of the media's role in producing and shaping it, as well as the challenge to interpret it. For the U.S. media as much as for the U.S. administration, there was a struggle to manage the story on their own terms and to avoid complicity.[27] Neither did much to render the ideological and political mechanics of this revolution transparent. Rather, they generated frames, narratives, and images that reflected geopolitical interests and long-standing stereotypes of Iranian and Islamic peoples. As David Harris notes, "The Iran hostage crisis was covered at once too completely and not enough. No space was opened up for a rational conversation about the crisis."[28] This reflects a long-standing ignorance about the nature of Iranian culture and especially the relationship between religion and politics—an ignorance due in some part to an ideological and essentialist view of Islam and the Middle East that did not differentiate between national and ethnic sensibilities and identities.[29] *Time* cover stories on Iran during 1979 read the revolution through a geopolitical lens in terms of what it portended for U.S. interests in the Middle East and also through a cultural lens that equated regional disorder with "Islamic militancy." Under such titles as "Guns, Death, and Chaos," "Iran: Anarchy and Exodus," "The World of Islam," "The Crescent of Crisis," and "Islam: The Militant Revival," *Time* offered little understanding of the hostage crisis as a catalytic event in the unfolding Islamic revolution, nor of the cultural and political factors that fanned conflicts between theocrats and secular nationalists. The obsessive nature of the coverage reflected and fed public hysteria about this event and (re)articulated an imaginary Islamic menace for American audiences.

Photojournalism certainly contributed to the media framing of the Iranian revolution and the hostage crisis, producing images that reflected the dominant frames. The most common image bank in the first year of the revolution was of mobs on the streets of Tehran, producing a sense of ongoing violence, though in fact demonstrations were increasingly staged and there was little violence. The second most common type of image was of the key actors—the shah, Ayatollah Khomeini, and President Carter—

all of whom had particular visual connotations that reflected the perceptions of Western media. During the hostage crisis, certain images took on iconic qualities in relation to these frames, most notably the image of a blindfolded hostage outside the embassy, which appeared on the front cover of *Time* and was widely reproduced throughout the course of the crisis (fig. 2.2).[30] It connoted both the vulnerability of the American hostages and the uncertainty of what course the crisis would take. With the passage of time, it has also been taken to connote the myopia of American geopolitical thinking on Iran. The image was taken by the Iranian photographer Reza Deghati when students led several blindfolded hostages outside the embassy to be filmed and photographed by the gathered media.[31] *Time*'s cover story, titled "Blackmailing the U.S.," begins: "It was an ugly, shocking image of innocence and impotence, of tyranny and terror, of madness and mob rule. Blindfolded and bound, employees of the U.S. embassy in Tehran were paraded last week before vengeful crowds while their youthful captors gloated and jeered."[32] The image of the blindfolded man (William Earl Belk, a communications specialist at the embassy) became a symbol of the crisis in the United States. In Tehran, a copy of the image was cut from a newspaper and pasted to the wall of the U.S. embassy.

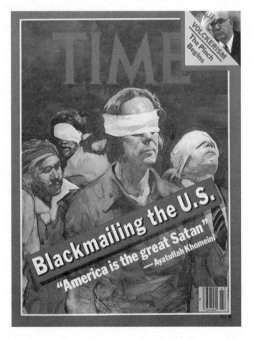

2.2 "Blackmailing the U.S.," cover, *Time*, November 19, 1979. (Reza Deghati, photographer.)

While most photographers contributed to these image banks, some also sought to expand or question the visual narratives. The early period of the revolution was covered by a small grouping of photojournalists, as David Burnett recalls:

Most of the photographers I know covering the revolution are French. There's Olivier Rebbot, freelancing for *Newsweek*; Alain Keler, Alain Dejean, and Patrick Chauvel with the agency Sygma; Alain Mingam with Sipa; the Franco-Iranian Abbas with Magnum; and Catherine Leroy, the only woman on the scene. Like me, she is shooting for *Time*.

Besides that, there's Englishman Bob Dear with AP, and Tom Cargas, an American staffer with UPI. There's also a coterie of Iranians, including Hatami, who had lived in Paris for 20 years, and Kaveh Golestan, an intense young photographer who's returned to his country from abroad just in time.

These are the main people I see every day—maybe a dozen photographers for the entire story.[33]

This representation reflects the limited international interest in the "entire story" prior to the hostage crisis. The relatively small number of major image makers (plus the stage managed nature of the revolution) meant that the image repertoire was reduced, with similar images appearing across the international media. The predominance of French photographers reflected the prevalence of French agencies competing for coverage of international conflicts in this period (as noted above). What Burnett terms "a coterie of Iranians" among the photographers is noteworthy as they took on increasingly significant roles in documenting the revolution for international media.[34] International newspapers and magazines were hungry for images, and several Iranian photographers became key contributors, most notably Abbas for *Time* and *Newsweek*, Reza Deghati for *Newsweek*, and Kaveh Golestan for *Time*. While the nationality of the photographers is not a defining feature of their work, it is significant and particularly so in the context of this revolution, in part due to restrictions on access to events and contacts but also because issues of distance and interpretation become key to decoding the event of a revolution in process. I will look more closely here at the work of Abbas, David Burnett, and Gilles Peress.

Abbas

Abbas is an Iranian photographer who spent most of his young life in Algeria before settling in Paris from where he worked with Sipa and Gamma. In 1977 he returned to Iran to document social and economic changes in

the country and stayed to record the beginnings of the revolution. His work shows the transition from a popular uprising against the detested shah to full-blown Islamic revolution. Abbas spent almost two years documenting this transition and during this period his views on and feelings about the revolution shifted, as his early hopes for it gave way to a deep disillusion. Recalling his reasons for covering it, he remarks: "I was for the change in Iran, so I wasn't just a concerned photographer, I was involved. It was my country, my people and, in some way, my revolution."[35] Unlike most Western photographers, Abbas's dilemma was not to so much to find a way to engage the revolution as to disengage and to find a balance between his political sympathies and his professional responsibility.[36] Though pressured by Iranian friends to produce only positive imagery of the revolution he refused: "My Iranian friends urged me on . . . 'we had to get rid of the Shah and then we'd see.' I preferred to risk weakening the image of the revolution, which at that point was peaceful and enjoyed support the world over, than to hide its excesses."[37] Perhaps the most distinctive feature of the extraordinary corpus of Abbas's work is the sense of his immersion in the revolution as a participant as well as an observer—his camera often appears to be in the center of events.

While he experienced and photographed the shifting contours of the revolution and began to believe it was being taken over by violent extremists at the expense of the people who had first supported it, Abbas traces the movement from spontaneous to organized action. It is the secret trials and summary executions that most appall him. In several interviews he has referred to one moment when his growing sense of disillusionment became critical. It was the morning of 15 February 1979, four days after the shah's regime collapsed. The day before, at Ayatollah Khomeini's headquarters, a summary trial had been held and four of the shah's leading commanders had been executed by firing squad shortly before midnight. Abbas photographed their corpses the next morning in the morgue (see fig. 2.3). For Abbas, the bodies symbolized not only an abuse of power but also a form of retribution that mimicked the political violence of the shah's regime and corrupted the idea of a revolution. A few days earlier he had photographed the trial of General Mehdi Rahimi, who was one of those executed. Later, he commented, "How could I forget the dignified face of the captive General who was interrogated in front of the television cameras? Five days later, I photographed his body, one of four lying in the morgue. Their trial had been held in secret . . . this revolution would no longer be mine."[38] The disgust was compounded by the torture that had evidently taken place, though Abbas does not comment directly on this.

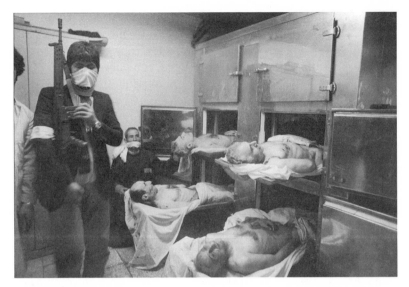

2.3 The bodies of four generals, Tehran, Iran, February 15, 1979. (Abbas, photographer.)

In this image, we see that Rahimi's arms have been severed, one placed on his chest and the other beside him.

Abbas also recalls this was a point at which he made a conscious decision: "I chose to continue with my obstinate testimony rather than withdraw, angry and scornful."[39] More and more he pictured the violent excesses of the revolution, including a picture of an elderly woman being pulled along a street to be lynched, and another of demonstrators carrying the charred body of a prostitute. He comments: "Not only did I take these photographs, I showed them. Because the germ of what happened afterwards was already there in the faces of the people you see in the photographs—this fanaticism, this anti-woman—it's all there."[40] His images constitute a powerful critique of the fanaticism of revolutionary fervor and the manipulation of religion for political ends. Reflecting later on his experience, Abbas notes that his images depicted another form of hostage crisis in which "45 million Iranians [were] hostages to religious fanaticism."[41] In a photograph of celebrations on the first anniversary of the revolution, on February 11, 1980, he underscores the fanaticism that he believes overtook the revolution. It shows a densely packed crowd holding aloft the body of a young man who has fainted and who takes on the symbolic presence of another martyr; the surrounding haze of smoke seems to emanate from the crowd, shrouding the scene and accentuating

the symbolic import of such an event. This photograph, underlining the powerful emotional connections between religion and politics, also signifies the direction Abbas would take his work for many years as he roamed the world documenting these connections, convinced the revolution would not end at the borders of Iran. The book publication of his images of the Iranian revolution, *Iran: La Revolution Confisquee* (1981), rendered him "camera non grata" in Iran and he did not return for seventeen years.

Burnett

David Burnett was the last photojournalist to cover the Vietnam War for *Life* magazine. As a cofounder and lead photographer for the Contact Press photo agency, he traveled widely, covering major events, shooting in both black and white and color, to produce both immediate news shots and more reflective pieces. He became renowned for shooting in-depth color features using Kodachrome 64 film, which was slow to process but showed remarkable tones and textures. On contract with *Time* magazine, he worked in Iran from December 1978 to February 1979, covering the fall of the shah's regime, the chaotic interregnum, and the arrival of Ayatollah Khomeini and inauguration of the Islamic republic. Despite limited access to Iranian leaders and limited knowledge of the country, Burnett covered many significant scenes and moments, providing a significant documentary record of this period (later organized into a book titled *44 Days: Iran and the Remaking of the World* [2009]).

Many of Burnett's shots draw attention to the staged or spectacular nature of the scene. Images of Khomeini seem ubiquitous on the posters held by marchers; often it is the same image. A picture of eight marchers holding aloft the same poster of Khomeini after the shah's departure connotes the iconography of the revolution. Only the legs of the demonstrators are visible, the rest of their bodies concealed by the head and shoulders of Khomeini on the poster—the effect is to suggest their dissolution of selfhood in the name of the revolution. Another photograph of a demonstration focuses at center on a man wearing a jacket that is decorated with photographs of victims of the shah's repression and a hat with the inscription "crown of the martyrs."[42] One of Burnett's strongest color shots of spectacular street action, widely reproduced, depicts an anti-shah demonstrator displaying his hands, which have been covered in the blood of a fellow demonstrator killed by the military in Tehran in January 1979—it became an iconic image of the revolution in Western media. Burnett also illustrates something of the repressive but barely visible institutions of the hated regime, most notably when he photographs a former secret SAVAK

(the shah's secret police) prison, which has been ransacked and burned by crowds. His pictures of people walking off the street into the house to examine the torture apparatus show them oddly relaxed and curious, and he notes: "I'd been told the house was trashed and burned by demonstrators over the weekend, and when I get there the rooms are still smoldering. Just the same, families stroll through the house as if they were visiting an art gallery on a leisurely Sunday."[43] Detained by a group of soldiers after he has photographed the prison house, Burnett furtively shoots some film that indicates the sense of fear and repression generated by activities of state power.

The most celebrated series of images Burnett shot was of Ayatollah Khomeini in his headquarters at the Refah School in southern Tehran as he greets thousands of followers. He explains how the scene was staged for adoring crowds: "Every half hour or so the guards open the gates at one end and let a couple thousand people, men alternating with women, into the courtyard, actually the playground, which measures approximately 50 by 60 meters. The crowd cheers and chants. Khomeini eventually comes to the window, waves a solemn greeting, and everyone outside goes berserk. Two minutes later he disappears and the guards open the gates at the other end of the yard to let everyone out and usher in a new group."[44] Burnett's images illustrate this stage management and the hysteria of the crowds counterpointed with the calm presence of Khomeini at a school window. Having taken many images from the midst of the crowd and an elevated building overlooking the playground, Burnett eventually persuades a press officer to provide him with access to the imam. Inside the room with Khomeini and his aides he shoots toward the open window with the crowds gathered outside. The compositions accentuate relations between inside and outside and the dramatic nature of these. Burnett notes that "the glass window overlooking the playground is closed, and it's as if I am looking through a TV screen with the sound turned off."[45] In this image (fig. 2.4), the most widely reproduced of the series, Burnett produces a dynamic composition, as Khomeini sits in a corner and is being served tea by Sadegh Khalkhali (who would later become known as the "hanging judge") and attendant mullahs. Through the window, we see heads of the crowd, mostly turned away from the window, apart from the man seated on the window ledge who stares directly at the camera, echoing the gaze of one of the mullahs in the room. Burnett notes that Khomeini "never makes eye contact with me and I have the impression he doesn't even know I'm there."[46] There is a sense of capturing an intimate moment and having moved behind the scenes of the revolution, though Burnett is well aware that he in turn is being manipulated through the

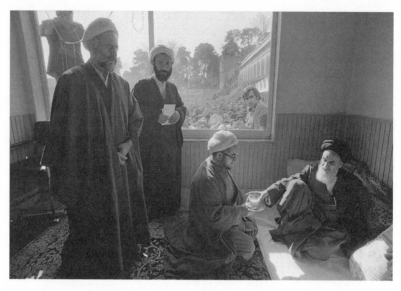

2.4 Ayatollah Khomeini is served tea, Tehran, Iran, February 5, 1979. (David Burnett, photographer.)

granting of access. In part because of the pregnant symbolism of inside and outside, private and public, held in the frame(s), the viewer is tasked with connecting these realms. The quiet ritual of serving the tea and the tumult beyond the window suggest that Khomeini has a cultural and emotional authority that the shah never had, and Burnett's images are among the first to decode this for Western viewers. Within the context of the series, we see that he particularly wanted to accent the power and authority of Khomeini and how this was exercised and managed yet also underscore the enigma that is "Khomeini" to Western eyes.

Burnett's sense of distance from or involvement in the scenes is ambivalent at times. There are several points where he comments directly on his activity or that of colleagues as professional photographers and on his identity as an American. One of the most dramatic sequences in his work is the set of images of a mob attacking and appearing to kill SAVAK's General Latifi. We see his burning car surrounded by a mob and then several shots of the mob beating him. In two of these shots, we see the photographer Olivier Rebbot, who is attempting to photograph Latifi and has been caught up in the crush of the mob. Burnett later reflects on this scene: "Olivier and I leave [the crowd] . . . we've had enough. Disgusted, we turn back toward the hotel. Neither of us says a word. Words seem somehow out of place. Witnesses—and voyeurs also—we hardly look at each other, and

don't speak again until we're back at the hotel."[47] This memory of the episode questions the role of the photographer as "witness" to such events. In a later episode, Burnett raises another complicated question about his role and identity. As he photographs the attack on the U.S. embassy in Iran by militants on February 14, 1979 and moves around the ransacked building, he admits to an unease: "At one point, looking at some papers on the ambassador's desk, I feel almost embarrassed, and wonder when I stop being an American and start being an 'international journalist.' The question doesn't arise often. Usually I know what my work is about, and how I fit into reporting the events of the world. But it's a spooky moment when your own country and your own ambassador are the victims."[48]

Peress

The unease of a photographer confronted with confusing and violent events, only occasionally articulated in Burnett's text and subliminal in the images, is the core motif of Gilles Peress's coverage of the turmoil in Iran. Frustrated by U.S. media coverage of the hostage crisis, the Magnum photographer spent five weeks in Iran from December 1979 to January 1980, photographing in Tehran and several other cities. He did not approach the event in a conventional journalistic fashion but produced a very subjective view of what he witnessed and the confusion he experienced. He accentuated this sense of confusion by re-presenting it to the viewer via images that appear skewed or oblique in terms of composition and meaning. His photographs do not tell a story but are a record of his perceptions, encounters, and emotions as he moves around Iran. He had some difficulty publishing this material in mainstream media, though the *New York Times Magazine* published a selection under the title "A Vision of Iran," a title that reflects the subjective nature of the work. Peress also published some of this work in specialist magazines and created an exhibition of his Iran imagery. The fuller body of work would become infamous once published in book form as *Telex Iran: In the Name of Revolution* in 1983. Cornell Capa called it "a book of brilliant visual nervousness between covers."[49] Many younger photographers came to revere it. Gary Knight, for example: "It was like someone had reinvented the wheel."[50]

Fred Ritchin, picture editor of the *New York Times Magazine*, supported the publication of a portion of Peress's work in the magazine and later wrote: "Peress's photographs are the puzzled, chaotic articulations of a self-avowed outsider looking for explanations in areas where other journalists, confined for months to their on-the-spot positions in front of the American Embassy, were unable to go. In this context, the photographs

are asserted as questions rather than answers, a strategy in keeping with a growing disbelief that it is possible to present conclusions without involving the reader in the photographer's attempt to understand. The revelation of the image is located in the telling not just in the evidence of what has been told."[51] There is a distinctive challenge to the eye—to make visual sense of what is being looked at—and to particular ways of seeing international conflict. This is more than a deliberate promotion of visual confusion. Rather, Peress subtly defamiliarizes (Western) viewers' predispositions in looking at news reporting of the Iranian "hostage crisis" at a time when the U.S. media was producing sensationalized and demonizing views of the new regime and portraying Iranian people as "fanatics jumping out of the television screen, knife between their teeth, red eyes demanding justice."[52] Eschewing the common photographic subjects of the revolution and hostage crisis—the mass rallies, the exterior of the American embassy—Peress covers an array of experiences and perspectives, presenting students, clerics, funeral mourners, and various laypeople, including heroin addicts, going about their daily routines. He also travels more widely than most (photo)journalists, documenting the experiences of Kurds and Azerbaijanis, visiting the cities of Tabriz and Qom as well as Tehran, indicating the breadth and depth of the revolution beyond the "hostage crisis." In some respects, his imagery reflects the chaos and fanaticism portrayed in much of the imagery coming out of Iran at that time, but the chaos of Peress's "vision" is one of perception as much as what is perceived. He offers no "centered" photojournalistic images (such as Burnett's of a man holding up bloody hands). Rather, he seems to reproduce rhythms of displacement and dislocation.

This image (fig. 2.5), which is also the cover image of *Telex Iran*, is taken at a demonstration in Tabriz in support of Ayatollah Shariatmadari, but the complex composition and the cropping and tilting of the image challenges the viewer to locate a central point of meaning or message. The image appears to be divided into four sections or planes, each distinct yet clearly part of the same scene and moment, a potent deconstruction of the act of observer reportage. Peress has said he has "always tried to break the frame," a key element of his efforts to deconstruct and reconstruct the visual language of reportage.[53] This includes a careful attention to the spatial relations within the picture frame.[54] Often, as in this image, objects or elements of the landscape—poles, walls, trees—become verticals or diagonals that bisect the picture plane. There are many similar street scenes in which people are looking in different directions, signifying the need to find meaning beyond the frame of the photograph. Such scenes owe as much to street photography (the work of William Klein and Garry

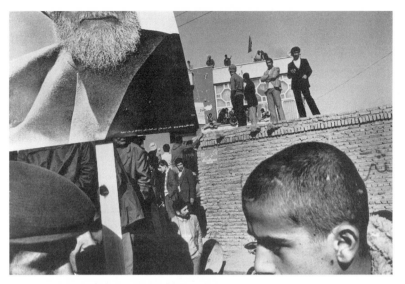

2.5 Pro-Shariatmadari demonstration, Tabriz, Iran, 1979. (Gilles Peress, photographer.)

Winogrand, for instance) as to traditional photojournalism. The use of wide angle and tilted views and of the light of winter sun to create deep shadows and strong contrasts also reference street photography. The mobility of the camera—people seen through doors or windows, reflected in mirrors, photographed from passing cars or buses—echoes Robert Frank and his pictorial sense of alienation. In these ways, Peress's work signifies the blurring of boundaries between photographic genres that was becoming common in the later 1970s.

Peress is aware that the revolution was also a war of images and that for those leading this war in Iran the hostage crisis is but a continuation. This is apparent in the first two images of *Telex Iran*. The first, on the inside front cover, is of layers of graffiti on a bathroom wall in Qom. As Gholam-Hossein Sa'edi points out in an accompanying essay, in the context of the revolution, "walls were mirrors that reflected events. . . . Thousands of slogans, chaotic and confused, covered the same wall. . . . Without even bothering to efface one graffiti, people scribbled another on top of it. Wars of opposites, bitter political messages, and mottos of different parties mingled with threats and abuses."[55] This graphic and textual chaos is an appropriate opening image for *Telex Iran*, indicating the chaos of perspectives we will encounter; the scrim of meanings is a palimpsest calling out for a clear interpretation and reinforcing the Western viewer's distance from the culture being viewed, yet it also tells us something about the

meaning of this chaos in the context of the revolution. The second image in the book, which appears alongside an editorial statement, is of a hand-written poster outside the American embassy in Tehran. It reads: "As an Iranian I want you correspondents + journalists + film-takers [to] tell the truth to the world."[56] It is dated 20.12.79 and signed Hossain. This image refers us to the mediated nature of the hostage crisis and the war of images between Iran and the United States.[57] It alerts us to the staged nature of much we are shown in *Telex Iran*: a wall of photos and cards under the title "Victims of the Shah and America," the demonstrations, the taking over of a television station, peasants arriving at the American embassy to join the continual protests there, the photographs of "martyrs" in graveyards, victims of SAVAK corralled for a press conference, and a press conference at a prison with two ex-SAVAK officers, behind whom are displayed pictures of victims.

Supplementing the visual confusion of *Telex Iran* are the fragments of telex messages that accompany many of the images. In some instances they are enlightening, providing information that opens up the meaning of the image. More often they appear to have little or no direct relevance to the images. They have a double function in the book. On the one hand, Peress reminds us of how significant but also errant the relationship between a news photograph and a caption or explanatory text is. On the other, he provides us with insights to the practice of photojournalism. A picture of a portion of a crowd depicts a man with an amputated arm, another holding an artificial leg, and another in a wheelchair—we might recognize connotations of violent conflict, disfigurement and protest but the text takes us to a fuller meaning: "It's a show organized by Iranians for the benefit of [U.N. Secretary General Kurt] Waldheim, who didn't show."[58] With another image, of a man who is gagged, the text tells us this is not a hostage but a training session on Iranian television.[59] In such instances Peress reminds us of the limitations of the photographic image as a document of reality. In others he more directly indicates the room for error in interpretation. An image depicting a group of women in chadors attending a meeting at a stadium in Tabriz is accompanied by this telex fragment: "Please make sure this material as other gets into right hands as I do not want any right wing French or U.S. magazine to use it out of context and without correct captions. Situation here too intricate and interesting for that."[60] This is also to say that the telexes are filled with confusions and elliptical references that are difficult for the reader to understand. Yet, they provide some insights into the ways in which the profession works— the reliance on couriers, the constant pressure to sell stories and meet

deadlines—and at times the pressures on the photographer become clear. At one point he says he will leave but receives the reply: "Impossible you leave. Rumor hostage will be freed next Thursday. Also Life interested . . . Pls stick it out."[61] The contingencies of trying to sell images is always present as his communicants discuss the possibilities of publication . . . "Sad to say but Life not using Gilles Iran because of Afghanistan as hot news story. Please let him know. I have all pictures. Shall I show to Geo?"[62]

Telex Iran is not a narrative documentation of the "hostage crisis" but in media res reflections on a revolution. In his introduction to the book, Peress writes: "These photographs, made during a five-week period . . . do not represent a complete picture of Iran or a final record of that time."[63] The book is designed to draw the reader into this confusion and foregrounds the instability of the photographer's role as witness. To be sure, the contrasts and tilted angles can become dizzying for the viewer, it is like trying to learn a new visual language where meaning is always just hovering outside the frame. Fred Ritchin notes that Peress "confronted and photographed what he did not know. The result is a dialectic between the photographer and the people of Iran, mediated by a Leica, which becomes, in turn, a dialectic that includes the reader."[64] Incompletion and fragmentation are at the core of this dialectic, which acknowledges the limitations of narrative. This *lack* of completion and finality is precisely the point of radical perception the imagery imparts. This is not, simply, a rejection of objectivity but, in addition, a rethinking and revaluing of what this is in the act of perception. As Peress notes: "There's no pretense of objectivity. That doesn't mean I'm not interested in objectivity; I just don't think one gets to it that easily. . . . Objectivity is something that you push for and arrive at by doubting yourself, doubting the process, doubting what's being shown to you."[65] This is why so many photographers acclaim Peress's work in Iran and this book in particular, for it not only "break[s] the frame," it also instantiated a new visual language for the interpretation of violent conflict.

Telex Iran impels us to measure the distance between perception and event and comprehend the significance of cultural differences in between. Though reluctant to discuss the meaning of his work, Peress has said of Telex Iran that it is "a book about the distance between the U.S. and Iran. I wanted it to be obvious that I was looking with Western eyes. It's really about the failure of the media, the failure to understand."[66] That failure of understanding is also a failure of the photographer and the viewer, but in the visual contract we have the opportunity to begin to understand alternative ways of looking at this revolution and at how it has been mediated.

Nicaragua and El Salvador

As U.S. geopolitical concerns shifted along the contours of Cold War imperatives toward Latin and Central America, from the mid-1970s and throughout much of the 1980s, American media responded to the new territorialization of Cold War scenarios and proxy wars. The American public would have to relearn its world geography once again, though now in terms of its "backyard," and the media played a crucial role in developing the primary frames, narratives, and tropes that imbued American perceptions of the region with a sense of moral drama and political urgency. This was not a new role for the media. Throughout the twentieth century, from the Spanish-American War onward, U.S. military and economic interventions in Central America were avidly covered by American media, which more often than not supported these interventions by representing the region as an imaginary landscape onto which they projected domestic fears and desires. By the early 1980s, as violent conflicts between military dictatorships and insurrectionary movements escalated, the geopolitical stakes in the region were hugely inflated—it became a Cold War "hot spot" and point of focus for fresh tensions between the agents of U.S. foreign policy and American media.

Central America came to serve as a testing ground for a range of American political, military, and cultural interests in this period. Greg Grandin has argued that it has served as "empire's workshop," noting that "policy intellectuals used Central America to invigorate America's moral purpose in the world."[67] This refers, in particular, to the ideologues in the Reagan administration who promoted an exceptionalist vision of intervention in the region. On the one hand, driven by a Hobbesian realism and embittered by the defeat in Vietnam, they forcefully promoted incursions into the region and the support of violence to deter insurrectionary forces that threatened to destabilize U.S. national interests.[68] On the other hand, they professed the pursuit of policy in the name of democracy promotion and human rights. The tensions between national security concerns and respect for human rights, already at the heart of the administration, would be played out in media coverage of conflicts in Nicaragua and El Salvador.

The American press came under close scrutiny while reporting from Central America at the height of U.S. military and political involvement during the Reagan administration. Critics frequently referred to the "sentimental" or "naïve" point of view of U.S. journalists, charging that they romanticized Sandinistas in Nicaragua and rebels in El Salvador as "underdog revolutionaries."[69] Such criticisms reflected an increasing politici-

zation of opinion on conflict reporting, which was often hyperbolic and contrived to add to existing pressure on journalists to reflect U.S. interests in their coverage. While this pressure was felt by all journalists working in Central America for U.S. media, shaping their efforts to document the conflicts, photographers often felt it most keenly as they could and did provide visual evidence of some of the most brutal activities of regimes and rebels. They provided eyewitness accounts of what was happening on the ground that were contrary to the claims of the Reagan administration about the issues and especially about its rhetorical commitment to human rights in the region. At the same time, though, as we shall see, the evidentiary impact and value of such images were circumscribed by powerful political and editorial frames in the United States.

As with the Vietnam War, U.S. reporting on Central America struggled to provide coherent interpretations of conflicts in the region. There was thoroughgoing mystification of causes and consequences of the conflicts, and this scrim of confusion was further muddied by the myths and stereotypes about Central America that already abounded in American media. Conservative and progressive media disagreed about if and how the United States should intervene in Central American states, yet most agreed on seeing the region as a site of endemic "instability" and political violence. This is apparent in the framing of stories about the region, as policy issues are to the fore and the view from "Washington"—a metonym for the U.S. worldview—is the privileged perspective. Due to this overlay of Cold War geopolitics, media frames consistently presented simplistic dichotomies—democracy and dictatorship, Sandinista and Contras—and emphasized the illegibility or opacity of Central American politics and cultures, accentuated the propensity for brutal violence among peoples of the region, and mystified the causes and effects of political struggles (see fig. 2.6).

This invariably restricted the repertoire of news photographers, whose work was used for primarily illustrative purposes within the mainstream press in the United States. Robin Andersen, in a study of images in U.S. media coverage of El Salvador, notes that representations of violence and atrocities are framed as indicative of the pathologies of political unrest in the region. He asks the reader to

consider the social and political realities that produce these images, the flow from which they were yanked. People running in the streets, being shot by right-wing snipers and security forces, are the results of decades of economic, social and political injustice. These disparities have existed for decades, with the wealth of a rich minority being maintained through force. This is the essential reality that produces these

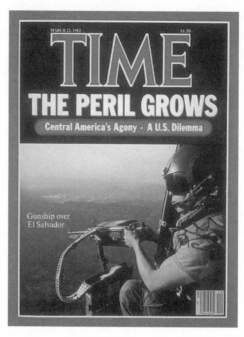

2.6 "The Peril Grows," cover, *Time*, March 22, 1982

images. They have been pulled from this context and reinserted into the US media frame. Their message in the new context is that struggle = death; revolution = chaos; and change = pathology. These meanings are anchored within the news text that indeed equates change in Central America with pathology. The photos (of surface appearances) are used to reinforce an ideology against change.[70]

This is a shrewd reading of the shift in meanings determined by media frames, and though it overdetermines the "essential reality" of El Salvador, it underlines a key thematic in U.S. media coverage of political violence and the lack of critical inquiry about its causes: "In the face of unexplained political upheaval, the problem in El Salvador became the country itself. . . . Conflict in the country has been visually depicted as random and chaotic, a baffling morass so bewildering that taking action to stop it seems utterly futile."[71] This mystification of political upheaval and violence is less a conscious intention of U.S. media as an ideological effect of presenting the "chaos" of the region from an American perspective.

The equation of El Salvador with political chaos and pathological violence was widely reported within the framing of U.S. media coverage. Underlying it was a view that the causes and development of the conflict

were barely comprehensible. This was a view lent intellectual credibility by Joan Didion with the publication of her travelogue *Salvador* in 1983. In her reflective new journalistic prose she depicts her sojourn in the country as an unnerving and disorienting experience, which causes her to eschew conventions and expectations of investigative foreign correspondence. Again and again she emphasizes dislocation. In the opening paragraph she describes El Salvador as "a state in which no ground is solid, no depth of field reliable, no perception so definite that it might not dissolve into its reverse."[72] Didion links her sense of dislocation and errancy to the inadequacy of positing conventional journalistic questions or trying to create a narrative that could explain the conflict or the meaning of the American political and military presence there. At the same time, her sense of place is deeply infused with an ironic American sensibility about the Americanization of the place, which is made all the more strange due to the unmoored cultural references that impinge on her consciousness:

I walked across the street from the Camino Real to the Metrocenter, which is referred to locally as "Central America's Largest Shopping Mall." I found no Halazone at the Metrocenter but became absorbed in making notes about the mall itself, about the Muzak playing "I Left My Heart in San Francisco" and "American Pie" (". . . *singing this will be the day that I die* . . ."). . . .

This was a shopping center that embodied the future for which El Salvador was presumably being saved, and I wrote it down dutifully, this being the kind of "color" I knew how to interpret, the kind of inductive irony, the detail that was supposed to illuminate the story. As I wrote it down I realized that I was no longer much interested in this kind of irony, that this was a story that would not be illuminated by such details, that this was a story that perhaps would not be illuminated at all, that this was perhaps even less a "story" than a true *noche obscura*. As I waited to cross back over the Boulevard de los Heroes to the Camino Real I noticed soldiers herding a young civilian into a van, their guns at the boy's back, and I walked straight ahead, not wanting to see anything at all.[73]

Didion's trademark irony appears to fail her, an insufficient rhetorical tool to leverage meaning from the scene. Instead she indicates the incomprehensibility of the scene and by inference the incomprehensibility of the country. This sense of defeat is also a knowing disavowal of her duties as a journalist: viewing the soldiers arresting the young civilian she walks ahead, "not wanting to see anything at all," a deliberate and chilling refusal of the role of the journalist as witness.[74]

For all her insights, Didion substantially cedes the role of witness. For many journalists and photographers, though, this was not an adequate re-

sponse to the realities of life and death in Central America, any more than the cruder stereotypes and myopia of mainstream press framing, which was mostly aligned with the U.S. administration's worldview. Between the strictures of mainstream media framing, the demands of spot reporting, and the assumption that the conflict was beyond interpretation, there would seem to have been limited room for the production and presentation of imaginative, questioning work by photojournalists, yet many sought to do just this. Richard Cross, who was killed in Honduras in 1983, represented the more idealistic wing. Reflecting on his work covering the revolution in Nicaragua, he comments that it "was the turning point, giving me a sense of direction and purpose, and feeling that the mass media can shape man's history."[75] Yet, Cross was also pragmatic about how to pursue "in-depth journalism" and was critical of photojournalists' self-imposed limitations. Considering coverage of El Salvador, he states: "In [news] photographs, the priority seems to be on getting good shots, shots of the news moment. And it's a sort of unwillingness to come to terms with what is going on down there in a systematic way. I think photographers sometimes are very short-sighted in looking at causes. They are interested in more dramatic symptoms of the problem rather than the cause of the problem. There's this sort of refusal to look at patterns." He also argues that to produce "good in-depth journalism . . . a person has to be dedicated enough to spend quite a long time with a story. And photographers have to take the initiative to try to have more control over the use of their photographs and they have to get more interested in the potential for combining images to make stories and to combine images with texts."[76] While Cross accurately describes the focus of much mainstream news photography covering Central America as an interest in the dramatic symptoms rather than the causes of problems, he was not alone in his commitment to what he termed "good in-depth photojournalism."

Meiselas

Susan Meiselas's work in Nicaragua and El Salvador in the late 1970s and early 1980s established her reputation as one of the world's leading photojournalists. Meiselas has an ambivalent relation to mainstream photojournalism, though, and is less comfortable with the designation photojournalist than that of documentary photographer. Both a proponent and critic of "concerned photography," she not so much maintains that tradition as challenges it to evolve. Her work is more conceptually grounded than most photojournalists active in sites of violent conflict and she is

especially reflective about "the tradition of encounter and witness" and the role of the photograph(er) as a "bridge" between cultures.[77] She not only examines the effects of conflicts on indigenous peoples but also explores the "event" of conflict, its multiple mediations and remediations, and her own role as an image maker; she is interested in the aftereffects of encounters between documenters and documented and the afterlives of images. These concerns produce a characteristic and sometimes strained balancing act in her work: expanding the frames of documentary photography while sustaining the values of reportage.

Having joined Magnum in 1978 and seeking about for a fresh project, Meiselas happened on a story in the *New York Times* about the assassination of Pedro Joaquin Chamorro, editor of *La Prensa*, Nicaragua's opposition newspaper. In June that year, she flew to Nicaragua with little idea of what to do there but remained for a year documenting the insurrection as it became a revolution, all the while exploring her own sense of what it meant to witness and evidence. She would later observe that she had a sense of purpose—"I wanted to go beyond the news event and document what I saw as history"—though what is most striking about this early work in a conflict environment is how her sense of confusion and self-consciousness about her limitations became key features in developing her photojournalistic practice.[78] In certain images, she abstracts or makes oblique references to this sense of confusion, as in an image of a boy looking at plastic soldiers in a marketplace—his quizzical expression mirrors the photographer's frustrated efforts to understand the culture of violent conflict in Nicaragua.

Meiselas has commented in some detail on her work in Nicaragua, partly in response to questions by critics and others, and partly due to her return to this body of work as she seeks to recontextualize it and to understand the remediations beyond her control. In an interview, she recalls her early frustrations: "In those first few weeks in Nicaragua, I heard about things going on, but I could only find expressions of them after the fact. . . . I felt the frustration of trying to find the manifestation of something I knew was going on, but sometimes couldn't find a way to photograph."[79] In 1985 Meiselas reflected at length on her work in Nicaragua in an experimental documentary film she coproduced, titled *Voyages*. In it, she narrates her feelings and perspectives on working there:

"I always seemed to ride in breathless at the end of events, just as they were finishing, adding emphasis and strength to the illusion that you could understand events without knowing why or from where they originated. You might say that's the condition of being a foreigner, not a journalist, whose professionalism should entail knowing.

But we were living at a time when all there was to know remained deeply hidden. It was as if we were watching a mime whose intentions were clear enough but whose images I was unable to place."

She was still looking for something, not knowing where it was. She was still at the stage of knowing what you are looking for but not being able to find it. You've heard about it, that is, you've heard about the word "repression." But it remains hidden; it has no concrete manifestation and you can't photograph it. And so—stumbling on evidence, coming out of darkness, information through signs, having to learn a new language.[80]

Meiselas's comments on her early frustrations in Nicaragua are fascinating both as an ethnographic insight into the thoughts of a working photo-journalist and as metaphorizations of her role in visual terms. Her comments posit a hermeneutics of visual interpretation that assumes a hidden meaning that must be searched for. At the same time, the reflective comments, although consistent in focus, are an evolving consciousness of her work, reflecting and reflecting on her practice as a photojournalist.[81]

More fundamentally, she portrays her experience in Nicaragua as a process of discovery and demystification in which she is forced to fundamentally rethink the relation between photographer and subject: "Slowly, I was beginning to understand: the problem with the photograph is that it always assumes that you've arrived, even before you've got there."[82] On the one hand, this is a general problem of visual documentation, of producing a knowledge of the event through the framing of that event. On the other hand, it is a particular problem in the context of an unfolding revolution, so that the ontological and epistemological meditations become political and professional questions, as Meiselas is thrown back on herself to consider the visual economy of which she is a part. The hermeneutics of photographic investigation that she lays bare becomes tied up with ideological inflections in concerns about the relations between North and South within the visual economy of photojournalism, about her status as a witness in relation to the events she images, and about what remains hidden or unreported. Over time, she became aware that foreign correspondents did not cover many events in the country and assumed that only what they covered existed as an "event." This seems to have fed her growing desire to produce imagery outside of "news" frames and to work against the assumption that "you've arrived, even before you've got there."

It was through her early process of "stumbling" that Meiselas came across and photographed the remains of a victim of President Somoza's death squads on the outskirts of Managua (see fig. 2.7). She says her

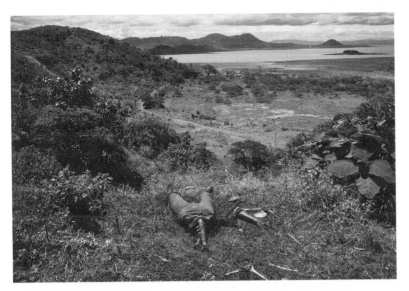

2.7 *Cuesta del Plomo*, Managua, Nicaragua, 1979. (Susan Meiselas, photographer.)

"involvement with Nicaragua really began with this picture. . . . I'd heard about disappearances, but it was only after I had stumbled on it that I knew that it was really taking place. It was the first time I myself saw what I had so often heard whispered, hurriedly, in a bus queue or in a market."[83] Meiselas responds to the scene of death as a site of evidence and produces her image as a form of evidence. The juxtaposition of the horror of the half devoured body and the beauty of the lush landscape is chilling and is very deliberately emphasized by the photographer via careful composition. She frames it as a formal landscape (appropriate to travel or tourist photography, and so connoting a foreign eye and concomitant visual stereotypes), and it takes a moment for the viewer's eye to decode what is being looked at, to make out the bodily remains and realize this has been a violent death. In this way the viewer is drawn into the scene and experiences the shock of the image as a moment of insight, an encounter with reality. And yet, this is an illusion in that this scene is already composed as a spectacle and a form of terror, for as Meiselas notes, "people wanted that body to be seen. This was a known site of execution."[84] The shock element in this representation of a scene of atrocity underlines the power of the image to document a terrifying reality, yet also to reproduce a spectacle of terror and to delimit knowledge of what occurred. This is something that troubled Meiselas over time, and she much later reflects: "For a long time I've lived with the inadequacy of that frame to tell everything I knew

and I think a lot about what is outside of the frame, what is beyond this body."[85] Notably, this image takes on a symbolic import within her critical practice, as a starting point or primal scene of a new stage of engagement with Nicaragua.

At the time of its making, the sheer graphic horror of this image made it controversial, and there was opposition to its publication in the United States. Meiselas later remarked that "the American public could not relate their reality to this image. They simply could not account for what they saw."[86] In other words, what she understood as evidence of the brutality of the Somoza regime was not viewed as evidence in the United States, where conditions of visuality militated against such interpretations. This beginning of her "involvement with Nicaragua" was also the beginning of her disillusionment with how her images were (not) being used in American and other media. For the first six weeks in Nicaragua, none of her images were published—this was in part due to the lack of interest in American and international media in events in a small Central American country where unrest was common and that few outside of the country viewed as on the verge of revolution. That would change with the insurrections in September 1978 after which Meiselas's images were in great demand. The first photograph published in mainstream U.S. media appeared on the front cover of the *New York Times Magazine* on July 30, 1978. It depicts three masked Indians from the town of Monimbo with contact bombs they are preparing for an insurrection. The headline reads: "National Mutiny in Nicaragua."[87] Meiselas recalls: "I was reluctant to take this picture, as I felt they were performing for the camera. I decided to take it because so much of Nicaragua's history remained unknown that I felt I had to respond to their demands to make their history visible."[88] This statement underlines not only her sense of compromise and complicity as she worked to document and publish but also her developing sense of the particular context of a revolution-in-the-making, where oppression and rebellion are complexly coded and the role of the journalist as witness can quickly be compromised. In September 1978 she sent images of battles between the National Guard and young rebels in the city of Matagalpa to *Time* magazine, asking that they not publish those in which rebels were not masked, but they were published by *Time* in its edition of September 11, shocking Meiselas into attempting to warn the subjects and bringing about the later sober reflection that "until that moment I did not understand that a photograph could kill; that one could not assume an implicit right to make pictures."[89]

The image of masked Indians is also significant as an indicator of how Meiselas was responding to her sense of Nicaraguan reality as hidden,

trying to access "another kind of knowing, which is produced by sign-reading and knowing at another level."[90] In doing so she projects an idea of visuality that is not predicated on hermeneutical models of surface/depth, rather it focuses on surfaces—signs and masquerade—and presents these as the visual codes of revolution. This is illustrated in her repeated use of tropes of masking, occlusion, and the carnivalesque, accentuated by her use of color, to lend an expressivity to the insurgent struggle. Many of her images show young guerrillas in casual clothing, including popular American caps, highly colored shirts, and bandanas. Richard Elman, in an article for *Geo* (with photographs by Meiselas) describes the Sandinista "rebels" fighting Guardsmen in Leon: "There must have been 30 or 40 in masks or gaudy kerchiefs with red and black berets or baseball caps or sombreros, with sticks of dynamite slung on their shoulders, lugging homemade bombs, or toting old shotguns, .22s, pistols, a few NATO automatics from Belgium. They stood about in small groups, ran to the corners where sentries were posted and shot upwards at snipers and then ran back again and conferred some more. They had been fighting for two straight days and nights and looked grubby but high and not sure what to do next."[91] Meiselas's photographs in the *Geo* article accentuate this somewhat romantic depiction of the insurrectionists as citizen underdogs, illustrating how soldiers and citizens become one in the everyday totality of the war.

This strain of imagery finds its iconic moment in Meiselas's photograph of a Sandinista guerrilla throwing a gasoline bomb at the walls of the National Guard headquarters in Esteli, on July 16, 1979 (see fig. 2.8). The moment is symbolic for this battle was a decisive episode in the war as Sandinista forces drove out the National Guard and precipitated Somoza's flight from Nicaragua the next day. The dramatic color image, centered on the young guerrilla as he arcs to hurl a Molotov cocktail at the garrison walls, also transcended the moment of its making, becoming an iconic image of guerrilla warfare in Nicaragua and beyond. The iconicity is heightened by the juxtaposition of symbolic elements: the beret, the crucifix, and the Pepsi bottle—all lending it connotations beyond the immediate context of the act. The bereted (and bearded) insurgent recalls a young Che Guevara and the broader iconology of popular revolt in Central America. The swinging crucifix reminds us also of the mix of religion and politics in Latin American cultures, while the flaming bottle links the scene to any number of moments of insurrection—the Pepsi bottle also more specifically signifies an American cultural imperialism, which is associated with the regime it is hurled against. The image speaks to the David versus Goliath framing of insurgency that is common to Meiselas's

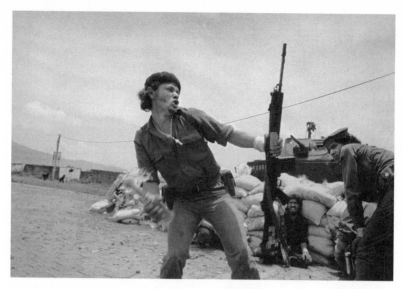

2.8 Sandinistas at the walls of the National Guard headquarters, Nicaragua, 1979. (Susan
Meiselas, photographer.)

depictions of the Sandinistas in much of her work. The iconicity was not
lost on Nicaraguans who adopted and adapted the image in many forms.[92]

In seeking to suspend or circumvent the established conditions of vi-
suality surrounding imagery of Nicaragua, Meiselas is constantly aware of
what is missing or not seen in the image. Projects to reframe the images
become a methodological focus of much of her work, beginning with the
book *Nicaragua: June 1978–July 1979* published in 1981.[93] The book, con-
taining seventy-one of her color images, culled from over five thousand,
is sequenced to form a narrative. The first sequence, titled "The Somoza
Regime," depicts rural poverty and class divisions, the chilling pageantry
of the Somoza regime, the National Guard in training and on patrol, and
signs of insurrection. The second section, titled "Insurrection," begins
with the image of the three masked Indians lifting homemade bombs
that appeared on the cover of the *New York Times Magazine*. It covers the
unsuccessful but wide-scale and violent insurrections in Masaya and Esteli
in September 1978 and provides the vibrantly colored street scenes that
became synonymous with the revolution. It also details the destruction
of the townscapes and the retreat of the rebels to the mountains. The final
section, titled "The Final Offensive," covers June–July 1979, with images
of rebels taking control of several areas, and their arrival in Managua. The
final two, juxtaposed images are of a father collecting the charred remains

of an assassinated son and a man painting a mural on a wall in Managua to honor the Sandinistas. The book ends with historical information, captions for the images, and testimony from participants.

Meiselas conceived the book as "a bridge between cultures," and in large part this explained her construction of a strong narrative at the heart of the book: "It was necessary to create a book that would link otherwise isolated images together to make them understandable to an American audience."[94] The narrative was linear, beginning with imagery of poverty and exploitation, through violent repression and resistance, to revolution. As Robert Stone observed, "Its sequential structure allowed us to experience history in terms of human moral action. It was a *story*, and its ending was everything our traditions lead us to desire: the triumph of the oppressed over the abusers of power, of the worker over the cheat, the patriot over the mercenary."[95] *Nicaragua* presents a visual story an American readership could understand and empathize with, but it was also an attempt "to overcome the sensational quality of fragmentary news reports by placing these events in the context of an evolving political process" and a forum to produce images otherwise not published in the United States.[96] And so, for example, the image of the half-devoured corpse Meiselas found on the outskirts of Managua appears at the center of the first section of the book, now framed within a sequence that underlines the violent repression of the state forces in Nicaragua.

Overall, Meiselas hoped to produce a visual story that would inform Americans about the historicity of the revolution, taking it out of "news" frames that sensationalized or abstracted it. Some reviewers recognized and applauded this aim, but many more focused on the style of Meiselas's work, and the relationship between form and content, either to laud it as a pathbreaking example of a new photojournalism or to damn it as such. Her work in Nicaragua became a lightning rod for debates about the death of photojournalism, the use of color in conflict photography, the lines between documentary and artistic practice, and the role of the photographer as witness. The formal complexity of her work and in particular her use of color divided critics. Andy Grundberg in the *New York Times* commented favorably that *Nicaragua* was "one of the first books of combat photographs to use ambiguity as a rhetorical device," yet also damns Meiselas as "a glorified tourist."[97] Several critics accused her of aestheticizing violence. For John Leonard, "The sickening is made slick . . . the grief has too much style."[98] Max Kozloff, in *Art Forum*, rebutted these critics to argue that "you can no more resolve the pleasure afforded the eye with the sorrow and outrage affecting the mind than you can confirm these images in terms of the better-known photographic genres."[99] For Kozloff, it is

this irresolution, conditioned by Meiselas's use of color, that distinguishes her technique. John Berger also applauds her use of color, arguing that Meiselas "redeems the color film . . . to express the dignity of those who revolt."[100] He adds: "Color photographs of this kind of subject inevitably give way to gore or to the aestheticization of violence. Here instead, we have enormous control, a sense of the everyday and a vitality rooted in an active community."[101]

Meiselas was vulnerable to criticism in part because she was working at the intersection of documentary journalism, art, and activism at a time when that was a particularly volatile area. As Lucy Lippard notes, fellow activists in New York were not impressed with Meiselas's chutzpah: "Precisely because she aspired to be more than a journalist, Meiselas was dragged into debates about art's depictions of war."[102] The most detailed critique of her work in this vein was that of Martha Rosler in a lengthy review of the book, which charges that it "bears evidence of contradictory aims and approaches, whose collision damages the book's ability to inform and to mobilize opinion."[103] While commending Meiselas for avoiding "the increasing nihilism and sensationalism of photojournalism and war," she nonetheless chides the photographer, arguing there are "disturbing qualities in Meiselas' photographic style that, while grounded in historical trends within photography, have an anti-realist effect."[104] In particular, she points to distracting elements of the use of color, isolation of people in the frames, and the detachment of text from image in the design of the book to suggest these undermine the collectivity of the revolution and abstract its political features into metaphor.[105]

To be sure, Meiselas romanticizes her subjects in *Nicaragua* and at the same time produces a narrative that is familiar to Americans. But she also rehistoricizes and complicates a revolutionary event that had been mystified by much mainstream media coverage. She was sensitive to charges of "political tourism." From early in her arrival in Nicaragua in 1978 she became aware that, as an American, she would receive privileged treatment from the Somoza government and the military. This sense of privilege, combined with the sense of complicity discussed above as she sought to illustrate the revolution for an international audience, politicized her as a witness. Whereas David Burnett awkwardly mentions his unease at being "American" in the context of photographing the Iranian revolution, Meiselas works to expose and interrogate her sense of American identity in order to foreground and move beyond the conventional framing of "them and us" in the documentation of foreign conflicts.[106]

Meiselas's reframing of the Nicaraguan revolution did not end with publication of her book. Over the last thirty years, while working on many

other projects, she has initiated several projects to reframe the Nicaraguan imagery in ways that open up the histories hidden in and by the images and explore the relations between photographer, subject, and viewer. In 1984 she revisited the Nicaraguan work in an exhibition titled *Meditations*, installing her original photographs alongside various publications that reproduced them, drawing attention to the effects of different contexts of production and reception. In 1991 she made a documentary film, *Pictures from a Revolution*, in which she tracks down many of the subjects in the Nicaragua photographs, recording their perspectives. In 2004—the twenty-fifth anniversary of the revolution—Meiselas made large digital blowups of several of her images, installing them very publicly at the sites where they were originally made, and filmed the process.[107]

In these ways Meiselas has maintained an extraordinary engagement with questions raised by her work in Nicaragua: questions about the aesthetics and politics of documentary reportage, about the politics of representation and memory, and about the contexts of iconicity. The reframings and repatriations of imagery, the tracing of their shifting uses, meanings, and values over time, and the reconnecting of photographs with their subjects and their subjects with their history—all reflect her interest in the dialectics of "encounter and witness" in documentary practice.

This commitment is indicated by her long sojourns in Central America throughout the 1980s. Reflecting on this period she comments: "I chose to stay through the eighties in Central America and then Latin America rather than move across the globe—like many people who worked alongside me did—because of the nature of those wars and the possibility that one could come to know those particular histories and people."[108] This form of long-term immersion in the cultures and communities being documented is more akin to documentary photography than conflict photojournalism, but it is characteristic of Meiselas's practice, and she tailors it to shape her representation of the temporality and historicity of conflicts. In particular, it sharpens her sense of "the narrative structure of time," as she observes in interview: "Staying in Nicaragua I started to see pictures in the present as they would be perceived in the future as the past. That was an incredibly powerful and important recognition for me. People were making history."[109] From Nicaragua, Meiselas moved to cover the coup in El Salvador and later covered Honduras and the Mexican-U.S. border. As she developed this work she came to believe she was "discovering the reality behind the face of U.S. foreign policy. . . . It gradually became clear to me that as an American, I had a responsibility to know what the US was doing in other countries. Throughout the period of work in Latin America, I looked at American power relations."[110] As time went on, though,

she became more pessimistic about the potential for photography to act as evidence in documenting U.S. power in the region.

An experience in El Salvador was particularly significant. On December 11, 1981, a unit of the Salvadoran army, the Atlacatl Battalion, massacred over eight hundred civilians from the village of El Mozote in the province of Morazan in northeastern El Salvador. The battalion was trained in counterinsurgency methods by U.S. Special Forces military advisers and was leading a military offensive in Morazan, which was a stronghold of rebel forces. The journalists Ray Bonner of the *New York Times* and Alma Guillermoprieto of the *Washington Post*, along with Meiselas, were the first reporters to visit the site of the massacre, on January 6, 1982.[111] They found large numbers of rotting corpses in the rubble of the village and nearby. Meiselas recalls arriving at the scene and observes:

For me, El Mozote is still a kind of bewitching remembrance of the sense that we had come upon something terrible that clearly had happened but we were not sure exactly how, so we began by desperately trying to collect testimony. My pictures showed only fragments, not enough to prove anything, yet they showed something had in fact taken place. At the time of the discovery of El Mozote we had a tremendous sense of its significance. We felt: "This is it. We have evidence!" We didn't doubt that there had indeed been a massacre, although the U.S. and Salvadoran governments denied it had happened. But it never occurred to me that our evidence was not enough to stop US military aid to El Salvador or that my pictures wouldn't hold the weight of what they needed to stand up against.[112]

The pictures were shown in the U.S. Congress and to the Human Rights Commission in Geneva, but it was not until ten years later that a thorough investigation was carried out. The photographs taken by Meiselas were all but ignored in the United States as the Reagan administration and portions of media turned on the messengers, especially Ray Bonner.[113] Meiselas's frustration surrounding the issue of visual evidence once again underlines the issue of the ideological conditions of visuality: "That's the place where I still believed that if people saw this they might actually pay attention. Not so much do something, but at least know something and care."[114] This lament alludes to the relationship between representation and responsibility at the heart of photojournalism as she questions the power of photography to frame injustice and suffering: "The larger sense of an 'image' [of the contras in Nicaragua] has been defined elsewhere—in Washington, in the press, by the powers that be. I can't, we can't, somehow reframe it."[115] This is a despairing indictment of the power of the Washington frame. Yet, this pessimism notwithstanding, reframing became the

methodological focus of much of Meiselas's work, as she has sought to work within and beyond such constrictions to produce challenging representations of the effects of American power in Latin and Central America.

A key element of this approach has been her commitment to collaborative projects.[116] In El Salvador, a significant collective project was initiated by Meiselas and Harry Mattison who, along with Fae Rubenstein and Carolyn Forché, assembled a book titled *El Salvador: The Work of Thirty Photographers*, published in 1983. The book brings together the work of international photographers working in El Salvador from 1979 to 1983.[117] The book was conceived as an attempt to raise public consciousness about the bloody conflict. It was also assembled as an exhibition in 1983 and toured the United States for two years, visiting galleries, libraries, schools, and universities. The frame was educational, accentuating the still live political issues in El Salvador rather than the artistry of the photographers.[118]

The photographs are all black and white. The only color image is the one on the cover, by Meiselas, of white handprints on a bright red door—the signature of Salvadoran death squads, in this instance on the door of a slain peasant organizer in Arcatao (see fig. 2.9). It is significant that this image should have been selected for the cover. It is an image of a visual threat, designed to instill fear in a certain populace and to signify the unhindered violence and authority of such groups within the culture. At the same time, it is an enigmatic image for those unfamiliar with its meaning, drawing us into the book, past the closed doors represented on the cover. This republication of the image asserts Meiselas's authorship—and of many other photographers whose previously published images reappear in this book alongside unpublished work. The result is a fresh assembly of imagery and a defamiliarization of visual assumptions about the conflict. This is a deliberate shift in the framing of the visual documents so that their meaning and value is not defined by the immediacy of the "news moment" but by their positioning within a visual narrative and an ongoing history. As such, the images take on the resonance Richard Cross refers to when he commends an "in-depth photojournalism" that looks at "patterns." Here, depth and patterns are not provided by the consistent vision of one photographer but by the coming together of thirty photographers and the layout of the book and exhibition, transforming news photographs into components of a larger picture that provides detailed documentation—a thick description—of the lives and deaths of Salvadorans.

The political resonance of Meiselas's practice resides in her consistent attention to the image as an errant document that is constantly being recontextualized.[119] This partly explains why her pessimism about the

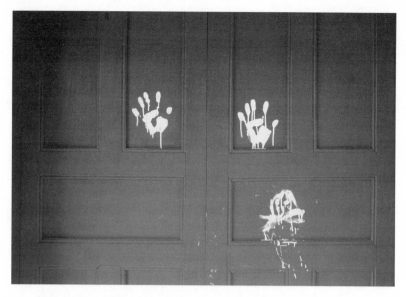

2.9 *Mano Blanca*, signature of the death squads on the door of a slain peasant organizer, Arcatao, El Salvador, 1980. (Susan Meiselas, photographer.)

possibilities of reframing images already defined by "the powers that be" is offset by a continuing optimism that photography provides a vital role in the making and remaking of history. As noted, several of her images became iconic in Nicaragua—particularly *Molotov Man*—while others have been taken up within legalistic or educational contexts as historical documents and forms of evidence.[120] In such ways, the photographs not only provide documentary evidence of the moment but also continue to be significant in shaping how the wars in Nicaragua and El Salvador are remembered.

In covering the revolutions in Iran and Central America in the late 1970s and 1980s, a number of photographers produced fresh visual vocabularies of violence and repression that were commensurate to the contexts they worked in and reflected their desires to push the boundaries of photojournalism. This new photojournalism questioned assumptions about the aesthetics, ethics, and politics of photojournalistic practice. As the work of Peress, Meiselas, and many other new photojournalists strongly attest, conflict photography did not expire in the wake of the Vietnam War. Like many media genres, it went through a period of exhaustion and was re-

newed by the imaginative work of a new generation. They responded to fresh questions around the agency of the photographer, including their role as "witness," and presaged reconsiderations of the relationship between the photographer, subject, and viewer. Their work is instructive in expressing the subjectivity (and authorship) of the photographer, charting the symbolic movement of the photographer from passive witness to moral agent, and rethinking the evidentiary status and usage of the photojournalistic image.

For all these photographers, the role of the United States as a geopolitical entity was ever present, and their "dissident photojournalism" was yet an engaged, critical commentary both on the workings of American global power and its effects—particularly on indigenous cultures—and on the need to challenge the Cold War framings in mainstream media coverage of political revolution in distant realms. As the Cold War came to an end—or endings—at the close of the 1980s and into the 1990s, photojournalism would have to reinvent itself yet again.

Unseen Wars and Humanitarian Visions: Somalia, the Gulf, the Balkans

As the dominant geopolitical paradigm of the Cold War fractured, so did the narratives and imagery of international media, to be replaced by fragmented and confusing representations that depicted a chaotic globalization. This confusion signified new conditions of conflict reporting that were significantly shaped by the geopolitics of liberal capitalist expansionism, the new forms of conflict and warfare that emerged in the wake of the Cold War, and the expansion of the mediasphere due to satellite and new communications technologies. What came to be termed the "new wars" or "ethnic wars" of the 1990s dramatized the politics of humanitarian (non)intervention and also the emergence of "virtual war" in which revolutions in both military and media technologies came together to define contemporary conflict. While this volatile landscape of globalization portended fresh energies and opportunities for media representation and influence in covering international conflict, it also gave rise to intensified forms of news management and manipulation. In this context, photojournalism once again struggled for relevance, perhaps most notably with coverage of the Gulf War in 1991, but it also adapted to new geopolitical landscapes and new forms of U.S. power and policy. Photographers began to revise and refine their roles as witnesses

under the new conditions of conflict and warfare. This chapter considers the work of selected photographers documenting the practices and effects of U.S. foreign policy in post–Cold War contexts—the Gulf War, the intervention in Somalia, and the Balkans wars—paying particular attention to ways in which it illuminates paradoxes of military humanitarianism.

With the ending of the Cold War, widely portrayed as a victory of and for liberal capitalist democracy and symbolic of the "end of history," media coverage of international conflict reflected the uncertain perception of an emerging "New World Order" among Western elites. It soon became clear that this new order would be designed and led by the United States in the guise of a "Washington consensus" that would advance neoliberal globalization by promoting core standards of free-market liberalization, increasing trade and freeing the flow of U.S. goods, service, and capital. Foreign and economic policies in the United States would strategically combine to wed the objective of market and trade liberalization to the renewal of political warfare against those "countries of concern" that supposedly presented a political or military threat to U.S. security. With the ideology and geopolitical strategies of "containment" now rendered obsolete, the United States would assert a new foreign policy mission: "the promotion and consolidation of democracy."[1] This was a reassertion of American exceptionalism in which the United States would promote both humanitarian values and liberal security. The strategic interests of the United States were now being redefined in ideological terms that sought to recalibrate the balance of values and interests and to determine the key grounds for intervention.

The rhetorics of democratic enlargement, globalization, and humanitarian intervention belied the uncertainties of global governance. As the United States struggled to assert its powers and leadership and align its strategic commitments with a more "open" global landscape of conflicting powers, it faced multiple tests of its willingness to be the world's policeman.[2] These rhetorics also reflected the tenuous belief in the new sense of mission asserted by political leaders. A key feature of the wars and conflicts involving the United States in the 1990s was the lack of any credible external threat and a concomitant lack of political purpose or strategic vision in shaping military interventions. This reflected the deeper ideological vacuum following the end of the Cold War as there was no grand metanarrative to justify or explain the projection of power. As many commentators have noted, the Gulf War was a spectacular demonstration of power absent a moral or ideological frame for using it—what Jean Baudrillard described as "the absence of politics pursued by other means."[3] An underlying theme of so much media coverage of the Gulf War and of

the Balkan Wars was the uncertainty about the United States' role in the post–Cold War world. Those waging war as humanitarian intervention were also involved in an effort to give a chaotic global picture some form and meaning.[4]

After the collapse of grand narratives, war is fought for "humanity," and heightened talk of "values" and "ethics" in foreign policy was a feature of international affairs in the 1990s. One of the most significant geopolitical features of the endings of the Cold War was the promotion of moral conventions in global governance, as the shift from national sovereignty to the rights of individuals was accompanied by the explosive growth of international nongovernmental organizations and drove the transnationalization of human rights claims and of the representations of these claims. Throughout the 1990s, the imperatives of humanitarianism became complexly entwined with issues of foreign policy and global governance. One result was that successive U.S. administrations came under pressure—galvanized by domestic media, which used an increasingly moralistic discourse about international affairs—to "intervene" in a range of conflicts, not on grounds of direct threat or territorial gain but on grounds of principles and values. For the Clinton administration, this would become especially challenging as it struggled to justify and promote interventions in Somalia, Haiti, and the Balkans while lacking a compelling schema that supported intervention.[5] The paradoxes of "humanitarian military intervention" are evident across these conflicts and their representations.

The two "wars" examined in this chapter—the Gulf War of 1991 and the Balkan Wars of 1992–95 and 1999—were both subject to intensive news management and spectacularization, though in different ways and with different results. Each were "unseen" wars in that the activity and results of violent conflict either were literally kept from the view of the media or were recorded but had little or no impact on American and Western publics. The Gulf War was a media-saturated military operation that, in its spectacular impact and brevity, epitomized strategic thinking among military elites about virtual warfare. For the attendant media, it was a daunting demonstration of how they could be manipulated and sidelined even as they were afforded front row seats. The various conflicts in the Balkans in the 1990s were also indicative of the new forms of warfare and mediatization. In this instance, though, the issue of representation was not about access but about legitimizing the imagery that was produced and making it meaningful to various publics.

That the wars were "unseen" is not solely an issue of news management but also due to the emergence of "virtual war," in which war is prosecuted

at a distance via advanced weaponized technologies and with the political imperative of minimizing casualties.[6] As this new form of warfare was attached to humanitarian rhetorics the result, as Michael Ignatieff remarks, is a military violence that "moralizes itself as justice and which is unrestrained by consequences."[7] A paradox of this form of warfare, Ignatieff further notes, is that "technological omnipotence is vested in the hands of risk-averse political cultures."[8] As we shall see, this is a paradox that colors the conflicts of the post–Cold War period and the media reporting on them.

The role of media influence on public comprehension of these conflicts and more particularly on the grounds for intervention has received a good deal of attention, especially in terms of what came to be called the CNN effect.[9] Less attention has been paid to the impact of visual imagery specifically on foreign policy decision making. As we shall see, there is some evidence that visual images played a role in shaping U.S. policy but what becomes more clearly evident across this period is that the intensification of media coverage and manipulations of this, both by actors and by military, government, nongovernmental organizations, and media, put a new pressure on image-based media to provide visual evidence of conflicts and abuses. In this new era of human rights, based on the emergence of transnational "crimes against humanity," visual representation is crucial to evidencing and witnessing of abuses and so to "mobilizing shame."[10] Throughout the 1990s, the idea of the photographer as witness took on fresh significance: as human rights issues came to the fore in global conflicts, the role of visual evidence took on a heightened significance and the nongovernmental organizations promoted this. Photojournalists refigured their conventions in relation to these contexts and now began to work more directly and self-consciously within human rights frameworks, in many instances commissioned by the nongovernmental organizations.

Somalia

Throughout the 1990s a number of events threw up questions about the relationship between visual imagery and foreign policy making. A notable instance is the intervention in Somalia, which began as Operation Restore Hope in December 1992 and ended shortly after the disastrous battle for Mogadishu in October 1993. The role of imagery in relation to policy has drawn some attention as it was mentioned by many political leaders at the time and since. It has been argued that the media influenced both the intervention and the exit of American troops: "Media images of starv-

ing Somalis got the world into Somalia and media images of a dead U.S. soldier being dragged through Mogadishu streets got the world out of Somalia."[11] Certainly there is evidence that policymakers believed imagery of starving Somalis was building public pressure to support intervention, to "do something."[12] In late 1992, American media published images of starving African children to illustrate the need for intervention, and President Bush referenced the imagery in framing the intervention: "Every American has seen the shocking images from Somalia."[13] The media endorsed this framing, calling the intervention an altruistic "mission of mercy." In December, both *Time* and *Newsweek* ran cover stories on Somalia and presented many pictures of starvation victims.[14] Following the deaths of eighteen marines in Mogadishu on October 3–4, 1993, images of U.S. casualties were widely published. They included video images and frame-grab still images (i.e., still images taken from a video) of the army pilot Michael Durant, injured and dazed, filmed by his captors. Most controversial were the images of the body of an American soldier being pulled by rope through streets of Mogadishu by a group of Somalis. The covers of *Time*, *Newsweek*, and *US News and World Report* all featured the battered image of Durant, while inside they showed the photograph of the soldier being pulled through the streets. *Time* (October 18, 1993) summed up the mission in the juxtaposition of imagery: "The mission to Somalia, which began with visions of charity, now puts forth images of horror."[15]

The impact of these images on policy was and is difficult to determine. Many believe that powerful images soured public opinion about the mission in Somalia and that the U.S. pullout from Mogadishu was a result of these photographs. Media and political elites broadly concurred on this. The *New York Times*: "The pictures of a dead American soldier being dragged through the streets of Mogadishu seem to have made it all but impossible for Mr. Clinton to change many minds."[16] Joseph Nye (who served in the Clinton administration) produced a similarly neat summary: "The American public's impulse to help starving Somalis . . . vanished in the face of televised pictures of dead U.S. soldiers being dragged through the streets of Mogadishu."[17] But the summary is too neat. As for the intervention, it is evident that policy formulation ignited the visual coverage. As for the exit, the evidence is less clear. To be sure, the initial reaction of Americans polled was that the United States should exit, but more careful examination of polling shows this was not sustained and there is a blurring of opinions, with many ready to stay or/and seek retribution.[18] This also reveals the volatility of the period as the Clinton administration vacillated in both framing events and articulating a commensurate response.[19]

The juxtaposition of imagery by *Time* and Nye shows up something of the banality of this line of argument for visual determinism for all it really does is compress the relationship between policy and icon and assume a causality based in large part on the "horror" excited by the imagery. With the Somalia intervention, the complex realities of both the intervention and exit get reduced to iconic moments and much is forgotten, including the media's general lack of interest in Somalia between intervention and exit and its negligence in understanding and explaining how the mission had drifted into a counterinsurgency mission well before events exploded on October 3, 1993. Such omissions are also telling as they remind us of the myopia of media in acknowledging its own role in shaping events. Among the many factors "forgotten" about this intervention are that Operation Restore Hope was a media-saturated military intervention and that when the initial troops landed on the beach they were met by teams of journalists and photographers, as planned by the Pentagon.[20]

Amid such spectacle the images of "desecration" of the American soldier dragged through the streets of Mogadishu are worth looking at more closely to consider the contexts of their making and framings and also the ways in which they illuminate the paradoxes of "military humanitarianism." The Canadian photographer Paul Watson, working at the time for the *Toronto Star*, took the now iconic image of Staff Sergeant William Cleveland being dragged through streets of Mogadishu (fig. 3.1). Watson comments on the making of this image in his book *Where War Lives*, providing valuable context for understanding its initial production and what lies beyond the frame. He tells a harrowing story of the escalating violence in Mogadishu as UN forces attempt to locate warlord Mohamed Farrah Aidid and massacres mount up. In particular, he notes and records instances in which UN/U.S. forces have killed Somalis with impunity and chafes as the external world shows little interest in these deaths. He also vividly describes the pressures on international media to leave an increasingly dangerous environment. He records how a Somali mob murdered four journalists in the aftermath of a massacre in which American Cobra helicopters destroyed a villa killing more than seventy Somalis in a failed attempt to kill Aidid and notes the awful irony of the mob turning on and killing the journalists "who were the only hope that an accurate account of the massacre would reach the outside world."[21] By late September, both "AP [Associated Press] and Reuters, the world's two leading wire services, had shut down operations in Somalia."[22] Due to such events, Watson began to see "helicopters as most Somalis did" and found himself "despising" Americans "who killed from the sky."[23] He was also frustrated by the lies and spin that the military created around American casualties. A

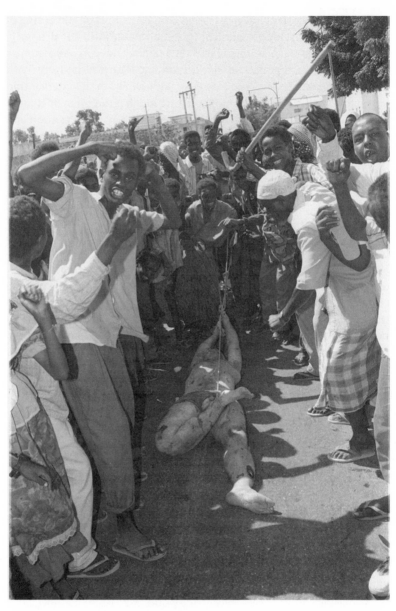

3.1 Staff Sergeant William Cleveland is dragged through the streets of Mogadishu, Somalia, 1993. (Photograph by Paul Watson/GetStock.com.)

month before he photographed Cleveland, he heard that the body parts of an American soldier were being paraded on the streets of the city and he reported this to Reuters and to CNN. The Pentagon denied the story and Watson reflects that, "without pictures, there was no proof, and little impact in the United States"; he vowed to provide the visual evidence should such an event occur again.[24]

Watson describes how he tracked a mob of over two hundred Somalis with his helpers and negotiated "permission from the mob leaders" to take photographs. As "the crowd parted, forming a manic horseshoe around the corpse," he struggles to concentrate: "I tried to focus on reality one step removed—the image in the frame—struggling to make sure that in the seconds that I had, I got proof that the military couldn't deny."[25] He relates how he had to return to the mob to seek more photographs as he realized that part of the victim's genitals would be visible in the first images and so they would likely not be published. The photographs were transmitted by Associated Press. The image of Cleveland that was most widely reproduced posed a problem for many editors who, wary of reader criticism, deliberated on whether or not to publish and how to frame it. A survey of thirty-four major daily newspapers in the United States found that eleven used the photograph on the front page (including the *New York Times* and *USA Today*), while fifteen used it inside and eight did not use it.[26] Many papers received large numbers of complaints from readers, and there were debates on the merits of publication. *Time* magazine ran the full-body image in color but digitally altered the underwear to conceal the genitalia (another decision that proved controversial).[27]

The image was quickly endowed with iconic status. Writing for the *Arizona Republic*, which published the photograph, columnist Steve Wilson remarked: "The photo said more about the failure of U.S. policy in Somalia than all the news stories written in the past six months."[28] But what did it say? Marvin Kalb argued that the picture is "not just an American body being dragged through the streets of Mogadishu, [but] a symbol of American power being dragged through the Third World, unable to master the new challenges of the post–Cold War era."[29] Such references to the image compounded its iconization both as exemplary of the failure of humanitarian intervention and as an example of visual determinism in U.S. foreign policy. However, there is limited evidence that it drove policy and was the singular catalyst for troop withdrawal. As David Perlmutter concludes, "The pictures undoubtedly were symptoms of international politics and prejudices, not their cause."[30] Nonetheless the *perception* that the pictures were a powerful lever was widely expressed and is an enduring one, becoming a key element in political memory of the event. The

body being dragged through a street has since been commonly referred to as a metonym for foreign policy failure and humiliation.[31] In 1996, Osama Bin Laden referred to the withdrawal from Somalia as evidence that the United States could not bear casualties, stating that when "one American pilot was dragged in the streets of Mogadishu you left. . . . The extent of your impotence and weaknesses became very clear."[32]

This is how it has been used and referenced over the years since it was first published, as a spectral image connoting the haunting memory of a traumatic incident. Notably, Watson also refers to the image in these terms as he writes about the effects of taking the photograph. He describes the moment he first saw the body of Cleveland: "In less than the time it took to breathe, I had to decide whether to take the picture. The moment of choice, in the swirl of dust and sweat, hatred and fear, is still trapped in my mind, denying me peace: just as I was about to press the shutter on my camera, the world went quiet, everything around me melted into a slow-motion blur, and I heard the voice: If you do this, I will own you forever."[33] Watson recalls the moment of taking the photograph as a primal scene of recognition in which he is forced to question his own humanity in taking an image of desecration. This becomes a framing narrative for his memoir as he tells us he is haunted by Cleveland and that his professional life thereafter becomes a search for redemption. The framing illuminates emotional and ideological connotations of his act in taking the image and coming to terms with the consequences of this. The moment of recognition also functions as an epiphany for Watson that returns him to his "American" identity: "I had no idea who the corpse was, and after weeks of looking at dead and maimed Somali women and children, I despised men like him who killed from the sky. Until now. Here we were on the same ground, in the blowing dirt and sour stench of fetid trash, on this nameless Somali side street where neither of us belonged, and for the first time, it felt like it was us against them. And there was nothing I could do to help him."[34] Watson references this distillation of recognition as an epiphany that accentuates the humanity of the moment as he gazes at Cleveland—the body stripped bare is no longer an American soldier— but also (re)asserts the radical difference that underlies this: "us against them." This iteration of a degenerated human nature is visually composed via a (neo)colonial gaze that inserts its primacy in place of the more cosmopolitan vision Watson had espoused in his text.

This shocking intimation of radical difference obliquely references both the moral economy of such image making and a paradox of liberal intervention. The dichotomy of "us" and "them" refers us to the core and

abiding though troubled structures of perception and emotion in conflict photography and, more broadly, the idealism of viewing photography as the neutral medium of a universal morality. The us-and-them dichotomy also dramatizes the essence of the doctrine of liberal humanitarianism, which promotes "right to life" as the sine qua non of human security yet uses extremes of violence to promote this. In this image, the universality of liberal humanitarianism encounters its limit and registers the paradox that Ignatieff noted, that "technological omnipotence is vested in the hands of risk-averse political cultures." Just as starkly, the image poses a question that haunts the enactment of military humanitarianism: who counts as human?[35] The question is both moral and political, referring us to the ideological conditions of visualization. That these conditions could quickly shift is indicated in a comment by U.S. Senator Phil Gramm: "The people who are dragging around bodies of Americans don't look very hungry to the people of Texas."[36]

The Gulf War

In preparation for the war in the Gulf, the U.S. government devised a press pooling system based on that introduced by the British military in the Falklands War. The system, designed by the Department of Defense, planned the mediation of the war as a component of its war strategy, effectively editing and "precensoring" it. The pool system ensured hundreds of reporters relied on the work of a small group, while support was withheld from those who chose to work outside the system. Over a thousand journalists were accredited to cover the war, but fewer than two hundred were selected to take places in media reporting teams in the field, where they were accompanied by escorts, usually public affairs officers. Department of Defense rules signed by all journalists prohibited reporting that would endanger troops, and all stories and pictures were subject to "security review" (military censorship).[37] It would be a virtual war, subject to a controlled information environment in which the military fed the media large quantities of information and photo opportunities. While many journalists chafed at the restrictions and in particular their complete removal from scenes of combat action, the diet of imagery and information provided by the military sated the larger media organizations, particularly those who would cover the war live by satellite television feeds, and especially CNN, which created an aura of "live" coverage (that served to promote the transparency of the American campaign). However, despite

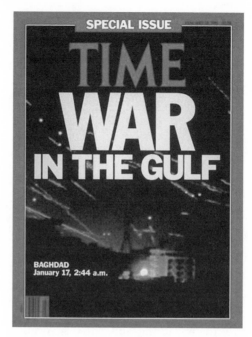

3.2 "War in the Gulf," cover, *Time*, January 28, 1991

the claims of "real-time" and spontaneous coverage, images obscured as much as they revealed, as the saturation coverage obfuscated the death and suffering (see fig. 3.2).

Despite frustrations, most of the mainstream media organizations willingly complied with the pool system and became an active element of the U.S. war effort, promoting American force and hegemony. They produced a very homogenous coverage, from early demonization of the enemy and celebration of high-tech weaponry to the disregard for civilian casualties and the Iraqi war dead. Even those who were in the advance reporting teams found they were being fed spectacular ready-made imagery of the war. The *New York Times*' Malcolm Browne describes his experience:

In the comfort of the commander's office, we look at videotapes of the bombing, recorded automatically when the pilots aimed laser designators at targets to guide their 2,000-pound bombs.

In ghostly, slow-moving, black-and-white video images, we see a cross-hair aiming device centered on a large building the unit commander tells us is a telecommunications center in Baghdad. After a few seconds, white jets spurt from the building, and it disappears in a silent puff of video pyrotechnic. . . . A half-dozen more videotaped

attacks tell the same story. This, manifestly, is the first war in history in which bombing is conducted with almost unerring accuracy.

The pilots are jubilant, the tape confirms all their claims, and it only remains for us news people to report what we have seen and heard, including the results of our close-up examination of the F-117A itself—an aircraft about which little was known until a few months ago. Ours is a positive story, likely to be as reassuring to American readers and viewers as it is informative: the first shots of the war have been "surgically" precise, destroying enemy nerve centers without causing widespread destruction or loss of life.[38]

Browne's commentary expresses both media fascination and frustration with this imagery they were fed by the military. It also articulates concern about the attenuated role of the journalist as witness, now more uncomfortably positioned and compromised as a spectator. Browne's comments signify a growing concern about the role of journalists in this new form of warfare; he ends his piece with an affirmation but with little conviction: "Americans still need to know what is happening, and it is still the task of the press to maintain the flow of information."[39]

Computer-guided missiles filmed remotely, some with video cameras in their nose cones, exemplified the hi-tech iconography of this virtual war—the iconic "action" images were those of "smart bombs" precisely hitting their targets. The relative lack of combat imagery is one of the most striking features of the war. Extensive media coverage of the buildup to war overshadowed coverage of the short-lived conflict itself, and remarkably little of the coverage was from the war zone—and very little of that was of combat-related military activity. As Elihu Katz has noted, "The fact is we didn't see a war at all. . . . We saw portraits of the technology—advertisements for smart planes, tanks, missiles, and other equipment in dress rehearsals of what they are supposed to do in combat, but we rarely, if ever, saw them in action. Indeed it was as if there was no other side."[40] In a study of pictorial coverage of the Gulf War in *Time, Newsweek,* and *US News and World Report,* Michael Griffin and J. S. Lee found that, "in all, only 3 percent of the published pictures showed events occurring in actual combat zones. . . . Only 27 of 1,104 pictures in the US news magazines (about 2%) showed any signs of wounded or killed soldiers. . . . The total number of images of hurt or killed civilians from all sectors of the conflict—Iraq, Kuwait, Saudi Arabia and Israel—was 19, less than 2 percent of published pictures."[41] Photographs were characterized by a narrow range of recurrent motifs and scenarios and the great majority of images fall into a restricted repertoire focused on military hardware and unengaged troops.

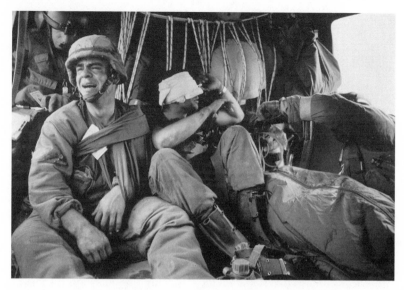

3.3 Sergeant Ken Kozakiewicz grieves, Iraq, 1991. (David Turnley, photographer.)

Perhaps because of the paucity of action images, the most celebrated image of the war was atypically a very conventional combat picture, one that owed a good deal to precedents in Vietnam. The picture (fig. 3.3) was taken by the American photographer David Turnley, who was working for the *Detroit Free Press* and *US News and World Report*. Initially assigned to a pool attached to the Eighty-Second Airborne, Turnley was frustrated by the presence of "a public affairs officer whose job was to make sure we stuck to Pentagon restrictions. This meant we would not be allowed to photograph casualties of war and certainly not war dead."[42] Turnley joined a MASH (mobile army surgical hospital) unit that did not have a public affairs officer attached. On the last day of the war, he traveled on an evacuation mission in a MASH helicopter that had responded to a fire-fight between the Iraqi Republican Guard and the Twenty-Fourth Mechanized Infantry Division in the Euphrates Valley. They landed close to a Bradley Fighting Vehicle that had been hit accidentally by U.S. forces and split in two. The impact killed the driver and wounded his colleagues. The wounded were taken onto the helicopter, and the corpse of the driver in a body bag was placed beside them. Turnley's photograph shows the scene at the point that the wounded Sergeant Ken Kozakiewicz learns the corpse is that of his close friend Private Andy Alaniz. Turnley later submitted his picture for approval for publication, and the next day, back in Dhahran, he discovered this had been denied as the pictures were deemed "sensi-

tive." He persuaded the officials to release the film, and his pictures were widely published. The picture of Kozakiewicz crying appeared on newspaper and magazine covers around the world; it also won the 1991 World Press Photo Picture of the Year award.

One of the reasons this photograph was seized upon and celebrated is that in the midst of a depersonalized war this was one of the few images that focused on the emotions of individual soldiers in combat. In Turnley's view: "Images reminding people there is killing in a war, and terrible human suffering, were suppressed. That explains the impact of my picture."[43] Kozakiewicz's father makes a similar point: ". . . this is war. Where is the blood and reality of what is happening over there? Finally we have a picture of what really happens in war."[44] The idea that this image depicted "what really happens in war" was the strongest current in its promotion and reception in the United States. President Bush later said that the picture "underscored the sobering reality of war."[45] It is a view expressed by Turnley himself: "It is an unbelievably intimate photo. It reveals the vulnerability of otherwise strong men. It is not necessarily a photograph about American soldiers—it's about war and the young men who go to war. There is a certain nobility and dignity on the faces of these soldiers. I think that Ken Kozakiewicz touches chords that are deeply emotional in terms of his grief and his heroism. There is a certain everyman quality that becomes a very strong icon for the reality of war, which is always a tragic reality."[46] Turnley emphasizes common components of an iconic image, trafficking between the particular and universal. In this instance, the iconicity arises in part from its atypicality in the picturing of this war yet depends on the typicality of this image within the America consciousness of what war looks like (when fought by Americans).[47] It is a narrow, ideological view of the reality of war, restricted to the grief of an American soldier; it not only glosses the conservatism of the picture as a conventional image of American men at war, it also elides the question of suffering as experienced by Iraqis and other victims of "friendly" and not-so-friendly fire. In other words, this atypical image becoming iconic indicates the lack of meaningful framing in this war and the widespread sense that it lacked "reality." And so, this image of death and grief can help validate the military engagement and restore some of the values associated with war that are absent in the dominant media coverage.[48] Turnley states that he "wanted to remind people that it doesn't matter what side you are on, there is a huge sacrifice," but sacrifice is a value that has been demoted in the promotion of virtual war.[49]

The atypicality of Turnley's image was in part due to the fact he skirted the standard operations of the pool system, finding a unit that happened

not to have a public affairs minder. Other photographers more deliber-
ately sought to avoid the pool system, believing it would mean the pos-
sibility of better access to war action and certainly less management by
the U.S. military. The most organized and sustained effort by a group of
photographers to operate outside the pool system was that of the Sygma
Photo News agency, which made extensive plans to do so as the war be-
came imminent. British photographer Derek Hudson set up his own pro-
cessing lab, and with a Hasselblad transmitter he sent all Sygma pictures
direct to his London office—no Sygma pictures passed through military
hands.[50] The agency signed a contract with *Life* magazine and later pro-
duced a book of images taken by Sygma photographers, *In the Eye of Desert
Storm: Photographs of the Gulf War*, which stands in stark contrast to the
many photo books that were assembled after the war by news agencies
and others, almost all celebrating an American victory.[51]

The Sygma photographers covered many aspects of the prepara-
tions for war and its action. They took a broad geopolitical perspective,
which included picturing young Saudis enlisting to fight, refugees on
the Jordanian-Iraqi border, and Palestinians demonstrating support for
Saddam Hussein in Jordan. They produced the fullest visual record of the
ground war by independent media. On January 31 they photographed a
battle in Khafji, on the Kuwait–Saudi Arabian border, as Patrick Durand re-
calls: "Although Khafji had been evacuated and was off-limits to the press,
I passed the last checkpoint with a French TV crew—all of us dressed in
U.S. Army uniforms, our cars draped with camouflage netting."[52] Coming
under fire, they photographed Saudi and Qatari tanks that were burning
and the attack by Qatari military on a water tower where Iraqi soldiers
were hiding. They also produced some of the earliest imagery of dead and
surrendering Iraqi troops (some of the surrendering soldiers are shown
holding flyers dropped by allied planes that explain how to surrender) and
accompanied U.S. Special Forces into Kuwait City. They were also among
the handful of photographers who documented the carnage of what came
to be known as the "Highway of Death" (see below) and they took surrep-
titious images. Derek Hudson photographed American Marines throwing
Meals Ready-to-Eat to a crowd of over four thousand Iraqi prisoners of war
(fig. 3.4). Although the Geneva Conventions prohibit photographing pris-
oners of war, Hudson took a few shots as he stood beside General Walter
Boomer: "I stood next to him as he watched prisoners lunging wildly for
the plastic food packets, then I slipped my autofocus camera by my side
and snapped away. It was a terrible way to record such a moment of his-
tory but better than not at all."[53] The book ends with imagery of the envi-
ronmental devastation caused by the destruction of oil wells by retreating

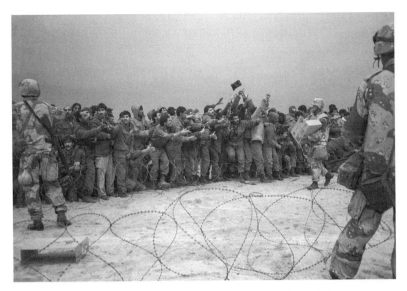

3.4 Marines throwing Meals Ready-to-Eat to Iraqi POWs, Iraq, 1991. (Derek Hudson, photographer.)

Iraqis and of Kurds refused entry at the Turkish border as they flee Iraqi forces.

The dedicated mission of the Sygma agency to provide a comprehensive visual coverage of the Gulf War was an exceptional project, not least because it provided some of the very rare imagery of combat and death. The *New York Times*' Patrick Sloyan observed: "More than 150 reporters who participated in the Pentagon pool system failed to produce a single eyewitness account of the clash between 300,000 allied troops and an estimated 300,000 Iraqi troops. There was not one photograph, not a strip of film by pool members of a dead body—American or Iraqi."[54] There were several reasons for the absence of dead bodies. The press pool system was a primary one as it curtailed access and instilled censorship, but there were also obstacles for unilateral journalists, including the dangers and limitations of access to theaters of action, and the refusal of wire services and newspaper editors to use certain images. Bodies also "disappeared" due to the means of death—fuel-air bombs and other explosive devices left little human remains—and the dead were also rendered invisible by the macabre military act of burying them in great numbers.[55] This hiding of death also extended to the domestic realm as the media were barred from Dover Air Force Base where dead American soldiers were flown. The ideological conditions of visuality were shaped to erase or minimize bodily

violence and "collateral damage"; there was no "body count" in this war as the dead were literally discounted.

Most of the more graphic images of death and destruction were produced by independent journalists who eschewed the pool system. In particular, the imagery of the "Highway of Death," the aftermath of the bombing and strafing of a large convoy of retreating Iraqis on the highway leading from Kuwait to Basra by allied aircraft during February 25–26. Sygma photographers produced a series of photographs of the scene, some of them showing charred corpses of Iraqi soldiers. A pointed picture by Jacques Langevin foregrounds the looted consumer goods piled on a truck surrounded by the abandoned and destroyed vehicles. Peter Turnley, David Turnley's twin brother, refused to participate in the pool system and also photographed the Basra highway: "When I arrived at the scene of this incredible carnage, strewn all over on this mile stretch were cars and trucks with wheels still turning, radios still playing, and there were bodies scattered along the road."[56] He photographed a military "graves detail" burying bodies in large pits, and Iraqi prisoners "being forced to pick up Iraqi corpses and put them in a pile."[57] One photograph in this series is particularly chilling in its visual connotations as it shows a bulldozer burying dead Iraqi soldiers, recalling Holocaust imagery.[58] Further north on another road he found a similar scene, with many carbonized bodies; in some images the bodies are almost indistinguishable from charred pieces of metal alongside them. Turnley photographed headless and gruesomely maimed corpses, often with U.S. soldiers standing nearby, some taking photographs. In one image, a U.S. soldier rests his foot on the head of one of the charred corpses. Turnley did not publish most of these images until early in 2002 when he produced an online gallery, stating that the lack of publication "has always troubled me" and that he was prompted to do so as the United States prepared for a second war in the region: "so viewers as citizens can be offered a better opportunity to consider the whole picture and consequences of that war and any war."[59]

The most famous of the graphic images of the "Highway of Death" was taken by Kenneth Jarecke, depicting an incinerated Iraqi soldier posed in the burned-out windscreen frame of his truck (fig. 3.5). On assignment for *Time*, Jarecke spent three weeks on patrol and combat duty with the U.S. Army's Eighteenth Artillery Division. For the first two weeks, he notes, "we did little besides sit in a strip of contested land at the Saudi-Iraq border," and even when the corps and pool then moved forty kilometers into Iraq as the ground war began, they saw little action. It was not until after the ceasefire that he took the picture, which he sent to *Time* and to Associated Press (AP) for distribution. *Time* declined to publish—the managing

3.5 Incinerated Iraqi soldier, Nasiriyah, Iraq, 1991. (Kenneth Jarecke, photographer.)

editor described it as "the stuff of nightmares"—and AP editors refused to even make it available to clients.[60] Jarecke laments: "The film was processed and when the image got to the AP office in New York, they all made copies for themselves to show people but then they pulled it off the wire. They deemed it was too sensitive, too graphic for the editors of the newspapers that are part of the co-op—too graphic even for the editors to see, not even to let them make the decision of what the market they served could see. So, basically, it was unseen in the US."[61] It was not published in the United States until six months later, when it appeared in *American Photo* along with comments by Jarecke. In the United Kingdom the *Observer* newspaper published it on the front page of its March 3 edition, with the caption "The real face of war." This publication of the image provoked controversy and was criticized by other UK papers, prompting Harold Evans to write an eloquent defense in the *Observer*: "No action can be moral if we close our eyes to its consequences. Here, in charred flesh and grinning skull, was the price of patriotism."[62] The disputed photograph, Evans further argued, did something to redress "the elusive euphoria of a high-tech war."[63] As John Taylor has observed, the debate on the photograph in the United Kingdom "struck a note of ambivalence, and allowed into the British press a discussion of what had been done in the name of Western values."[64]

It did not do so in the United States though, where those newspapers and magazines that had illustrated the events on the Basra highway mostly

showed images of wrecked trucks and other vehicles. It slowly gained attention as the "euphoria of a high-tech war" waned and doubts and questions began to emerge about the Gulf War campaign and the uncertain aftermath. There was belated recognition as the photograph appeared in *Time*'s year-end issue, and in January 1992 it was awarded the Leica Medal of Excellence.

Retrospectively, this photograph became an iconic image of the Gulf War, and like so many iconic images, its iconicity is commonly rendered in universal terms. Jarecke lends to this interpretation in his own comment on the image: "I think the reason it stands out is that you can imagine the driver alive. I believe I have captured his humanity. He is fighting to get out of his burning vehicle, and anyone looking at the photograph can understand how powerful the desire to live is."[65] The ironies and conflicting valences of what constitutes "humanity" in looking at this image are generally elided in its remediations. The buildup to the second war in the Gulf was a stimulus for some fresh publications and questions about the conflict and the media's role. The *Guardian* newspaper in the United Kingdom published a special section titled "The Unseen Gulf War" and included several of Turnley's and Jarecke's photographs.[66] This use of graphic imagery long after the event to warn against the horrors of war is not new in Western media, and often attends liberal or leftist moralizing about war. In such instances, the afterimagery of war and conflict takes on a posthumous shock value.[67] The shock value of this image is hard to deflect or defuse, however, and it is still not commonly featured in American narratives of the Gulf War. It retains a particular charge in relation to the conflict it emerged from, depicting the horror that lay behind the simulations of virtual war. As such, it is a haunting example of "postreportage," disrupting dominant narratives of the conduct of the Gulf War and questioning the celebrated sense of "catharsis" that American leaders claimed the conflict symbolized in relation to the Vietnam syndrome.[68]

The uncertain ending of the war was also visually illustrated by media coverage of the fate of Kurdish refugees in northern Iraq. Having been encouraged by statements of American leaders to rise up against Saddam Hussein, they were exposed to his violent retribution at the end of the war. Extensive media coverage of the "Kurdish crisis" encouraged intervention and helped stimulate the political move to create "safe havens" and "no-fly zones" to lend protection to Kurds in northern Iraq. This action has been viewed as the beginnings of humanitarian intervention as a strategic tool and the media coverage celebrated as a significant example of how the media could advocate for "the globally vulnerable."[69] To be sure, visual imagery of the fleeing and dying Kurds was widely produced

and discussed for a short time as photographers accompanied human rights groups and aid missions to document starving and dying Kurdish refugees in the mountains at the Iraq-Turkey border.[70] Media and public interest were not sustained, however, and the "Kurdish crisis" faded from Western mass media. It also faded as a significant story for most photojournalists, though a few maintained a focus on the Kurd's experiences in efforts to document evidence of abuses.[71]

For many photojournalists, the Gulf War was a major nail in the coffin of documentary photography. Fred Ritchin, photo editor at the *New York Times* during the war, wrote an article titled "The End of Photography as We Have Known It," in which he observed: "Never has 'spin control' and 'photo opportunity' been so easily embraced in the world, nor so successfully. The tradition of the war photographers . . . was circumvented and very likely ended with another first—pictures seen from a bomb's point of view. The world of Robert Capa and W. Eugene Smith and Don McCullin begins to fade next to the technological wizardry of a 'smart' bomb taking its own images."[72] As with so many predictions of the death of photojournalism, this one was premature, but it nonetheless marked growing concerns about the role of the photographer and of the photograph in documenting conflicts and violent abuses under conditions of virtual war and about a concomitant, growing "crisis of belief" about photographic representation.[73] Underlying Ritchin's comments is a suspicion that "the end of photography" was congruent with "the end of history"—nowhere is this clearer than in the Balkan conflicts of the 1990s.

The Balkans: "The War That Can't Be Seen"

The conflicts in the Balkans in the 1990s presented serious challenges to Western media to make them meaningful to their publics. For some this was a crisis of moral legitimacy, striking at the core of Western assumptions about the documentation of atrocities and the suffering of others. Photographers at work in the former Yugoslavia in the 1990s were particularly cognizant of this. The Russian photojournalist Oleg Klimov, discussing the Kosovo crisis, observed: "With this war something crashed in the very core of the planet, the East and the West got all mixed up. What we saw in print and on TV was the hi-tech information war with man lost in it. And that is probably how wars will look from now on."[74] The result of the end of history in this telling was the loss of man, that is of the verifiable human subject as the focus and locus of the moral imperatives of documenting conflict and suffering and of the role of the photographer

as witness. Klimov was right, something had crashed, the sense of moral mission that accompanied Western photojournalism's visualizing of distant suffering was thrown into confusion—first, by the breakdown of the bipolar structures and narratives that had shaped the telling of Cold War stories and, second, by the palpable failure of the West to intervene in the Balkans despite the visual evidence produced by many photographers.

The Balkan Wars marked a watershed in mainstream Western photojournalism's role as an architect and agent of the postwar liberal humanist imagination. In the conflicts of the former Yugoslavia, the narratives and ideals of liberation and freedom that accompanied the endings of the Cold War broke down violently and comprehensively, as Europe looked into the abyss of its own making. The historical resonance of this is signified in the work of many photographers. Gilles Peress's image of the "evacuation of Jews" from Sarajevo in 1993 may be viewed as a disturbing echo of World War II transportations of dispossessed peoples (fig. 3.6). Luc Delahaye's image of three brothers of a deceased Bosnian soldier succumbing to grief in a hospital emergency room in Sarajevo in 1993 is a disturbing tableau. James Nachtwey's image of a Croat sniper shooting through a bedroom window at Muslim people in the area below, in Mostar in 1993, symbolizes neighbors killing neighbors, turning the landscape of everyday domesticity and community into a war zone. In all these images, there is a sense of the failure of the postwar vision.

3.6 Departure of Jews, Sarajevo, Bosnia and Herzegovina, 1993. (Gilles Peress, photographer.)

The framing of the Balkan Wars within American media reflected political uncertainties about the causes of the conflicts and what they portended for American geopolitical interests and international security. In the early 1990s, the Bush administration made it clear the United States did not have a strategic interest and insisted the war in Bosnia was a civil war and that all sides were equally culpable. In the early stages, the conflict in Bosnia was widely designated as "ethnic war," connoting a primal eruption of long-standing ethnic hatreds that had been held in check by the Soviet rule and the Cold War. As many commentators have observed, this framing served to depoliticize the conflict, putting it beyond direct Western responsibility or concern, creating the sense that all sides were to blame and defusing any urgency of response. The war was confusing to interpret and frame. It lasted over four years, during which there were shifting intensities, alliances, and epicenters, as well as confusions about victims and aggressors. It was low-intensity warfare of daily persecutions and killings, with occasional atrocities; there were no conventional military battles. While aspects of the war were hidden from media coverage, journalists had relative freedom to move around the region, and over the course of the war they produced many narratives and images of refugees, detention camps, and destroyed villages, illustrating the effects of what came to be known as "ethnic cleansing," and they documented atrocities. For the most part, media coverage of atrocities had minimal impact on policy, though there are examples of U.S. and UK governments providing emergency aid missions in response to these.[75] The paucity of political or broader public responses in the West to the reporting of the war became a major frustration and challenge for journalists.

Throughout the conflict, photojournalists became especially frustrated by the lack of interest in and response to the imagery they were producing. In 1991, as stories began to emerge about Serbian aggression and the forced migration of Croatians, the plight of the refugees was filmed and photographed but drew little interest among editors or publics, not least because it had little obvious drama and lacked a clear narrative of explanation. Carol Williams, eastern European bureau chief for the *Los Angeles Times*, reflects: "Stories that might have prepared people and educated them about this conflict early on, did not get the space. If the world had got the picture earlier that what happened in Croatia was a one-sided war of aggression, action might have been taken to prevent the spread to Bosnia."[76] There was a more particular challenge for photojournalists covering the refugee camps, as Paul Whyte, photo director of *USA Today*, notes: "The faces in the refugee camps I visited in Croatia looked just like folks back home. Yet, all had suffered terrible losses. That was the single great-

est challenge photojournalists faced—how to realistically portray the human condition of these war casualties to the world."[77] This was not only a formal challenge to the imagination and artistry of the photographers; it was an ideological and strategic challenge as well, to overcome the lack of interest in what they were reporting.

What only slowly became clear to Western observers was that by the beginning of 1992 the Serbian authorities and forces were instigating a policy of "ethnic cleansing," a systematic village-by-village expulsion of Muslims from their homes, at first to detention centers and then out of the country. It was mostly concealed from external observers, though rumors emerged by July of detention centers and mass executions, and a number of journalists sought to find evidence of these.

The first photographer to produce graphic evidence of what was going on was Ron Haviv, a young American photojournalist who first went to Slovenia in June 1991 and covered the various conflicts in the region over the next eight years. In November 1991, Haviv was in the Croatian town of Vukovar after its destruction by a Serbian bombardment, accompanying a platoon of Serbian irregulars. In two instances soldiers commanded him not to take pictures as they executed civilians. Haviv has commented that he "felt guilty" about the experience and vowed to take pictures of such atrocities should he have another opportunity. In April 1992, he traveled to the Bosnian town of Bijeljina, having heard that Serbs and Muslims were violently clashing there. He was at first greeted by friendly Serbs who claimed that Muslim extremists had sparked the violence. As tensions grew and he resisted warnings to leave a militia led by the warlord Željko Ražnatović, known as Arkan, arrived in buses and announced they had come to rescue fellow Serbs. Having already met and photographed Arkan, Haviv was invited to accompany the militia as they moved to "secure" the town.[78] He soon witnessed an execution but was once again ordered not to take pictures. As more violence ensued he moved away from the soldiers and managed to photograph several events. The most graphic images are of a young man pleading for his life and a series of images that depict the killing of a Muslim butcher, his wife, and her sister on a street. Due to the dangers involved, Haviv was not able to take a photograph of the soldiers doing the killing, and he recounts the significance of this: "I don't have a photograph of the soldiers with the people, which is what I need to prove that these Serbian soldiers were the ones that killed them. I mean, aside from my word, I wanted to have it actually on film."[79] As soldiers moved away from the scene and walked past the bodies Haviv photographed them from behind—in one image a soldier kicks one of the women in the head (fig. 3.7). Shortly after, Haviv photographed a Muslim man who had

3.7 Arkan's Tigers kick and kill Bosnian Muslim civilians, Bijeljina, Bosnia and Herzegovina, 1992. (Photograph by Ron Haviv/VII.)

been thrown from a third-floor window onto the street by Serbian militia. When it was reported to Arkan that he'd taken the latter photo, he handed over the film but retained and subsequently published the images of the earlier events he witnessed.

Haviv's imagery of the Serbian brutalities in Bijeljina was the first visual documentation by a Western journalist of atrocities in the region, and the images were widely published. *New York Times* reporter Chuck Sudetic comments: "You had lots of descriptions of events coming your way, but where was the real sound evidence? Here was this set of pictures coming in from up there in the north where I couldn't get, and it underscored the reality. It gave lots of reports we had heard great credibility."[80] However, there was little public or political reaction to the images, much to Haviv's initial surprise. He would later observe: "What's interesting about these photographs is that this was a week before the war officially began in Sarajevo. And these pictures were published by American magazines and seen by American politicians, as well as by German politicians and French politicians. I was always quite sad that there was no reaction by the politicians to these photographs. They had seen that this ethnic cleansing had started and they still had an opportunity to stop actually what was going to happen three weeks later in Sarajevo."[81] Haviv's photograph of the Serbian soldier nonchalantly kicking the dead or dying woman who

lies on the pavement would become widely reproduced over time. David Rieff comments: "For almost every correspondent who covered the Bosnian war this image sums up what took place there. There, before you, is the face of ethnic cleansing. The photograph is also almost a parable for what took place in Bosnia, which was not war in any traditional sense, but slaughter; not the clash of armies, but the destruction by soldiers of civilians."[82] For all that the photograph took on such meaning for correspondents, it did not have an immediate impact beyond them. It may be more appropriate to cite it as a parable for the gap between documentation and action that was such a feature of media coverage of this war.

The next major publication of graphic imagery evidencing "ethnic cleansing" appeared in the summer of 1992 as journalists followed up rumors of Serb detention camps. Most significant were the reports on detention camps at Omarska and Trnopolje in August. Footage of the Trnopolje camp, initially shot by the British news organization Independent Television Network on August 5, 1992, showed emaciated Bosnians behind barbed wire—the image that was most widely republished as a still frame was that of Fikret Alić, a Muslim man whose topless torso and emaciated frame appeared on the front pages on newspapers and magazines around the world (fig. 3.8). In the following days, the British print media reproduced the image as evidence of atrocity, with headlines such as "BELSEN'92" and "THE PROOF"—almost all made direct reference to Holocaust imagery and Nazi concentration camps. In the United States, the imagery was also widely reproduced, first by ABC and then in many publications. It coincided with reports by Roy Gutman breaking the news of a Serbian prisoner-of-war camp at Omarska, which were first published by New York *Newsday* with the phrase "The Death Camps of Bosnia" in its front-page headline. *Time* reproduced some of the Trnopolje images, with a story that began: "The shock of recognition is acute. Skeletal figures behind barbed wire."[83] *Newsweek* linked pictures and policy: "Shocking images from battered Bosnia put pressure on Bush to decide what America should do—or can do—to stop the nightmare"—though this was less a call for intervention than a reflection on what the events mean for the United States.[84]

The Holocaust template quickly moved to the fore in media reporting—a striking example of how images can function to "premediate" events.[85] It contributed to a new sense of urgency and crisis in relation to Bosnia that occasioned a flurry of outrage among political leaders—the *New York Times* reported that Secretary of State Lawrence Eagleburger was calling for a war crimes investigation. However, there was no impact on policy subsequent to publication of the imagery, and as the *New York Times* remarked

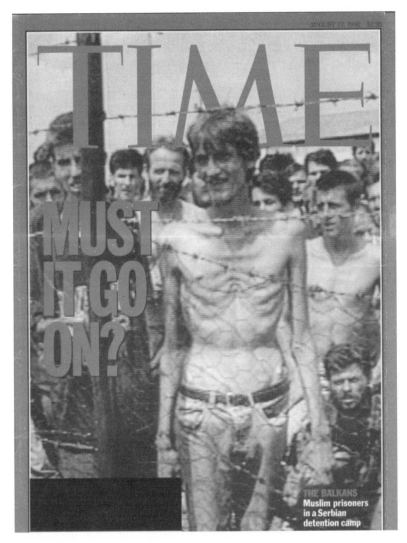

3.8 "Must It Go On?" cover, *Time*, August 17, 1992

a week after the story appeared, "the responses have been confused and tentative."[86]

Within the media, these reports sparked discussions that would continue throughout the 1990s about the value of such imagery to understanding the events in the region and, more broadly, about the difficulties of reporting on the war in a clear and meaningful way. In the *New York Times* in 1994, Roger Cohen called the conflicts in Bosnia "the war that

117

can't be seen," arguing it was "lost in the fog of second-hand reporting" and that "Western journalists, almost without exception, have been unable to get there."[87] There are differing views on why it was not "seen." In 1995, CBS anchor Dan Rather reflected: "Many reporters were stunned when the first pictures and stories—concentration camps, maimed and raped children, starving grandmothers—didn't interest more Americans. Because their first efforts failed, many news organizations told themselves the audience didn't want to hear the story. So they covered it less, losing more opportunities to serve the public."[88] Looking at these discussions, Susan Moeller has argued that one result of the frustrations was the growth of advocacy reporting: "Journalists became engaged. They wrote passionate accounts of the horrors of the camps. Some received front-page attention. Some received top-of-the-news coverage on the nightly news. But the images from Bosnia never really backed those stories up. The journalists' advocacy was an attempt to force Americans to care. But the reporters couldn't overcome the paucity of damning visual evidence."[89] Others argued that there was a great deal of "damning visual evidence," most notably Susan Sontag who stated that "the genocide of the Bosniak people has taken place in the glare of worldwide press and TV coverage."[90]

These discussions were about much more than the relationship between pictures and policy—they registered a concern that the gap between representation and responsibility was growing and that "the act of bearing witness may no longer compel responsibility."[91] The significance of such concerns for practicing journalists was evident in the ways in which many began to rethink their approaches to reporting the conflicts. A notable example of this is recounted by Roy Gutman: "A group of us journalists and photographers who had covered the Balkans met in 1996 to review what we'd done there. And we were all asking ourselves: 'What are we doing wrong? What did we miss? How is it possible that in 1996 the international community still hasn't arrested a single war criminal; that everything we covered seems to have been in vain. There must be something more we can do.'"[92] One result of this meeting was a consensus that journalists needed greater understanding of international law and how to go about reporting on crimes of war. This was the genesis of the book *Crimes of War*, put together by Gutman and David Rieff and with contributions from ninety writers and photographers.[93] It is a significant example of the rethinking taking place about the role of the journalist as witness and documentarian in the time and space of war and, more particularly, it signifies the fresh attention to legal and human rights frameworks in media practice. Journalists recognized there was a diminished

moral economy in the relation between representation and responsibility and the need to revitalize this. For some photojournalists, this meant rethinking the role of the photographer as witness and committing themselves to providing evidence of crimes against humanity. I will look here at the work of Gilles Peress and Gary Knight, who developed "forensic" approaches to the aftermaths of violence in an effort to provide forms of documentation that can support legal testimony on war crimes and acts of genocide.

Gilles Peress worked in the Balkans in the 1990s with a strong sense of moral responsibility that was intellectually charged by his perception that the end of the Cold War had left a vacuum where grand narratives of progress and history once existed.[94] Peress casts an unflinching eye on the results of violence in Bosnia and Kosovo, committing himself to lengthy and intense projects of documentation that produced a range of outcomes.[95] He published three books from this work. The first, *Farewell to Bosnia,* documented the conflict from March to September 1993. The second book, *The Graves,* documents the painstaking search for human remains in mass graves in Srebrenica and Vukovar. The third, *A Village Destroyed*, focuses on Kosovo in 1999. He also produced an exhibition and an innovative online photo essay of his work in Bosnia. With these projects he pressed the boundaries of photojournalism further than most in efforts to challenge and stretch our comprehension of human violence and suffering and to indict what he saw as Western apathy and indifference.

Peress's formal experimentation reflects these concerns as he began to "work much more like a forensic photographer in a certain way, collecting evidence."[96] In a 1997 interview, he says he has begun to "take more still lifes, like a police photographer, collecting evidence as a witness. I've started to borrow a different strategy than that of the classic photojournalist. The work is much more factual and much less about good photography. I don't care that much anymore about 'good photography.' I'm gathering evidence for history, so that we remember."[97] A common feature of this work is Peress's use of a forensic aesthetic that creates crime scene–like imagery, focused as much on objects, remnants, and traces as on people. It is an evidentiary approach that he argues means a shift in the methodology of the photojournalist, requiring "a shift in relationship to journalism, the tendency to generalise things, to put everybody in big categories and to overlook details as a hindrance to a few pages, a shift to attention to detail; details of method, fieldwork, anthropology, sociology, tradition of investigation, familiar with ethnographies and narratives."[98] This work is more impersonal and detached than conventional concerned

photography that attempts to appeal to compassion in the viewer. He wants to separate the evidentiary from the sentimental, so that the act of witnessing will catalyze thought as well as feeling.

Farewell to Bosnia, like Peress's earlier book *Telex Iran*, is constructed in the mode of a travelogue, covering several regions of the country, primarily the areas of Tuzla, central Bosnia, Mostar, and Sarajevo. It also uses similar visual elements of the mobile camera eye that he used in Iran, with many shots framed through car windscreens. There is also the same sense of off-balance style that creates visual confusion for the viewer while transmitting the chaotic energy and sense of terror in what passes for daily life among refugees and those trapped within ruined urban enclaves. In his text, Peress states he is documenting "the continuum of life during wartime" and that he "set out to provide a visual continuum of experience, of existence."[99] What he appears to mean by this is that he sought to document as much detail as he could include in the framings, regardless of what seemed consequential in terms of the broader conflict. There is an equivalence of detail and activity in the imagery; there are no singularly dramatic images to center attention and focus meaning. If there is a common theme it is that of dismemberment—of bodies, families, communities, and nations—and the degradations that follow from this. The rawness of the black-and-white imagery is oppressive on viewing, the more so as much of it deals with disfigurement and ruin. Unlike in *Telex Iran*, the images are larger in number and smaller in size, and they are more tightly grouped, often with four to a page. They produce an overwhelming amount of fragmented details with little textual guidance to context or meaning. The style and layout reinforces the sensory overload of the viewer, as is Peress's intent: "My photographs show a nation divided, a nation at war. Refugees are on the road, drifting through the rain, moving through camps and hospitals, an endless cavalry of images flashing by in a blur: exhaustion, too many images, too much horror. The witness becomes indifferent. My point is that we, in the comfort of our lives, must question our role in the history of Bosnia, which is also our history."[100] There is a lesson in "our" discomfort as viewers.

This is not to say there is no coherent commentary on the conflict in *Farewell to Bosnia*, but what is there is fragmented and subliminal, mostly constituted through repetitions that are sometimes oblique yet cumulative and linger in the memory. The first image of the book is a two-page spread depicting a military map on a wall, covered in markings, and with two hands, one on either side, gesturing to the map. The map shows Central Bosnia and is covered by a plastic sheeting that has military force positions marked on it. With this overlay of representations, Peress refers us

to the military gaze on Bosnia, refracted via the plastic sheeting, which seems transparent but is actually a screen of military representation that turns the landscapes of Bosnia (already mapped in geopolitical and ethnic terms formed by colonial and Cold War power struggles) into a strategic space of military surveillance. The photograph is a palimpsest of representations: the map overlaid by the military screen, which is framed by the gesturing hands on either side, which is framed and photographed by Peress as a portal for the book—it comments not only on the confusion of frames and interpretations surrounding Bosnia at this time, and gestures to the histories of its divisions and mappings, but also comments on the act of interpretation and the puzzle that awaits the viewer in *Farewell to Bosnia*.

This first image is also significant as it introduces a key visual motif of the book: the presence and use of hands as symbols of human identity and communication. The hands in the image may be gesturing toward the map but their disembodied presence at left and right of the image throws up other connotations. They may be read as gesturing at each other, though whether in friendship or enmity is difficult to tell. As the "cavalry of images" tumble from the book, we begin to notice that hand gestures and signals abound and that Peress is attuned to them. There is a series of images in which people inside and outside a bus put hands against the windows, in gestures of affection and loss (fig. 3.6). Peress notes that these images were taken "during the evacuation of the Jews of Sarajevo. They had been there since their expulsion from Spain in 1492."[101] The hands on the smeared window of the evacuating vehicle form a metonymy of separation that echoes World War II imagery. Later in the book there is a sequence of images of people, mostly children, with no hands, amputees injured in the war. The motif is also on the cover of the book, which depicts the marks on the landscape caused by a shell, in the shape of an open hand. These repetitions are no accidents but the result both of Peress's camera eye in the field and his careful editing. One key element of these associations is to evoke visual memories of the Holocaust, particularly in the images suggesting deportation—not only of the Jews departing in the buses but also several images of trains with boarded-up windows.

Trauma and memory are the undercurrents of historical association in *Farewell to Bosnia*, a reflection of Peress's sense that he is witnessing (and the West is refusing to understand) a "cycle of history" in which the past is being repeated. In a letter at the end of the book, he refers to "mental images so horrific that one is compelled to actually 'see' them to deal with them. And to see them you have to act them out."[102] This is the discourse of trauma and a weighty obligation to place on images, indicative of his

bold assertion: "I'm gathering evidence for history, so that we remember." This imperative led Peress to seek further outlets for the work in an effort to reach wider publics.[103]

An online exhibition of further work he did in the region in 1996 was published by the *New York Times* in the summer of that year. Titled "Bosnia: Uncertain Paths to Peace," it was an innovative project instigated by Fred Ritchin, then picture editor at the *Times*. The exhibition presented images Peress took in Bosnia in early 1996 in the wake of the Dayton Peace Accords. The online presentation goes beyond a conventional gallery or book display of his work to incorporate a great deal of contextual information, and to allow viewers varied pathways through the work, and to respond to it in discussion forums attached to the site.[104] The photo essay covers the last weeks of the siege of Sarajevo in February and March 1996 and deals with the perilous endings of war and beginnings of peace and reconciliation. Peress provides his own narrative comments, dated and placed beside images or recorded and embedded in the site. In his introductory narrative, Peress comments that "the ending of war is almost more depressing than war itself because once you don't have to run for your life, the evidence of waste is fully there to contemplate as slowly as you want, inch by inch, bullet hole by bullet hole."[105] The imagery is less rushed than in *Farewell to Bosnia*—the frequent use of diptychs makes for more meditative viewing—and the textual materials add considerably not only to the understanding of context but also to the human interest narratives that run through the sections and that are particularly suggestive of the difficulties of reconciliation. Much of what Peress documents is marked by a "collective angst" formed by the uncertain interregnum between peace and war.[106] The disruption of Serbs evacuating the suburbs is evident in their domestic possessions filling the streets and the tearful departures, in the fearful faces of those left behind, and most potently in the digging up of graves and disinterment of bodies so they may be reburied in Serbian land. The unrest is manifest, too, in the violent trashing of neighborhoods that will soon be occupied by Bosnians. Offsetting this fear and hatred, Peress also documents the story of a Serb man who moves from his home but returns a few days later to be embraced by Bosnian Muslims he had known years before and had been fighting.

While his work on the first Bosnian war illustrates the development of a forensic aesthetic in Peress's work, this comes more fully to the fore in his dedicated documentation of war crimes after the conflict ended and again in Kosovo in 1999. In 1996 and 1997 he worked with forensic teams exhuming mass burial sites in Srebrenica and Vukovar, and the images are published in *The Graves*, accompanying text by Eric Stover, director of the

University of California at Berkeley's Human Rights Center. These photographs focus even more intensely on the evidentiary approach, treating the environment as a huge crime scene. Peress documents the painstaking work of the forensic anthropologists and takes the viewer close to the detail, of body parts and the objects that have been recovered from the sites—the cover photo of the book is of a set of keys found in the trouser pocket of a corpse and now deposited in a plastic bag marked for identification. A number of images direct our gaze to bodies entwined in mass graves, their features so decomposed and muddied it is difficult to tell one body from another. Stover's narrative and Peress's images build a compelling and graphic narrative of human depravity but do so in a constrained manner that accentuates their aim to uncover and document "crimes of war" and do so in ways that will provide evidence for legal proceedings against those who are culpable. They carefully record and illustrate the scope and manner of the slaughter that took place, include testimony from survivors, and comment on failures of the United Nations.

Peress and Stover returned to the Balkans in the spring of 1999 to document the plight of Kosovar refugees returning home after NATO began its bombing campaign against the Serbian military. They stationed themselves in Morina on the Kosovo-Albania border and proceeded to photograph and interview refugees with a view both to reporting to the outside world what was happening there and to compiling evidence admissible in the international criminal prosecution of Serbian aggressors. A collection of Peress's photographs, with text by Philip Gourevitch, was published in the *New Yorker* in July 1999 under the title "Exile and Return," and a fuller account was published in *A Village Destroyed: May 14, 1999—War Crimes in Kosovo.* According to Stover: "Our aim in creating *A Village Destroyed* was to prepare a document that would illuminate the Kosovo war through many different perspectives, including those of victims, perpetrators, war-crimes investigators, and journalists." In this, they were part of a larger project organized by human rights organizations to quickly document the abuse in a comprehensive manner. Carroll Bogert, director of communications for Human Rights Watch, comments on the significance of the way in which human rights researchers worked the borders of Kosovo, interviewing refugees: "From these terrorized refugees came surprisingly detailed accounts of the atrocities they were fleeing. When, after the war, researchers and reporters rushed into Kosovo, they found a chillingly accurate nature morte: almost invariably, the dead bodies were just where the refugees said they would be."[107] This was indicative of a new ecology of war reporting, in which human rights actors became significant reporters of conflict.[108]

Several other photographers took up versions of the forensic aesthetic that Peress practiced in his coverage of the Balkans (and of Rwanda) in the 1990s. The American photojournalist Gary Knight, in response to the Kosovo emergency, asked his editor at *Newsweek* to allow him to "take on the issue of war crimes, take it on and deliver the images when they are ready, and not be under pressure to deliver them to deadlines."[109] Knight worked in Kosovo, Macedonia, and Albania in the spring and early summer of 1999 documenting evidence of war crimes and crimes against humanity. He produced a prize-winning photo essay for *Newsweek,* and the work became the basis of a book he created with the writer Anthony Lloyd, *Evidence,* published in 2002. Frustrated and angered by media reports that they believed fudged issues of crime and justice, Lloyd states their aim in his text: "The luxury of disbelief is cut off by Gary Knight and his pictures, each an unremitting challenge to cynicism, a challenge that does not stop until readers close their eyes or turn away."[110] The book, Lloyd states, "does not set out to be the definitive record of crimes committed in the province. Rather, it tests the meaning of 'evidence' in its most fundamental sense, forcing viewers to test their belief or disbelief in the face of images of what happened to the Kosovar people, both the living and dead."[111] Taking the indictment of Slobodan Milošević as their narrative theme, they illustrate the charges against him—deportation, persecution, and murder—by providing visual and oral eyewitness evidence of each. There are striking images of each charge. One of the most haunting is the imprint of a body on a charred floor, resonant of World War II imagery, but also a more specific reminder that this whole "war" is a crime scene and that thousands of Kosovar's are still missing and presumed dead (fig. 3.9). Knight states: "I approached the story as a curator of a crime, rather than as a journalist, photographing mass graves and scenes of crime. . . . I believe the universal language of photography renders the concept of war crimes less alien to those for whom the idea is normally abstract."[112]

This last statement goes to the heart of the moral and political dilemmas surrounding photographic documentation of the violent results of the Balkan conflicts. The work of Knight and Peress and others became very deliberately tailored to the conditions of warfare in the Balkans and the need to produce forms of documentation that differed from conventional conflict news reporting. For a number of photographers, a key lesson of covering the Balkan Wars was that while the moral economy that bridged representation and responsibility was diminishing in conventional media reporting of conflict, there were emerging new opportunities for photographers to witness and evidence and, thereby, to effect international responses. Many believe that the wealth of visual documentation

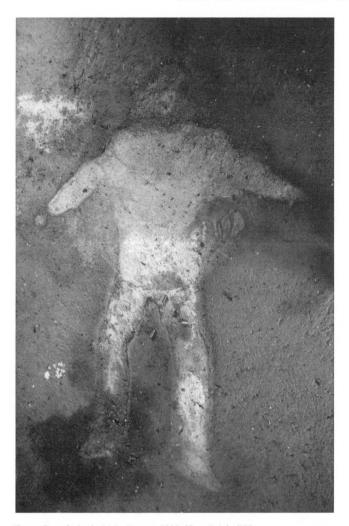

3.9 The outline of a body, Meja, Kosovo, 1999. (Gary Knight/VII).

of war crimes was crucial to the prosecution of war criminals. Roy Gutman reflects: "In some ways, the Yugoslav tribunal would not have come about but for the mass of material that was provided by the media. At one point, I was told that some of my stories were like a road map for the court."[113] The work of Peress and Knight has been taken up within tribunals.

The work of Ron Haviv has also been presented in forums investigating human rights abuses in the Balkans. Haviv, too, shifted his views about the value of photographing atrocities and their aftermath. In 2000, he published a book, *Blood and Honey: A Balkan War Journal*, which was ac-

companied by an exhibition and documentary film. In the concluding statement in *Blood and Honey*, he writes: "Originally my work was intended as news photographs. . . . Today, I hope my work stands as a testament to the war. It is an accusation to those who had the power to do something, yet stood by and did nothing as hundreds of thousands died and millions more became refugees."[114] This statement is accompanied by the final photograph in the book, of "a Kosovo Liberation Army soldier on the front line with a wallet containing family pictures and a photograph of President Bill Clinton," taken in 1999.[115] Haviv later reflected on this: "Although the majority of my work is taken as news photographs to influence the situation immediately, I have come to realize that photography has a second and sometimes more powerful life as a historical record and a form of evidence."[116]

Haviv's commentary on how he shifted sensibility from the immediacy of news photography to also work with a sense of the *longue durée* of historical evidence reflects the incremental but powerful effects of much media coverage on the creation and subsequent prosecution of the war crimes tribunals and of the politicization of memory around the wars. There is a permanent exhibition of Haviv's work in the historical museum in Sarajevo, and he is pleased it is often used for educational purposes. But violent responses to his work when it was exhibited in Serbia in 2002 demonstrate that the politics of memory continue to reflect and feed conflicted views on the Balkan Wars.

This heightened attention to the practice and impact of visual witnessing was a key feature of the work of several photographers at work in the Balkans, both during and after the conflicts. It presaged a shift in the terms of the debate about the relationship between pictures and policy and, more broadly, between representation and responsibility. This shift was aligned with the photographers' motivations and objectives in relation to the emerging human rights architecture. Essentially, they moved from a moral to a political framing of events and issues, from efforts to evoke empathy and compassion to producing evidence of crimes and abuse.

This was a significant journalistic response to the particular features of warfare in the Balkans. Yet, it also underscores the underlying paradox of "military humanitarianism"—as Michael Ignatieff succinctly puts it: "technological omnipotence is vested in the hands of risk-averse political cultures"—and the confusions of moral and political imperatives for intervention. When he put the case for military intervention in Kosovo in March 1999, President Clinton cited the imagery of bloodshed in the Balkans over the 1990s and said there was a need to create a world "where we don't have to worry about seeing scenes every night for the next 40 years

of ethnic cleansing in some part of the world."[117] Yet, he also made it clear no ground troops would be committed. In this gap between statement and action resides the paradox that Ignatieff refers to and that photographers sought to circumvent by attempting to bridge the widening of the gap between representation and responsibility.

––––––

The conflicts in the Balkans became test cases for the politics and ethics of humanitarian intervention and also for the role of the visual media in shaping the scope of ethical concern in international affairs. For many journalists (and thinkers) the West's compromised promotions of human rights and humanitarian missions produced a moral miasma, a "problem of bad faith," as Michael Ignatieff termed it, "a conflict within our own principles: between commitments to human rights and to self determination."[118] This miasma shadowed the work of photojournalists as it troubled issues of representation and relationality in the visual documentation of pain and suffering. In the wake of post–Cold War conflicts and interventions, there emerged competing views on the morality of representation of suffering others and on the effects of increased flow of images and information about human rights matters. The more optimistic tended to argue that visual mediums of representation were globalizing human conscience, expanding our understanding of the human and claims of the vulnerability of others. Other commentators pointed out that greater volumes or flows of imagery and information about human rights claims do not necessarily produce either greater enlightenment or action among viewing publics. Some of the more skeptical commentators also point out the fallacy of mistaking seeing for knowing and questioned political and public wills to translate emotional responses into directed social action. The more cynical readily referred to a growing consumption of suffering and an accompanying "compassion fatigue."[119]

These debates in the 1990s reflected the heightened consciousness of humanitarian and human rights matters in terms of media coverage and particularly visual documentation. The "unseen" wars of the post–Cold War period challenged photojournalists to reconfigure their approaches to the documentation of violent conflict and question the linkage between humanitarian ideas and security concerns of Western powers—a linkage that would become all the more deeply troubled in the wake of 9/11.

Visualizing the War on Terror: Afghanistan, Iraq, the United States

With the endings of the Cold War and, more particularly, the onset of a global "war on terror" in the twenty-first century, the American worldview has become both attenuated ideologically (it is more difficult to identify an "American" way of seeing international affairs) and dispersed technologically, due to the emergence of new communications technologies and the disintegration of discrete categories and genres of visual information in the digital age. At all points, though, it is tied up with broader geopolitical perspectives underlying U.S. foreign policy and the broader formations of a neoliberal global order. More and more, the geopolitical imperatives of the American worldview operate through assumptions of omnipresence and transparency that attend the visualizations of interventions enacted in foreign lands. These assumptions support an emergent visual schema of securitization that aligns the formation of the global war on terror with that of the homeland security state. This worldview reflects and refracts the conditions of the perpetual wars of terror and securitization that sustain it. These are wars without end; they are also wars without a principal enemy.[1] The immanence of these wars dissolves cognitive borders between foreign and domestic affairs, unsettling assumptions about the relation between friend and enemy and between war and murder. These perpetual wars have dislocated registers of temporal and spatial distance that structured and

promulgated American perspectives on war and conflict during much of the twentieth century. In their place are emerging new visual protocols for framing the American worldview.

As a new paradigm and frame for U.S. geopolitical imperatives, the war on terror poses particular challenges of representation. A subtext of this chapter is the beguiling question that troubles representation (and perhaps especially documentary representation) of the war on terror: how do you represent a war that is hidden in plain sight? This is not so much a question about occlusion and silence as about transparency and disavowal, for diffused as this perpetual war is, it is not invisible. Rather, it is imbricated in multiple media spheres as both condition and object of representation. In other words, there is no lack *of* representation of the war on terror, but there is a lack (or limit) *in* representation, which needs to be considered in relation to the wider documentation of reality under conditions of perpetual war and within a public sphere in which the democratic polity is happily prepared not to believe what it sees. Like other visual media today, photography screens the war on terror, that is to say, it functions both to show and conceal the conditions and effects of perpetual war. It dramatizes the hauntology of this war—most obviously in representation of the figures of enemies that take the place of a principal enemy—and it also mystifies and demystifies its violence—most commonly registered either as the shock and awe of spectacular violent killing or as the collateral damage of the discounted dead.[2] The optics that are critically commensurate to the logics of the war on terror are also going to be symptomatic of these logics, this includes the ethics and aesthetics of documentary representation itself. In this chapter, we will look at a range of representations that illustrate this.

Framing 9/11

The image shown in figure 4.1 was taken on September 11, 2001 by Magnum photographer Thomas Hoepker. It depicts a group of people in the neighborhood of Williamsburg in Brooklyn sitting by the waterfront; in the background we see smoke emanating from the World Trade Center. Hoepker chose not to publish the image at the time, noting later: "It's a kind of troubling picture. The sun was shining. They [looked] totally relaxed, like any normal afternoon. They were just chatting away. It's possible they lost people and cared, but they [did not appear to be] stirred by it. . . . The idyllic quality turned me off. It was too pretty. Maybe we didn't need to see that, then. Maybe I wasn't sure it would stir the wrong

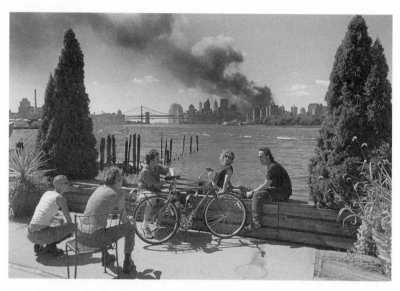

4.1 Young people relax along the East River after the attack on the World Trade Center,
Brooklyn, USA, 2001. (Thomas Hoepker, photographer.)

emotions [in the viewer]."³ Troubled by the complacency of the scene,
Hoepker effectively self-censored the image. In 2006, the photograph
was published in a book on 9/11 photography and became the source of
a minor media controversy over what it connoted about 9/11 and Ameri-
can responses to the events of that day. *New York Times* writer Frank Rich
ignited the controversy when he commented on the image in his column.
Rich wrote:

Seen from the perspective of 9/11's fifth anniversary, Mr. Hoepker's photo is prescient
as well as important—a snapshot of history soon to come. What he caught was this:
Traumatic as the attack on America was, 9/11 would recede quickly for many. This is
a country that likes to move on, and fast. The young people in Mr. Hoepker's photo
aren't necessarily callous. They're just American. In the five years since the attacks,
the ability of Americans to dust themselves off and keep going explains both what's
gone right and what's gone wrong on our path to the divided and dispirited state the
nation finds itself in today.⁴

The people in the photograph came forward to comment on their per-
spectives and Hoepker also commented on it in *Slate*, where he asks if his
picture "was . . . just the devious lie of a snapshot, which ignored the sec-
onds before and after I had clicked the shutter?"⁵

I suggest this photograph represents something more than "just the devious lie of a snapshot," and to better understand this we need to return to the event of 9/11 to consider some of the ways in which photography (mis)represented it. The photographic image proliferated around the events of September 11 and their aftermath. The devastating attacks on the World Trade Center were photographed from numerous perspectives, as anyone who had a camera trained it on the destruction, from streets, windows, and rooftops across the city. Around the world on September 12, the front covers of newspapers depicted the twin towers burning or collapsing, and many went on to devote whole pages and double-page spreads to full-blown images.[6] In the days that followed, newspapers supplemented this imagery with a wide array of other visual sources, including stills from amateur video footage and satellite pictures. The New York Times ran a daily gallery of portraits of people dead or missing. Impromptu, makeshift shrines and memorials, many adorned with photographs, appeared throughout the city. Posters advertising "missing" persons were pinned or plastered to street furniture. More formalized exhibits emerged, displaying the photography of New Yorkers, and within weeks an avalanche of books began to appear, most packaged as forms of tribute or memorial and all visually led. Although there is compulsive fascination with the repeated screenings of the television footage of the airplanes striking the towers and of the towers burning and collapsing, the still image has taken on more resonant cultural and political functions within the visual history of September 11. Photography not only documented the events of the day, it also transformed them into potent symbols and iconic reference points and was instrumental in communicating the trauma of a citizenry—its function was not only evidentiary but also testimonial and mnemonic.

All of these functions are evident in the more vernacular modes of image use and representation. The images of people on missing posters and on photographs adorning pavement shrines and vigils underscored the link between photography and death that many commentators on the medium have made. Photography's temporality, its freezing of a moment in time, lends it a pathos that seems inherent to the medium and to "photographic seeing."[7] With the missing posters, the pathos is pronounced, as smiling faces look out from contexts of intimacy to one of public trauma and grief. The trace effect of this photography—its haunting representation of absence—was widely endorsed in the aftermath of the September 11 attacks, perhaps as a means of mitigating or addressing trauma.

This intensive tribute to photography's testimonial role correlated with wider photographic representations of September 11 in American print media and with the rhetoric of many photography critics and pro-

fessionals. The organizers of the exhibition *Here Is New York* (now online) stated their belief that "the World Trade Center disaster and its aftermath has ushered in a new period in our history, one which demands that we look at and think about images in a new and unconventional way."[8] Brian Wallis, chief curator of the International Center of Photography in New York, restated this view: "Without question, the photographs of September 11 have changed the way we look at the world. It is imperative to examine what photography means in the wake of these seismic shifts, how what occurred . . . has altered or re-ignited our sense of what photography can achieve, both as document and as personal vision."[9] Among photography professionals there was a notable concurrence that photography's documentary integrity had been significantly rejuvenated, that post–September 11 photography had "got its job back."[10] To be sure, through intensive coverage of events of September 11 photojournalism came to the foreground of mass visual communication in a striking fashion. Peter Galassi, curator of photography at New York's Museum of Modern Art, claimed that "the most interesting, most successful, and most imaginative response to [September 11] within all the visual arts came from photojournalism."[11] Such statements propose that September 11 ushered in not only a new period in American history but also a new way of seeing and a renewed belief in the photographic image as a form of documentary "witness" to the travails of a nation.

It is understandable for photography professionals to seek to restore or rejuvenate the medium's reputation for documentary integrity and historical claim to "bear witness" for a nation. But did the photographic coverage of 9/11 usher in or reflect a new way of seeing, a new role for photography? In certain respects, this seems very doubtful. With the work of the vast majority of professional photographers recording the events of September 11 we find the use of standard, generic photographic conventions and the repetition of visual tropes and motifs. Certain scenes recur again and again: the towers burning, people running ahead of dust clouds, the remains of the tower facade still standing, rescuers at work at Ground Zero, dust-covered objects and people. Of course, the very repetition of these scenes is suggestive of the use of photography to make trauma bearable. Andy Grundberg, the *New York Times*' photography critic, reflected that people needed to keep looking at the images because "they freeze-frame a calamity so great that the mind struggles, even months later, to comprehend the data being sent by the eyes."[12] The idea that people could not believe their eyes may be clichéd yet suggests that the issue of a new way of seeing goes beyond the use of genre conventions: it implicates an

emergent visual culture in the wake of September 11, one that reflects significant shifts in the American worldview.

The implication of Grundberg's statement is that the horror "literally had to be seen again and again to be believed," but what if the visualizing of the horror had precisely the opposite effect and function? What if the vast photographic coverage of 9/11 worked to conceal what it depicted? What if the imagery enabled American viewers to suspend belief in what they were seeing? David Harvey suggested as much soon after 9/11 when he noted that whereas the attacks on the World Trade Center and the Pentagon were reported across the world as attacks "upon the main symbols of global U.S. financial and military power" it was not interpreted this way by American media, which emphasized "an attack upon 'freedom,' 'American values' and the 'American way of life.'"[13] These differences in interpretation draw attention to the disjuncture between seeing and believing. What Americans did not see were the geopolitical realities underlying the events of 9/11 as acts of spectacular terrorism. Like the people in Thomas Hoepker's controversial picture, they both looked and looked away.

This suspension of belief in what is being viewed is a defining feature of the post-9/11 American worldview. If 9/11 is the traumatic primal scene of this emergent worldview, it is the consequential inauguration of an external war on terror and an internal homeland security state that provide its everyday frames. What is further suspended in this worldview are assumptions about the reciprocity of attachments and identifications in documentary image making—focused on the idea and image of the human. Already diminished in force in media reportage on post–Cold War conflicts, in the wake of 9/11 these assumptions are even more fully weakened, effectively losing the power to explain what we are looking at. In some part, it is the failure of this way of seeing that is encoded in the real-time imagery from Afghanistan and Iraq, a failure that is exacerbated not so much by these wars as by the conditions of perpetual war that underlie and drive these particular imperial adventures.

Perpetual war erases boundaries between soldier and civilian, between actor and observer, between home front and war front. This erasure is also a consequence of the rapid developments in digital media technologies, contemporaneous with the wars in Afghanistan and Iraq, that have facilitated the explosion of imagery documenting violent international conflict and the real-time experiences of warfare normally beyond the gaze of the media and of their audiences. The now infamous imagery of abuses at Abu Ghraib was produced by participants and bystanders, not conventional journalists, and circumvented established forms of news produc-

tion and dissemination. Hugely important as Abu Ghraib is as an instance of the documenting of abuse and of the biopolitical power of the United States at war, though, it is but one example of the visual blowback from Afghanistan and Iraq as imagery of the making and conduct of warfare is produced and disseminated by varied individuals and groups. This includes the imagery produced by civilians in the war zones and by serving U.S. soldiers, who have diverse reasons for documenting their experience and disseminating that imagery globally. This "amateur" imagery is disruptive of the conventional flows of news and has become a major issue of concern for both military and media elites.

In what follows, I do not intend to describe or illustrate this visual culture in detail. Rather, I will consider some examples of documentary photography that work to draw attention to its features. I will also consider what potential for critique documentary photography—more particularly, photojournalism—retains or is reinventing in the context of the war on terror and I will ask: What is its role in delineating the values and purviews of an American worldview and of an American way of life at this time in history?

Embedded Images

The advent of digitalization has affected the production and dissemination of war images by American media, but the results, within the more mainstream media channels at least, have been neither a more plural nor a more investigative visual repertoire. In the recent wars in Afghanistan and Iraq, photographers have had the opportunity to be "embedded" with military forces near the front lines, a scenario that led to speculation that they would have access to the raw realities of warfare. But despite the claims of real-time and spontaneous coverage—all promoting the transparency of the American campaign—photographs from the conflicts in Afghanistan and Iraq have been characterized by recurrent motifs and scenarios. Several studies of the range of photographic imagery of the Iraq War in American newspapers and magazines show that the great majority of images fall into "a highly restricted pattern of depiction limited largely to a discourse of military technological power and response."[14] This was perhaps most clearly evident in the early days of the conflict when a great deal of imagery focused on military hardware and the media reproduced the "shock and awe" produced by this hardware (fig. 4.2). But it has remained the norm of coverage even as the organizing news narratives of the war have become more confused or attenuated in framing the meaning of

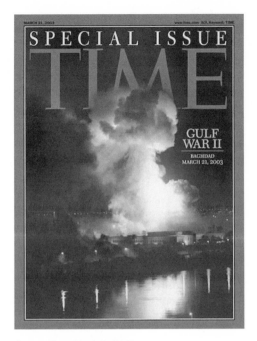

4.2 "Gulf War II," cover, *Time*, March 21, 2003

depicted events. To be sure, the embedded photographers have produced a greater ratio of combat images than in the Gulf War, but this is still a small number of overall coverage, and photographs of wounded or dead bodies remain rare.

Hailed by Donald Rumsfeld as a "historic experiment," the embedded system held initial appeal for American media due to the promise of frontline reportage, which was a clear improvement over the pooling system of the Gulf War. The embedded journalists had to sign a contract with rules on what and when they could report, including restrictions on reporting details of military actions and on showing faces of dead or wounded. In return, they got close to troops and action and enjoy military protection. Bryan Whitman, assistant deputy secretary of defense for media operations, addressing Washington bureau chiefs, stated that "embedding means living, eating, moving, in combat with the unit that you're attached to. . . . I think that you probably agree with us that there is a lot of advantages to having the opportunity to stay with a unit for an extended period of time. To build up the relationships, to build up the trust, to build up the basis of reporting."[15] Some American editors and journalists responded positively to the experiment, claiming the embedded reports

have a heightened "sense of immediacy and humanity."[16] But others have spoken of distortion and propaganda, highlighting the effects of the intense focus on American military hardware and personnel. *New York Times* photographer Vincent Laforet wrote about his experience, saying, "My main concern was that I was producing images that were glorifying war too much. These machines of war are awesome and make for stunning images. I was afraid that I was being drawn into producing a public relations essay."[17] Many photographers have commented on the limitations placed on their reporting by the close connection to American personnel. Rita Leistner, a Canadian photographer comments: "When I was embedded, my story was about the soldiers. This was simple access and location: you report on where you are. . . . I felt like I was trapped in a heavily armored plastic bubble. I could see Iraq from the back seat of those humvees, but I couldn't touch it or feel it or interact with it. And it was impossible to have any kind of meaningful contact with Iraqi people while wearing body armor and surrounded by American soldiers."[18] The close relations with American soldiers not only restricts movement and vision, it also creates a cultural pressure on the embedded journalists not to report on events that reflect negatively on the unit they are traveling with. This has been most starkly apparent in instances where embedded photographers have taken pictures of acts of violence, released these, and then been either ostracized or removed from the unit.

The embedded system mirrors and mandates the rationality of perception promoted by the state in its geopolitical visions of a globalized war on terror. It promises real-time and transparent imagery of life on the front lines of the war but restricts the visual coverage to comply with "security" requirements and produces an American-centered vision of the conflict. This is not to say the embedded reporters are happily complicit with the system; rather, the system produces a frame that regulates their visual productions. This frame, as Judith Butler points out, is always already charged with interpretation: "The mandated visual image produced by embedded reporting, the one that complies with state and defense department requirements, builds an interpretation. . . . We do not have to have a caption or a narrative at work to understand that a political background is being explicitly formulated and renewed through the frame. In this sense, the frame takes part in the interpretation of the war compelled by the state; it is not just a visual image awaiting its interpretation; it is itself interpreting, actively, even forcibly."[19] This is a more general truth of the ways in which the state controls visual productions during wartime and not only a reflection of the embedded system.

However, while it is useful to consider the embed system as a form of

framing, it is important to acknowledge (as Butler does not) that there are many other elements contributing to the sanitized imagery of the wars in Afghanistan and Iraq. The restricted visual repertoires, embargoes on images of graphic violence, and American-centered viewpoint are due to a complex mix of military, political, editorial, and practical considerations. Moises Saman, a photographer with *Newsweek,* argues that "Americans understand we are at war—but not many people want to see the real consequences, especially when they involve one of your own. I think some publications cater to this sentiment by trying not to anger subscribers and advertisers with harsh 'in-your-face' coverage of the true nature of war."[20] When editors make decisions about the reproduction of images, notions of professional ethics, public accountability, privacy, and taste are invoked and sometimes intensely discussed. But these notions are inextricably tied up with political and economic motivations and considerations. Not surprisingly, this area of decision making has become a target of political backlash as editors are charged with both doing too much and too little to censor war imagery. It is all too easy to generalize about the effects of embedding or the patriotism of American editors, none of which is reducible to a singular government policy, and the very liveliness of the debate among American journalists and photographers about the restrictions placed on their work evidences their own sense of agency. For all the constraints, many embedded photographers have been producing imaginative work, some of them pushing at the boundaries of the frame even as they work within it.

Photography of these conflicts has evolved as the wars have changed, yet the very duration of the conflicts and the restrictions on coverage have meant a growing sense that the image making is uniform. This has led many photographers to reflect on their practice and seek fresh approaches and tools, in part due to their own frustrations, but also as they are cognizant of the declining coverage of the war among mainstream media. Writing in 2008, *New York Times* photographers Michael Kamber and Tim Arango note several reasons for this decline, including "the danger, the high cost to financially ailing media outlets and diminished interest among Americans in following the war. By a recent count, only half a dozen Western photographers were covering a war in which 150,000 American troops are engaged."[21] To be sure, Kamber and Arango are referring to professional news photographers, most of whom are embedded, and discounting the unembedded Western journalists and the many Iraqi photographers, some of whom are accredited to Western news agencies. Their point nonetheless has force in relation to mainstream media reporting, and the "diminished interest" in the United States about the wars af-

fects all media production and consumption. Photographers have had to be imaginative in their work in order to engage editors and the public and daring if they wanted to break or bend the embed frame.

Gilbertson

One of the most comprehensive and lauded documentations of the early years of the war was undertaken by the Australian photographer Ashley Gilbertson. Not ostensibly a war photographer, Gilbertson first went to northern Iraq in 2002 as a freelancer to photograph Kurdish refugees and document the effects of Saddam Hussein's long campaign to kill and displace them. On his return in February 2003, he began to witness combat involving American Special Forces several weeks before the U.S. invasion: "That was the first time I was exposed to combat. I realized during the cold nights atop the mountain that while I had covered dozens of issues around war, I had never looked inside it. I decided to expand my focus in Iraq, from the Kurds in the north to the war in its entirety."[22] Over the next three years, he covered varied dimensions of the war, from the effects of the invasion in the north to the growth of the insurgency and urban combat in several cities and the first national elections at the end of 2005. He was signed up as a contract photographer for the *New York Times* in 2003, and his work steadily appeared on the front pages of that paper and widely elsewhere. His coverage of the U.S. assault on Fallujah in November 2004 was one of the most admired examples of combat coverage in the war and earned him a Robert Capa Gold Medal Award. The work took its toll, though, as Gilbertson suffered post-traumatic stress disorder and was reluctant to return to Iraq, focusing instead on domestic projects related to the war—we will look at one of these in the next section of this chapter.

In 2007 Gilbertson published a collection of his photographs in *Whiskey Tango Foxtrot: A Photographer's Chronicle of the Iraq War*. In his introduction to the book, the *New York Times* journalist Dexter Filkins, with whom Gilbertson worked in Iraq, notes that beyond the individual scenes depicted there is "the arc of a much larger story," that of American victory followed by the implosion of Iraq: "With thousands of Americans and hundreds of thousands of Iraqis dead and maimed, the worst we can imagine seems to outdo itself each day. The Americans grope for a way out, while the Iraqis, fighting over irreconcilable visions of the future, drag their country toward an abyss. The arc has tuned sharply downward, and it has not yet run its course."[23] This is an apt description of the chronological and thematic organization of the book into five sections. The first focuses on Kurds preparing for war, the looting of Mosel following

the invasion, and Kurdish attempts to reclaim homes they had lost to the policy of "Arabization." The second covers early stages of the occupation in Baghdad and in the towns of Ramadi and Abu Hishma, where insurgent attacks and U.S. operations were particularly violent, and the unheralded work of a poorly equipped bomb squad in the Iraqi police force. The third covers the U.S. offensives against the Mahdi Army in Karbala and Samarra, with a series of images closely documenting the work of American snipers; the death of a soldier Gilbertson had befriended; house-to-house searchers; and U.S. soldiers patrolling the Sadr City neighborhood of Baghdad. The fourth documents the assault on Fallujah in November 2004 and the bloody nine-day battle for control of the city as U.S. troops move street to street in combat with insurgents. The fifth covers the 2005 general elections.

Each section is introduced by a commentary by Gilbertson, describing events depicted, the experience of being embedded, and his thoughts about the war. They help shape the arc of the narrative, as a personal one from innocence to experience, mapped onto the downward arc of the American mission that Filkins describes. Fallujah is the pivot in both arcs. In Fallujah, Gilbertson and Filkins were embedded with Bravo Company of the First Battalion, Eighth Marine Regiment, which swept through the city to kill and remove insurgents. Gilbertson described the conflict as, "without question, the most intense, horrible, scariest experience in my entire life."[24] He photographed several soldiers who died in the mission. On the seventh day a twenty-two-year-old lance corporal, William Miller, was killed by an insurgent as he moved up a minaret, escorting Gilbertson who was in search of a photograph of a dead sniper. Miller's death sent Gilbertson into a spiral of guilt and depression as he blames himself, and he later interprets it as pivotal to his perspective on the U.S. presence in Iraq: "The minaret attack on Miller, Dominguez and me forced me to confront a truth I knew before but had never experienced with such intensity: war is death. But innocence, if you can call it that, wasn't all that I lost after that battle. It seemed to me that in Falluja [sic], the Americans taught Iraqis a symbolic lesson: they were no longer interested in playing ball politically or culturally. Any hope that I still had that America's involvement in Iraq could end positively was destroyed along with Falluja."[25] Following the death of Miller, Gilbertson left Iraq.

The narrative of a journalist moving from a state of innocence to one of experience in the midst of violent warfare is a common one, and *Whiskey Tango Foxtrot* risks cliché in this regard. Yet, it also enhances this narrative through the power of the imagery and, in particular, our sense that Gilbertson is growing as a photographer over the three years as he attempts

to make sense of what he experiences and documents. Throughout, he retains what Michael Shaw terms "a sense of open curiosity," producing work that is "thoroughly reverential to the soldiers and the mission at one moment, then unselfconsciously revealing of its cruelty or ineptitude the next."[26] This curiosity is evident in Gilbertson's growing stylistic confidence, often eschewing conventions of war photography and unafraid to make use of aesthetic options. In particular, his use of light and color add rich dimensions to the work, used at times to humanize the subjects or, at others, to introduce symbolic associations.

Perhaps the most suggestive photograph in these terms is one he took during the Fallujah assault, which depicts an Iraqi detainee bound, blindfolded, and bent over on the ground (fig. 4.3). He notes that the marines had covered the man's wounds with tape and then guarded him, while several "wandered up sporadically to study their elusive enemy."[27] When the captured fighter claimed to be a student, a marine responds, "Yeah, right. University of Jihad, motherfucker."[28] Gilbertson did not take the photograph hurriedly but contemplated the shot he wanted: "It was dawn, and the light was perfect. Long shadows dappled a wall above one of the detainees. . . . I waited for the guard to cast a silhouette over the Iraqi."[29] It is an image in which the aesthetic and the documentary elements meld to invite contemplation—the viewer's reference points are as likely to be painterly as photographic, including Christian iconography and colonial master-slave scenes. It invites reading as an image of imperial domination, yet the identity of the "elusive enemy" remains hidden, symbolizing a relationship of which Gilbertson was cognizant. Commenting on the image in an interview, he draws attention to the relationship between a "very faceless insurgent with a very faceless American" and remarks: "I think most Iraqis and Americans would be able to identify with that image. . . . The anonymity of both the insurgent and the American soldier is really important there. . . . Both of them see the other as a faceless enemy."[30]

While this speaks to an important aspect of the power relations signified in the image, there is a further level of complexity in the viewing relations. There is a dissonance on viewing the photograph that is implied in Gilbertson's comments and that is indicative of the ambiguities inherent in using photography as a documentary witness to imperial American power. We traffic back and forward between the particular and the universal, between the humanistic and the imperial, between care and domination—where does our gaze rest? This question entails a whole history of looking relations surrounding imagery of subjugated bodies and bodies in pain, particularly those framed by colonial or postcolonial conditions of power and conflict. In such instances, the subjugated body is

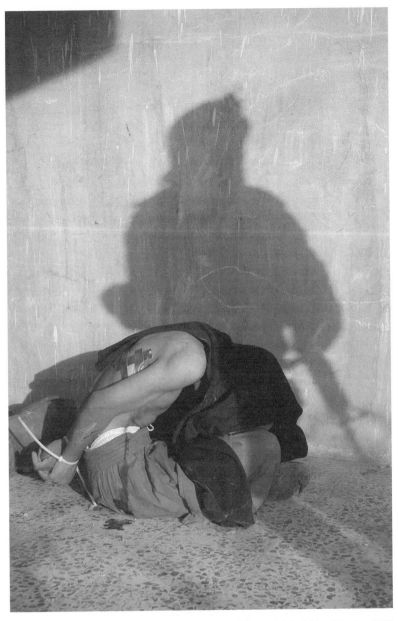

4.3 Marines detain an insurgent, Fallujah, Iraq, 2004. (Photograph by Ashley Gilbertson/VII.)

the focus of mute testimony.[31] In this image, the spectacle of the subjugated body denotes the performative power of the American military to humanize and dehumanize. We might say that what we see in this image is the mise-en-scène of the war on terror as a perpetual war, wherein war becomes "an abstract form of the theatrical capture of an adversary."[32] What we see, to use Alain Badiou's terms, is a performance of an unlimited power that "promises to liberate the other from his non-existence"—this scene is a performance of liberation that mimics the military performance of liberation as a (rhetorical) political aim of the U.S. invasion of Iraq.[33]

What this spectacle of subjugation represents is the ethical knot in viewing relations conditioned by American imperialism.[34] The photograph fails to provide us with an interpretive frame that might allay or organize our confused thoughts and feelings as we look at it. Yet, the ambiguities of the image and very failure to provide answers make it valuable as an indicator of the limits of our knowledge formations and ethical imaginations. In his introduction to *Whiskey Tango Foxtrot*, Dexter Filkins writes: "The Americans went about their task with energy and determination, but as the years dragged on Iraq kept eluding their grasp."[35] That is the underlying irony of this image: what is "captured" both by the U.S. military and by Gilbertson's embedded lens remains elusive.

Being embedded was key to Gilbertson's experiences and his photographs, their strengths and weaknesses.[36] His work does register the embed frame yet there is also a tension within the frame as he begins to signify his despair about the value and meaning of what he is doing. The testimonial authority of his work, particularly as it is narrativized in *Whiskey Tango Foxtrot*, is marked by this tension.

Hondros

Another photographer who has worked within the embed system and tested its limits is the American Chris Hondros, who covered the war in Iraq for several years until his death in Libya in April 2011. The image in figure 4.4 was taken in the town of Tal Afar in northern Iraq on the evening of January 18, 2005. Hondros, embedded with a platoon from Apache Company of the 2-14 Cavalry, accompanied a number of soldiers on an evening patrol during which soldiers fired on a car that approached them at a checkpoint. The car crashed following the firing and was found to contain a civilian Iraqi family. The father and mother, Hussein and Camila Hassan, were killed by the gunfire. Of the six children in the back seat of the car, one child was wounded and five were not physically scathed. Figure 4.4 shows one of these five, Samar, then five years old, surrounded

by U.S. soldiers. Hondros sent out his photos before the commander of the unit he was embedded with could stop him. They were widely circulated, and this image in particular came in for wide discussion, much to the consternation of the U.S. military—Hondros was removed from the battalion shortly after the pictures were published.

Hondros bent the embedding rules in sending out the images in the first instance, and a number of mainstream publications took what they considered to be risks in publishing them. Hondros has commented in an interview on the events surrounding the making of the photograph:

> . . . [the military] didn't try to obstruct me or stop me from photographing—and they could have—and it's kind of remarkable that they didn't; it's kind of a human reaction and so on. But they didn't, and that has happened before: sketchy things have happened on embeds. Almost every soldier in Iraq has been involved in some sort of incident like that or another, I would say. . . . But I realize, as much as that happens in Iraq, it almost never gets photographed, and so I did realize I was onto an important set of pictures.[37]

Hondros took more than a dozen images of the event. Those that have been published can be viewed as a narrative sequence that starts with blurred images of the car containing Samar's family before and after it has been shot at by U.S. troops, followed by images of shock and grief among the children, of her dazed brother who has been injured, and of the transportation of the children to the hospital.[38] Viewed within this series, the image of Samar is but one image of shock and horror at the scene of a confusing and violent event, but it was the image of Samar screaming that was most widely and prominently published. *Newsweek*, for whom Hondros was working at that time, used it in several reports on the event and its aftermath. The media coverage pressed the military to explain the actions of the platoon and has been credited with putting pressure on the U.S. military to change its protocols regarding military engagements with civilians in Iraq. It also provoked some citizens in the United States to set up aid support for the Hassan family.[39]

Hondros's picture of Samar is often referred to as an iconic image of the war in Iraq. Generally, the claim to iconicity is based on the symbolic role of Samar as an innocent witness to violent horror. But this is an ambiguous role that has been framed in different ways within U.S. media. For some, the image powerfully punctured the censorship and silence surrounding civilian deaths in Iraq and Afghanistan and functioned as an indictment of the arbitrary violence of U.S. foreign policy. But the more common framing in U.S. mainstream media positioned it as an "accident"

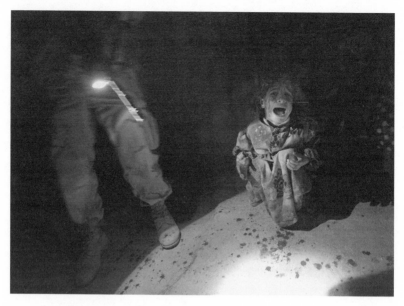

4.4 Samar Hassan screams after her parents are killed by U.S. soldiers, Tal Afar, Iraq, 2004. (Chris Hondros, photographer.)

and a "tragedy." In *Newsweek*, for example, Owen Matthews observed that "it's hard to see the Hassan shooting as anything but a horrible accident of war."[40] This framing focused on Samar's expressive enunciation of shock and grief and the correspondent compassion this is assumed to engender in the viewer. It is exemplary of the ways in which affective responses to the violence of war may be channeled by spectatorship ideologies of collateral damage.[41] To be sure, viewer responses to the imagery will vary due to many factors, but the emphasis of such textual framing works to deflect even as it announces growing domestic unease about the meaning and impact of the war. It promotes compassion as a commensurate response to this moment but also glosses disillusion and any deeper questioning of the meaning or impact of the war. In other words, it functions to sentimentalize the violence done to Iraqi and Afghan civilians by U.S. forces, reassuring American readers that the United States acts responsibly, with humanitarian intent. This is precisely why such framings of collateral damage are not antithetical to those of shock and awe—they exist in a symbiotic relationship in visualizations of perpetual war.

As we have seen, the generation of compassion is a common motif of photojournalism that deals with bodies in pain and other human damages caused by wars and violent abuses. As we have also seen, visual ap-

peals to compassion are unstable interpellations of ethical or political consciousness or critique. As such, they register the multiple professional and ideological demands on the photographer and the multiple tensions that the framing of the photograph signifies even as it works to create a stable image. These tensions are evident in Hondros's image, which *is* a powerful critique of the actions of the U.S. military but also dramatizes the complex relationship between photographer and the event and registers ideological conditions of the embed system. In particular, we should note the ambiguity of the photographer's role, which is reflected in visual ambiguities in the image. The lower half of the picture is bathed in a light emanating from a torch mounted on a gun held by the soldier standing beside Samar. It provides the image with an oddly dramatic sense of setting and occasion, as though on the edge of a stage, and so lends the scene symbolic or allegorical associations. The light is of course necessary for the photographer, if he is to take a legible image, and so he is dependent on the soldier's presence; they are further linked by their anonymity and power, including the power to stage and record the event. On this reading, we might consider Samar a victim of both, her pain subjected to the point of view of the victimizers, and to other spectators in the darkness, including those who will view the published image. Yet Hondros is also operating to witness effects of this military power, so his image is also a form of critical illumination, revealing what is not usually seen or is disavowed in the activities of the U.S. military in Iraq. On this reading, the darkness surrounding the image is suggestive of the need and the difficulty of looking beyond the frame of the image to pursue the questions it raises but cannot answer.

The ambiguity of the framing and of the sense of staging also pertains to the relationship between the soldier and the girl. We note that while the soldier's weapon is the source of light and implicitly of power in this scene, he is mostly in darkness while Samar is mostly in light, holding the attention of the viewer. The relation between the two is ambiguous. To be sure, once we know the context, the solder becomes a threatening and deadly presence, the more so due to his proximity to the traumatized girl and to his anonymity. But like any iconic image, this one has multiple visual echoes, including the numerous shots pairing U.S. soldiers and innocent children in many wars and sites of conflict.[42] Such images raise questions about the relationship between the role of the U.S. military as violators and defenders of peoples whose countries they have invaded. In several of the other images in the series Hondros took, U.S. soldiers are shown tending to the wounds of one of the children and then carrying him to hospital. What are we witnessing in these scenes? The confusing

correlations of scenes of empathetic care and violent domination emblematize the contradictions of the American mission in Iraq.

The ambiguities of the photograph are not contained by the embedded frame. Beyond its direct appeal to compassion, it remains compelling because of the shifting connotations of care and violation that attend the relations between the photographer, the soldier, and the girl and because of the excessive affect induced by Samar's soundless scream. As such, it represents the complexity of the moral economy that informs the photographer's mission to "bear witness" to a scene of atrocity under conditions of perpetual war; it frames Samar as a victim of collateral damage, her humanity acknowledged but also discounted in the calculus of the "costs of war." Samar Hassan is, of course, but one haunting figure of collateral damage, a consequent yet inconsequential supplement to the preemptive violence of the war on terror.

Romano

Once again we see how the embedded frame shapes the making and meaning of imagery from the war in Iraq, yet is also critically exposed by it. The final example of embeddedness to consider here is that of photography by U.S. soldiers who are photographing their experiences while still serving in the military and posting them on the Internet. Soldiers are doing this in large numbers, some within dedicated web clusters, others in a more ad hoc fashion, and they are creating something new in the process. These images have a distinctive visual language, blending the genres of institutional, touristic, and war photography into a new type of soldier photography. This form of visual communication—in real time and communal—is new in the representation of warfare; in earlier wars, soldiers took photographs, but these were not immediately shared in the way websites can disseminate images globally. Digital cameras, camera phones, and photo blogs are the media that have proved visually commensurate to the war in Iraq, and the soldiers using them are truly "embedded" photographers. This digital generation of soldiers exist in a new relationship to their experience of war: they are now potential witnesses and sources within the documentation of events, not just the imaged actors—a blurring of roles that reflects the correlations of revolutions in military and media affairs.

American soldiers have diverse motivations for producing imagery of their experiences in Afghanistan and Iraq, and there are several platforms for the dissemination of the photographs. The most common functions of the imagery are to communicate with family members and friends in

the United States and to provide alternative imagery of the war zone to that being produced by mainstream media. For some, the focus is on everyday life on the base; for others, it is to produce imagery that challenges viewers to see the "real" war. Most want to share their personal stories and perspectives, and they frequently register a sense of compulsion, fueled in some part by the technology, to record their experiences and, in particular, the everyday happenings around them. Not surprisingly, a number of soldiers have used photography to reflect on some of their questions about their role in Afghanistan or Iraq and the effects of the wars on both soldiers and indigenous communities. Often, they foreground their roles as witnesses to disturbing realities and raise questions about their responsibilities, including responsibility for what they are looking at.[43]

Some of the images being posted by serving soldiers have a more manifest journalistic quality and intent. There are a number of soldier photographers who have set out to create their own visual dispatches from the war front and supplement if not challenge mainstream reporting. One of the best of these is Jay Romano, who has extensively documented his tours in Iraq since 2005 and posted many of the results on Flickr. By carefully editing for online posting only several hundred of the eighteen thousand images he claims to have taken, Romano has produced several sets of imagery that establish thematic and stylistic traits that become recognizable looking across his work. A prominent and consistent theme in his photographs is imagery of explosions from improvised explosive devices (IEDs), which he often captures in the middle distance during the fullness of a blast (fig. 4.5). The images are remarkably crisp and composed given the immediacy of the event and that they are usually shot from inside an armored vehicle. On his adeptness at capturing these explosions on camera, he comments: "When it comes to balancing the soldiering and photographing, the act of looking and seeing has helped both. I can only say this because of the results. In comparison with my peers, I can locate 300% more IEDs. Why? It's because I'm looking for images, not that I have a gift or am working with the insurgency as some of the guys tell me."[44] This compulsion to look for images (rather than to snapshot what randomly occurs) sets his work apart from many soldier photographers and lends it both depth and insight. The work is not political but it is more engaged with the contexts of the war on the ground than most.

Romano is a little unusual among soldier photographers in that he had already had training as a photojournalist before going to Iraq. He acknowledges that there can be tension between his military role and his journalist sensibility but asserts his primary allegiance to the army and dryly notes: "With journalists being as rare as a unit function sponsored

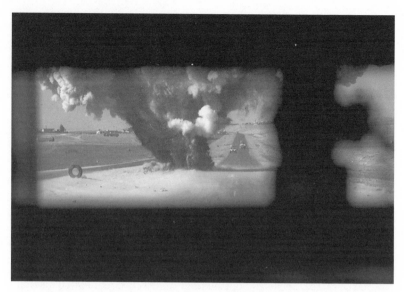

4.5 IED explosion, "Purgatory Road," Mosul, Iraq, 2008. (Jonathan Romano, photographer.)

by Budweiser . . . how can I not take on the burden of documentation."[45] The quality of his imagery stands out from much soldier photography due to the quality of the equipment he uses but also due to his skills in composition and other techniques. As noted, much of his imagery is of scenes viewed from moving military vehicles. This can lead to blurred or banal imagery by many soldier photographers, but Romano is able to produce clearly focused shots that capture remarkable street scenes and the expressions on the faces of Iraqis nearby. The distance that is so much a feature of this imagery is maintained but also becomes a stylistic device in Romano's work (with conscious references to the genre of street photography), so that he uses it to signify the ways in which being a soldier frames particular experiences of the war zone and encounters with indigenous peoples.

Posting images of his last tour in Iraq, Romano selected one image for particular emphasis as symbolic of the distance between the Americans and the Iraqis. It depicts a young street sweeper staring at the photographer. Of this image he remarks,

I will always remember the countless blank stares received from the people we were supposed to be helping, supporting and fighting for. . . . If this was my life, my world . . . the indifference makes sense. For a pseudo-American civilian life I've now found myself in, these stares have left me guilty. There's a certain detachment many of us "over there" have spoken about during our time over there. And it is true if you

look at how we have evolved our war fighting. I come home and see where this indifference and detachment has come from.[46]

Such reflections denote a critical self-consciousness about his dual roles as soldier and photographer and, also, about the relations between colonizer and colonized. In this image, the blank stare of the sweeper obliquely mirrors the empty gaze of the occupying forces, emphasizing the indifference and detachment of the latter. Notably, Romano associates this detachment with new forms of warfare and the sense of distance they instill in both war-front soldiers and home-front citizens. Another image by Romano powerfully if quietly reflects—and reflects on—this sense of distance. It depicts his desk in the corner of a dimly lit tent in his station in Iraq. On the desk is his open laptop, which displays a pornographic image of a naked woman. Romano's short statement posted with the image reads: "My new home, simple yet utilitarian. All madness usually begins and ends right here."[47] A poster on the Flickr site leaves a comment: "Strong picture, it could be a metonymy of the soldier's condition. The dim light, the rough set-up, the empty chair, the obscene desktop wallpaper, all these elements produce an atmosphere of dull violence, in complete contrast of your description of the place as a 'home.'"[48] Romano responds:

It's an interesting place to say the least. Much of my time here it feels as if the war is so far away. . . . A lot of what has happened in the last seven months seems to start coming out of the closet so to speak. I think with a lot of time on my hands more images like this will start surfacing. . . . I like your description on how it is a 'dull violence.' I never really thought about it but that's how it feels. You know it's there but it's just not actually happening.[49]

This is a suggestive exchange, indicating not only a soldier's sense of distance from "the war" but also the collapse of distance between the war front and the home front. It also suggests that this image references what is commonly disavowed in representations of American military culture. What it depicts is not only a metonymy of the soldier's condition in Iraq but a primal site for the screening of soldiers' fears and desires—what is "surfacing" in and through such images is the optical unconscious of U.S. policy in Iraq.

Ultimately, the historical significance of soldier photography may reside less in the controversial or revelatory images (though some of these will undoubtedly take on iconic status) but in the mundane images, in the documentation of the environments, activities, and feelings of American soldiery at war, especially in more ordinary moments. These images con-

stitute a chronicle of what American soldiers desired and feared, of what they avowed and disavowed, of "the things they carried."[50] This material is slowly building into what will become one of the most complete archival records of the experience of war. For now, this photography offers compelling, real-time perspectives on the American soldier at war that suggestively supplement other forms of visual knowledge about the conflicts in Iraq and Afghanistan and indicate the effects of such "amateur" documentation on our understanding of war today. In particular, the compulsion to visually document war experiences suggests a new invigoration of the documentary impulse to bear witness to otherness, an impulse long shaped by colonial and postcolonial conditions of power and knowledge.

Homeland Insecurity

The war on terror is not only an external event and threat but also an internalized condition of everyday life in the United States. Because the immanence of this war dissolves the ideological and affective borders between foreign and domestic affairs, the "American way of life" no longer characterizes the imagined community of the nation. Rather, it describes its dislocation within the inaugurated homeland security state, which has extensively naturalized the domestic dramas of constant emergency. There are a number of significant photographic treatments of this domestic impact, and I will consider several in this chapter. All of these photographers seek to represent the war on terror by looking inward at a time when much documentary attention is focused on Iraq, in order to ask questions about the conditions—material and mental—of war at home; indeed, as we shall see, the idea of home is a significant trope in much of this work.

This is not only a consideration of what these documentary images represent but also an inquiry into the capacity for documentary imagery to critically mirror American society, at a time of multiple crises in the American worldview. As noted at the outset of this study, photojournalism does significant political work as a mediator of the meanings of civic life and action, re-presenting democratic life to its participants. Robert Hariman and John Louis Lucaites have argued that "photojournalism is an important technology of liberal-democratic citizenship": it both mirrors and shapes relations between liberalism and democracy, between public and private spheres, and between the individual and the state. In the long wakes of the wars in Afghanistan and Iraq, it continues to map these relations, critically and symptomatically. I want to consider the role

of documentary photography in delineating the values and purviews of an American worldview and of an American way of life under conditions of perpetual war.

Berman

Nina Berman has worked as a photojournalist in several countries but began to concentrate her focus on the United States in the wake of 9/11. In an interview, she remarked, "My intention was to work out through photography my own conflicted responses to September 11, the call for security and what that meant."[51] Over the last twelve years she has developed a body of work under the title Homeland, which encompasses several projects. At the core of this work is her effort to explore the intertwining meanings of militarism, security, and identity in the United States. Two books and several exhibitions have so far emerged from this work.

The first book, titled *Purple Hearts: Back from Iraq* (2004), is a series of photographic portraits and interviews with severely wounded American soldiers who have returned to the United States from Iraq. The portraits were taken in sites across the United States, in military hospitals, army bases, and, mostly, soldier's homes. In all instances, the portraits are tightly framed so that the individuals appear isolated and without any clear institutional or emotional support. Almost all of the subjects have moved beyond the initial stages of return to the United States, when they were hospitalized; Berman seeks to photograph them at later points when "the reality sets in that this is it."[52] In doing so, she both questions the post-9/11 conception of "hero" and underlines unsettling linkages between war and domestic fronts.[53] Berman says she undertook the *Purple Hearts* project when she realized there were no images of wounded American soldiers in the mainstream media. It has toured schools as well as museums and galleries in the United States. Berman has reflected on what pressed her to undertake the project:

Looking back, I now understand how desperate I was to carve out a place of truth amid the spectacle of "shock and awe," "mission accomplished," the "hunt for Saddam," and the yellow ribbons and freedom fries. There is a curious divide between those who live the reality of war each day—the combatants, their families, the civilians under occupation—and those for whom war is just background noise in the nightly news reports. For me, photographing the soldiers made my country's actions very personal and real. . . .

There are no lists of the wounded, unlike the dead. In newspapers, the names of the dead are published every day along with their ages, hometowns and command

units. I read these names and feel sorry for the soldiers' families and friends. But the dead tell no stories. It is the wounded that survive and present us with our own complicity.[54]

In intent and style, *Purple Hearts* is a quintessentially traditional documentary project—focused closely on human subjects, revealing hidden truths, witnessing the pain of others, and stylistically utilizing conventions of the medium format and clear composition—these are images as evidence. The photographer's mission is to inform, driven by a desire "to carve out a place of truth," conscious of the discourses of war and security that obscure the realities of war and insecurity.

Berman's second major book of images from the Homeland series, titled *Homeland* (2008), more directly addresses these discourses. She traveled around the United States, photographing terrorist attack simulation drills, gun shows, and military recruitment events. This is a project she began shortly after 9/11 and it was reenergized and focused in part by her experience interviewing and photographing the wounded veterans as many of them commented on growing up "thinking that war would be 'fun' and remembered watching the first Gulf War on TV which they described as 'awesome.'"[55] With this in mind, Berman decided to focus on "how we visualize war": "Rather than continuing to show evidence of war, it seemed appropriate for me to now show the fantasies of war, the selling of war, and with it, the militarization of American life."[56]

This project evidences a shift in Berman's methodologies and representational strategies. Again she went on the road, but now she wanted not to produce portraits but to delineate and document the culture of fear that was naturalized by the homeland security state. Her images capture the way fear and theatrics are being used to make anxiety an acceptable part of everyday American life. Many of the photographs use saturated color and skewed compositions to disorient the viewing process. In an interview, Berman remarked, "I've always had very saturated color and aggressive compositions—there's very little white space, so you feel claustrophobic in my pictures, and there's no single place for the eye to go. I think that over the years the work has become more abstract, less grounded in the information of the scene. The images are more symbolic than informational. They're almost non-journalistic."[57] This more impressionistic photography accentuates the surreality of the American way of life in the homeland state. In some images, this is quietly stated as the photographer alerts the viewer to the incongruities of terror alerts in the landscapes of the American heartlands. One image focuses on a warning sign about Homeland Security in a snow-covered suburban street outside Chicago—

its bright colors contrast with the peaceful winter idyll of the setting. Other images are more immediately disconcerting. An image taken of U.S. soldiers at the 2001 Columbus Day parade in New York City focuses on their swinging legs and boots marching on a bright red carpet, with eerie echoes of Nazi goose-stepping. In many images, the faces of people are concealed or turned away from the camera. An early image in the book depicts two people sitting in a camouflaged hide, the upper parts of their bodies visible but the top half of their faces hidden by the camouflage. There are several images of Americans at beaches or parks, looking up at military fly-bys. In an image taken on a beach in Atlantic City in 2007 during an air show, a stealth bomber flies overhead and people sunbathing on the beach stare up at it (fig. 4.6). In the background, children play, seemingly oblivious to the plane. In the rear middle ground, a sign attached to a pier reads "PAINTBALL: LIVE TARGETS." The people in these images are cast as casual spectators of military technology as they go about their everyday lives and leisure rituals. What the photographs emphasize through repetition is the normalization of the homeland security imaginary and its concomitant militarization of everyday life in the United States.

Berman documents an evolving security state in which public spectacles play an increasingly significant role. She comments: "Some of these events have the look and feel of state-sponsored performance art, where

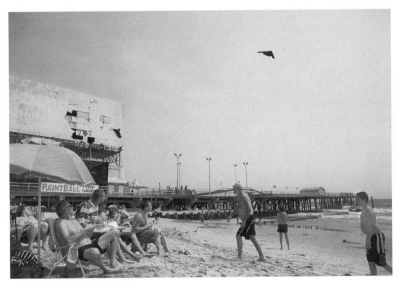

4.6 A stealth bomber flies over a beach in Atlantic City, USA, 2007. (Nina Berman, photographer.)

realism is replaced by theater, giving participants a powerful sense of identity and value through a militarized experience. It is this identity and the ambiguity between real and made-up, so emblematic of post 9-11 discourse, that interests me most."[58] This is well illustrated by many images in which civilians are cast as active performers in military scenarios, especially the simulation exercises in which large numbers of people enact roles in response to terrorist threats. With these images Berman is more pointedly illustrating the performativity of citizenship and implying that this has been intensified in the wake of 9/11 as the public learns its active and passive roles, as participants and spectators, in the visual drama of homeland security. This focus on performative and embodied citizenship also foregrounds the role of photography as a "technology of liberal-democratic citizenship," which can reflect and reflect upon the tensions between individualism and governance in the public sphere. It is in part due to her manipulation of the conventions of photojournalistic reportage that Berman renders the homeland figured in these images as an uncanny space, an unsettling admixture of the familiar and the unfamiliar. This uncanny homeland, brilliantly emphasized by the compositions, is the mise-en-scène of Berman's visualization of the American way of life.

Suau

Anthony Suau is a distinguished American photojournalist who was based in Europe for twenty years, during which time he covered global projects for the Black Star agency and, since 1991, as a contracted photographer with *Time* magazine. Perhaps in part because of his long residency outside of the United States he has tended to view the United States from an international perspective. Since the U.S. invasion of Iraq in 2003, Suau has focused almost exclusively on the impact of international events on the lives of people *in* the United States. Watching the build up to the invasion while based in Europe, he decided he would photograph the home front rather than set off for Iraq like most of his colleagues. In a striking series of photographs, many of them first published in *Time* magazine, he chronicles the build up to the invasion and the first days of the war. The photographs were published in a book titled *Fear This: A Nation at War* (2004).

Suau traveled across the United States, documenting a wide range of subjects and landscapes linked to the making of war, covering both "news" events and everyday insignia of the war's presence on the home front. Attention to the news of the war and its documentary reproduction in American society is a key theme of the book. In early sections,

Suau mixes his own imagery of discussions in the United Nations with images of television broadcasts of these discussions. Thereafter, the news of the war becomes a central focus, as we follow its development via photographs of newspaper headlines and television news broadcasts. Several images depict people sitting in bars as imagery of the war plays on television sets. In others, large screens in Times Square display news imagery while people move along in the streets below. There are several pages depicting multiple, close-up images of television coverage of the war and of newspaper vending machines, displaying headlines about the war. Throughout *Fear This*, Suau underlines how "invasive" and everyday the imagery of Operation Iraqi Freedom was at that time, filtered into the consciousness of Americans in myriad ways; he notes: "The war was being broadcast *everywhere*. You'd walk into a Wal-Mart store in North Carolina, and all the televisions mounted on the walls would be showing the bombing of Baghdad. It was *there*. It was so present."[59] This pervasive screening of the war in public spaces connotes a spectacularization of politics that is also signified by the theatrical actions of politicians and demonstrators alike. Suau includes both pro-war and anti-war demonstrations, counterpointing the symbolism and theatrics of each. Across several sites—from the UN and CNN interiors, to sites of public congregation (bars, churches), to the streets of several cities—he illustrates connectivities and polarizations of the public sphere in the United States and draws our attention to the performativity of citizenship as the nation is prepared for war.

In *Fear This*, the ubiquitous screening of the war does not render it closer, more immediate to Americans; rather, it naturalizes the war as spectacle and the "home front" as the sphere of spectatorship. Whereas Berman depicts the American homeland as a culture of fear fixated on securitization and civic paranoia, Suau depicts it as a fractured public sphere in which a mediated war both divides and conjoins the populace in a state of perpetual disinformation. Like Berman, though, he valorizes the potential of documentary photography to illuminate the damages in the civic fabric of the nation. Also like Berman, but more pointedly, his practice seeks out the connectivity of international and domestic realms, conjoining spheres of information usually separated by media conventions. This remains evident in his more recent work, focused on the U.S. economic crisis.

In early 2008, Suau convinced *Time* magazine to commission him to take a series of photographs in Cleveland, which was already an economically depressed area at that time. He shot imagery of the work of police officers who conducted the evictions of people who were unable to pay their mortgages. For much of his three days in Cleveland, Suau followed an

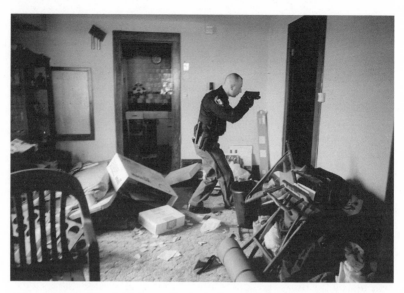

4.7 Armed sheriff in eviction home, Cleveland, USA, 2008. (Anthony Suau, photographer.)

officer of the Cuyahoga County Sheriff's Department, who would deliver conviction notices and ensure that houses were secured. A series of photographs document the movements of the officer and the environments of vacated houses. One photograph in this series warrants some critical scrutiny, not least because it won the award of 2009 World Press Photo of the Year (fig. 4.7). The photograph was taken in March 2008. It depicts the officer moving through a house that had belonged to an elderly couple. According to Suau, the house had been vandalized, and there was "evidence that vandals had taken a gun that used to belong to the couple."[60] The image has suggestive domestic and geopolitical frames of reference that are interlinked. They render the United States as the locus of an economic crisis that is global in scope and was precipitated precisely by the mortgaging of American homes, such as this one, now foreclosed—in this sense we might say we are looking at a primal scene of America's neoliberal disorder. More pointedly still, in the context of state interventionism in privatized economic sectors in the early stages of the financial crisis, we should note here that Suau records the impact of the state in domestic life, in the role of protecting private investors. If we read the policeman as the agent of the state in this image, his armed yet uncertain entry into the American home also symbolizes broader insecurities and vulnerabilities in the United States in the wake of 9/11 and under conditions of a perpetual war on terror. In these readings, the American home registers

insecurities of the American way of life, symbolically and economically destabilized by international events instigated by the United States but now beyond its control.

The war on terror and the financial crisis are complexly interwoven features of an unregulated globalization that has effectively dislocated established registers of empathic identification with the worlds of "others." Today, international landscapes of violence and despair are less securely framed as distant spaces. Perhaps this is what Suau's image most fundamentally signifies: the dislocation of photojournalism's (and more particularly, an American-centered photojournalism's) relationship to its subject.

Gilbertson

Where Berman and Suau work to illuminate the impact of perpetual war on American public life and space, Ashley Gilbertson has created several projects that are less political in conception but also aimed at demystifying the war by documenting its aftereffects on the home front. For Gilbertson, the urge is to find new ways to represent the war in order to galvanize the American public: "Photographs of a thousand more bloody soldiers won't change anything. I can't make [the public] care about the war by bashing them over the head with it."[61] Convinced that the stories that need telling are on the home front, he has worked on several related projects, including post-traumatic stress disorder and suicide among veterans. In 2007, he devised the project "Bedrooms of the Fallen," photographing bedrooms of young soldiers killed in Afghanistan or Iraq, and has come to believe this represents "the true cost of war. It's the most authentic war photography that I've ever captured."[62] This project, he says, "was in response to my failed work in Iraq. It was about the failure of people to engage with the pictures I took while I was there and, I think, my failure as a photographer to present them freshly. By working on the bedrooms, I can help people understand who's fighting in the war and what we're losing as a nation."[63] More particularly, he says that William Miller's death was the catalyst for the project: "If anything good came out of Miller's death, it's that I know I'm trying to articulate the war to a country that doesn't really care. I want to make them care."[64] There is an intense personal investment in the work, filtered through a humanistic vision that is consistent in his image making but now charged by his belief that the true impact of war is not visible in combat photography but can be experienced in looking at the bedrooms of dead U.S. soldiers.

The first major publication of the work was a photo essay, "The Shrine

Down the Hall," in the *New York Times* in March 2010.[65] Since then, Gilbertson has photographed not only the bedrooms of dead U.S. soldiers but also of soldiers from several other NATO countries. The resulting images are immensely affecting. The austerity and directness of his black-and-white photographs, all presented in a similar format, invite contemplation from the viewer. He uses a wide-angle lens for panoramic effect, exploits natural lighting, and uses black and white "so that the viewer had an even playing field to explore the objects in the room. I didn't want colours to lead you away from things in their bedrooms that might connect with a viewer."[66] The bedrooms have been preserved since the death of the inhabitant, with many of them taking on the aura of a shrine. They are private retreats, filled with the paraphernalia of the everyday life of the young people who occupied them—posters and high school photos, stuffed toys and figurines, sports trophies—all of which the eye travels over, seeking out meaning about the identities of those who are dead (fig. 4.8). There is a sensation of transgression in looking at these rooms, that we are not really supposed to see such private spaces that are now private for the living rather than the deceased. It is impossible to look at them without thinking both about the dead soldier and the surviving family. Most of the rooms look composed, as though the objects have been carefully arranged, so that we ponder the degree of artifice in their presentation—not by the photographer but by the families—yet to ponder this is also to realize the emotional pitfalls of attempting to "preserve" these sites of memory.

With "Bedrooms of the Fallen," Gilbertson seeks to recharge the humanistic contract in documentary photography—the assumption that there is a direct, ethical relationship between representation and responsibility, compelled by the act of bearing witness. As we have seen, this assumption has been significantly challenged by events and by the

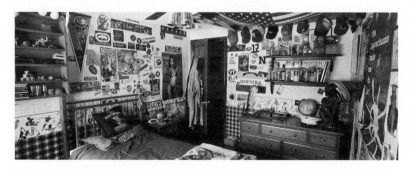

4.8 The bedroom of Corporal Christopher G. Scherer, twenty-one, East Northport, USA, 2009. (Photograph by Ashley Gilbertson/VII.)

indifference of publics. It has also been questioned by critics, especially to the degree it hinges on the evocation of compassion and empathy. Gilbertson certainly seeks to evoke these responses—"I want to make them care"—and is unabashed about his sense of responsibility to the families of the "fallen" and the need to "honor" the dead. In some respects, this effort to renew the humanistic contract is a regressive exercise, not least in its exclusive focus on *American* deaths and experiences and in its apolitical stance. While Gilbertson's sincerity of purpose is not to be doubted, his argument that "I think you can be anti-war without it being political" might be viewed as naive. However, this also functions as a shrewd effort to sidestep polarized political positions that debar many forms of human interaction and understanding and is, in addition, a pragmatic reflection of his need to engage military families. Gilbertson's project is a brave and imaginative one, in part because it addresses the issues of distance and disavowal that are so important to the conditions of visuality that influence perceptions of the war on terror in the United States. Commenting on the project, he states: "It tells us that these men and women died far away from home, and that while our country may not feel like it's at war, the tiny fraction of people that volunteer to serve and their families are feeling the vast brunt of that engagement. We, in a functioning democracy, should all be aware of these losses and empathize with those affected instead of ignoring it."[67] This is an important recognition of the gap within American society between those directly affected by the wars in Afghanistan and Iraq and those who are not.[68]

Gilbertson's reference to "functioning democracy" brings us again to the issue of the role of photojournalism as a "technology of liberal-democratic citizenship" and to its potential to critically reflect the war on terror. The work discussed here might be said to evidence such potential, in the sense that it allows us to glimpse beyond the rationality of perception that binds value and security in the American worldview, to apprehend realities of the homeland security state. However, this glimpse may be as much as can be asked of these photographers' work given the limits of their truth claims in relation to the wider documentation of reality under conditions of perpetual war and within a public sphere in which the democratic polity is happily prepared not to believe what it sees. This suspension of belief is one of the most beguiling and disturbing features of American public life since the inauguration of the homeland security state. It has not been effectively named or analyzed, though it has attracted some critical at-

tention. It forms the defining characteristic, for example, of what Mark Danner has termed "the age of frozen scandal," in which there has been "a harvest of rapidly aging images and leaked documents," but "the public, that repository of right, showed relatively little interest."[69]

In the age of frozen scandal and perpetual war, the truth claims of documentary photography are more dependent than ever on ideological conditions of visuality that shape the production and consumption of those claims. Both Berman and Suau allude to these conditions in their work, documenting a public both blinded by and complicit with the spectacle of war—a war that was and is hidden in plain sight, on the multiple public screens shown to us by Suau and in the performances of securitization shown to us by Berman. This may be the most significant legacy of their work, to have documented the expansive ways in which the American way of life has been penetrated by the war on terror. To put this another way, their intervention has been to hold up critical mirrors that reflect collective deceptions, denials, and complicities.

This should be part of the work of photojournalism if it is to critically mirror the constraints and borders of "functioning democracy" in a time of war. This entails acknowledgment of the charged ethical relations constituted in the activity of taking and looking at photographs. Berman recognizes these relations at work in visualizing the wounded soldiers in her *Purple Hearts* book, where she observes that the wounded soldiers "present us with our own complicity." Asked in interview to explain this statement, she answers: "The complicity is that we are supposedly living in a democratic society where our leaders are answerable to the public. When you live in a nation that goes to war unprovoked, you have to realize you are somehow to blame."[70] The work of Berman, Suau, and Gilbertson would suggest that what remains of the documentary ethos of an American-based photojournalism is a commitment to continue to represent the "big picture," the nation and its discontents, but also to recognize how global concerns inflect this picture and dislocate conventional frames of reference. In visually documenting the effects of the war on terror on the domestic sphere these photographers map the shifting contours of liberal-democratic citizenship in the United States at a time of manifold crises in the American worldview.

The Costs of War

Today, we live in the perpetual present of a war that exists in real time and for which we have as yet no adequate ethical gauge of our human affiliations. Photographic representations of the war on terror mimic this lack, reminding us of the limits of our knowledge formations and ethical imaginations. This is one sense in which the war on terror may be described as unrepresentable and suggests photography may be losing the power to explain what it is we are looking at. The imagery reviewed in the last chapter denotes the difficulty of gaining a critical purchase on the war on terror, not only due to the formalized media restraints such as the embedded system but also collective forms of disavowal in the American public sphere. Under conditions of perpetual war, the capacity of photography either to critically shape public understanding of events or to activate affective registers of empathy and compassion is in question. In a "post-photographic" era, we may be experiencing the limits of the photograph's truth claims.[1]

Is this yet another declaration of the "death of photography"? Not quite. The many deaths of photography are evidence of its afterlives, its propensity for exhaustion and reinvention. Over the fifty years of conflict involving the United States that we have observed in this book, from the beginnings of the Vietnam War to the ongoing war on terror, we have seen evolution in the technologies of visual representation, in the stylings and framings of representation, and in the philosophies underlying the activity of photojournalism. More pertinently with regard to the critical documentation of U.S. foreign policy, we have seen that

161

this evolution is far from a smooth succession of formal innovations but rather a series of reinventions based on the questions photographers have asked of their medium in relation to the shifting realities of war and violence and the ideological conditions of their visuality. Moreover, the questions asked by photographers have been shaped by distinctive stages of American global hegemony and at times reflect the entanglements of the genre with imperial perspectives. In other words, photographers are seeking answers to not only formal problems of visualization but also ideological problems, ways of seeing war and state violence, ways of seeing U.S. foreign policy. As such, the limits of the photograph's truth claims are a register of the tensions and challenges that adhere to the ideological conditions of its production and circulation. A particularly daunting challenge for the photographer is voiced by Susan Meiselas: "The larger sense of an 'image' has been defined elsewhere—in Washington, in the press, by the powers that be. I can't, we can't, somehow reframe it," and yet Meiselas has devoted her career to reframing images in contradistinction to hegemonic frames.[2] Throughout *Afterimages* we have seen this ideological tension again and again functioning as a vital if often frustrating element of a photographer's aims and innovations, from Philip Jones Griffiths and his idealistic and didactic efforts to produce a critique of the American war in Vietnam to Ashley Gilbertson, whose concerns are driven by the entwined complexities of his relationship to U.S. foreign policy as witness and embedded actant.

This is to say that photographers have recognized limit points of the medium's documentary truth claims and incorporated this within their highly self-aware practice. To pose the question of limits is not to point up the failings of the medium but rather to underline this limit as a necessary component of its inventiveness and development and also to draw attention to and question the assumptions and expectations the very idea of a limit creates. Photojournalism has long been burdened by assumptions and expectations that devolve from its mid-twentieth-century, Western origins. A key tenet of the visual philosophy of twentieth-century photojournalism was its commitment to a democratizing vision of human affiliations and an imaginary globalization of conscience. It posited compassion as a commensurate response to the suffering of distant others and promoted the role of the photographer as "witness." This philosophy, fueled by abstract principles of liberal humanitarianism, defined categories of human need and harm and constituted caring and suffering subjects through conventions of visual representation. This now classic model of photojournalism has been widely challenged and in some significant respects superseded, yet it has left a legacy of assumptions that

greatly inflate the capacity of the genre to both document and enact social change. These assumptions should be understood as necessary fictions, illustrative of both professional and public investments in the medium over time. They should also be understood as burdens on the medium as they create unsustainable expectations about the workings and impact of photojournalism.[3]

To focus on the limits of evidentiary power or of the effective impact on policy (including U.S. foreign policy) as failings is to mystify the workings of photography as a medium and to forget that such failings are not unique to photography. All media and cultural forms have such limits, but photojournalism has been set a higher bar, saddled with a burden that highly overdetermines its ethical and political mandate and impacts. Perhaps this burden has been created in some part due to the nature of photojournalism as a public art form that exceeds paradigms of journalism and goes beyond news coverage to entail questions of ethical and political judgment about war and state violence and about the broader public understanding of foreign affairs. The genre needs to be disburdened of some of the values and assumptions associated with it; we should focus on what conflict photography does rather than on what it fails to do—the better to understand what it can tell us about America at war and about new forms of violence in international conflict.[4]

Afterimages argues and demonstrates through close analysis that photographic images are important means for critical reflection on war, violence, and human rights. They remain so in a postphotographic age, though now within a new visual economy and in relation to new formations of American global hegemony. In the mid-twentieth century, we recall, *Time*'s owner Henry Luce articulated a national prospectus in terms of an imperial vision: "To see life; to see the world. . . . to see and to take pleasure in seeing; to see and be amazed; to see and be instructed; thus to see, and to be shown, is now the will and new expectancy of half mankind."[5] Mid-twentieth-century photojournalism responded to such confidence and played a key role in representing the intersections of national and international affairs and in delineating an American worldview. In the twenty-first century, as noted in the last chapter, this will to see has become both attenuated ideologically and dispersed technologically, while the intersections between national and international have become more multiple and virtualized, less clearly demarcated. Does it any longer make sense to talk of an "American worldview" in this context? What role does photojournalism have in documenting the workings of American power when it is increasingly less tangible and less national? As twentieth-century photojournalism was in some significant ways in a

symptomatic relationship with dominant liberal values and assumptions, has twenty-first-century photojournalism moved into a symptomatic relationship with neoliberalism, understood as the hegemonic global order determined by the workings of free-market capitalism? Might this in some part explain the limitations on visions of social change? What can photography tell us about the relations between U.S. foreign policy and a neoliberal global order? Can photojournalism continue to function as a privileged "technology of liberal-democratic citizenship" at a time of manifold crises for paradigms of the nation-state and of liberal capitalism?

In this concluding chapter, I pick up some of these outstanding questions to consider the role of photojournalism as both a symptomatic and critical mirror of U.S. foreign policy in a postphotographic age. Today, photographers are seeking ways to revitalize perceptions of war and violence, humanity and otherness, and visually map the shifting forms of American warfare. In doing so, they are working to visual vocabularies of documentation and representation that are less idealized than those that have preceded them, less burdened by assumptions about the truth value of the image.

Seeing and Believing

When Philip Jones Griffiths exhorted photographers to "Follow the Americans," he expressed assumptions about the evidentiary value of the documentary image as a revelation of the workings of power and about the role of the concerned photographer as an active witness on behalf of an interested if uninformed polity. These were once widespread assumptions. Harold Evans, writing in 1981, eulogized the evidentiary authority of photography—"some issues of importance can only be understood through photography"—and endorsed "the compelling authority [of photography] in description, documentation and corroboration. We believe what we see; and only what we believe can become a public issue."[6] This belief in the authority of photography to define public issues has greatly diminished. As we saw in chapter 2, it was already weakening in the 1980s, as photographers in the Balkans questioned the value and impact of their work and expressed a growing wariness about the promotion of compassion as a commensurate response to the suffering of distant others. Today, in the age of perpetual war, Evans's confident assertion that "we believe what we see" must be tested anew as the workings of power are more resistant than ever to the evidentiary truth claims of visual and news media. Long-cherished assumptions about the revelatory powers of visual

documentation have been cruelly challenged by the selective blindness of the democratic polity. Proponents of photojournalism have long assumed that to bear witness is also to arouse concern, to provoke indignation, perhaps even to move the viewer to action. In such cases, the image is an indictment. However, this assumption of cause and effect—in the relationship between the image and emotion and, beyond that, in the relationship between suffering and justice—is open to many questions. Not least of these is the question Evans begs: what is the relationship between seeing and believing?

Writing about a videotape showing an American soldier shooting an Iraqi man in Fallujah in 2004, the documentary filmmaker Errol Morris observes: "For many people the interpretation of this videotape will devolve into general questions about Iraq. People will interpret this videotape according to their ideological dispositions. . . . Unhappily, an unerring fact of human nature is that we habitually reject the evidence of our own senses. If we want to believe something, then we often find a way to do so regardless of evidence to the contrary. Believing is seeing and not the other way around."[7] This is a bleak but all-too-apt observation about the capacity of the American public for self-deception, its incapacity to confront the truth claims it is presented with, and, of course, it works against powerfully engrained assumptions about the causal relations between knowledge, action, and justice that underpin much of American popular culture, not to mention the rhetoric of its political governors. That chain may never have existed, but belief in it was once stronger. Morris's argument that "believing is seeing" has value in foregrounding the role of "ideological dispositions" (what I have termed the conditions of visuality) in shaping the American worldview.[8]

How are these dispositions activated by the imagery of war? A potent example is provided by the image in figure C.1, which has rapidly accrued iconic status and is commonly titled *The Situation Room Photograph*. It was taken by White House photographer Pete Souza on May 1, 2011 and initially posted on the White House section of Flickr on May 2, 2011, where the caption states: "President Obama and Vice President Joe Biden, along with members of the national security team, receive an update on the mission against Osama bin Laden in the Situation Room of the White House, May 1, 2011."[9] It quickly became one of the most viewed images on Flickr (1.4 million views within twenty-four hours) and has been subject to multiple interpretations. It was published on the front pages of the *New York Times*, the *Wall Street Journal*, the *Washington Post*, the *Chicago Tribune*, and many other leading national newspapers across the globe. Mainstream media such as CNN and the *Washington Post* lined up experts to

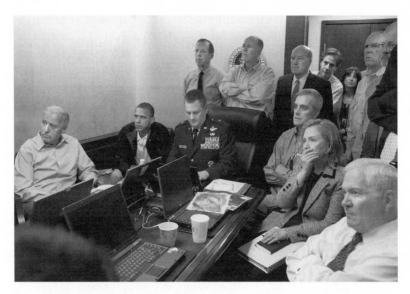

C.1 *The Situation Room*, White House, Washington, DC, USA, May 1, 2011. (Pete Souza, photographer.)

comment on varied features of the images, including body-language experts, remarking in particular on the facial gestures of Hillary Clinton and President Obama. Online, legions of conspiracy theorists have questioned every aspect of the image's production and framing, while Photoshoppers have created multiple memes.[10]

All of the commentary and remediation of this image exemplify its production and circulation as a significant visual event and it has been widely labeled iconic. To be sure, the *Situation Room* image has not yet had extended circulation across time but it has been widely circulated and its iconicity is symptomatic of the conditions of visuality under which it has taken on meanings about the power of the state. The Flickr stream sends out the message that there is nothing to hide, that we have visual access to the events as they unfold. This illusion of transparency is a key feature in the form and content of the *Situation Room* image and helps explain why it has so quickly become iconic. The illusion is enhanced by the allure of the real, the irreducible if fragile "reality effect" of the documentary image that denotes the authenticity of the moment, the slice of time captured in the frame. With this image the reality effect is activated and enhanced, first, by the viewer's sense of seeing "behind the scenes" of power—of having special, momentary access to a reality usually unseen—and, second, the apprehension that this a singular moment of national import. (There

is an added frisson, of course—the possibility that the people in the room are watching the killing of bin Laden.)

This illusion of transparency—a powerful component in the image's iconic rendering of the workings of power—needs to be resisted and debunked. The idea that this image is transparent to the reality of the moment ignores various ways in which it is staged or edited.[11] Beyond such technical issues, the illusion of transparency should be questioned as an ideological conceit. In particular, the framing of the people in the image as spectators displaces the agency of power and violence to a distant, invisible elsewhere.[12] It posits actors as spectators and focuses on the reactions of those exposed to the event rather than the event itself, or more correctly, the staging-as-reaction—the "situation"—becomes the event. This is what occasioned most of the media commentary, a fixation on reading the meaning of the event off the gestures and expressions of the people in the room and off their arrangement within the confined frame of the "situation." Following such readings, we might conclude that the "shock and awe" of this image resides precisely in the dramaturgy of human vulnerability and anxiety of those in power. An apt conclusion perhaps, for viewers are implicitly being asked to identify with the role of spectatorship those in the Situation Room appear to take up on our behalf. But this reading elides recognition of the agency of power and violence that appears to be offscreen but is before us in this room.

The Situation Room is a key node in the networks of military and political power that prosecute the doctrine of preemptive violence.[13] It signifies a militarized extension of vision beyond that technologically available to most citizens (yet which is mimicked in the popular cultures of U.S. gaming, television, and cinema)—an omniscient geopolitical gaze that is activated in the surveillance, targeting, and destruction of "adversaries" at a distance.[14] This omnipresent surveillance of the globe makes possible the conduct of preemptive war-at-a-distance, the targeted killings by drones and other forms of so-called surgical strikes. In the *Situation Room* image, the state is witnessing the execution of its sovereign power to extend violence with impunity. Such violence creates its own interpretive conditions and so suspends ethical and legal conventions of response to its enactments. This image of perpetual warfare documents the power of the state to ratify what will be called reality. It is a reminder that the documentary image can and does function as an analog of the state, naturalizing its violence and authorizing its power to witness on behalf of the polity.

Yet another aspect of the iconic quality of the *Situation Room* image is its symbolic linkage with the national trauma that is named 9/11. The

linkage is made explicit in President Obama's speech announcing completion of the mission to kill bin Laden:

It was nearly 10 years ago that a bright September day was darkened by the worst attack on the American people in our history. The images of 9/11 are seared into our national memory—hijacked planes cutting through a cloudless September sky; the Twin Towers collapsing to the ground; black smoke billowing up from the Pentagon; the wreckage of Flight 93 in Shanksville, Pennsylvania, where the actions of heroic citizens saved even more heartbreak and destruction.

And yet we know that the worst images are those that were unseen to the world. The empty seat at the dinner table. Children who were forced to grow up without their mother or their father. Parents who would never know the feeling of their child's embrace. Nearly 3,000 citizens taken from us, leaving a gaping hole in our hearts.[15]

Obama's description of 9/11 as a national archive of shared and absent images is a striking articulation of the visual trauma that circulates around the event of 9/11. It also obliquely enunciates the disjuncture between seeing and believing in the American worldview:

The American people did not choose this fight. It came to our shores, and started with the senseless slaughter of our citizens. After nearly 10 years of service, struggle, and sacrifice, we know well the costs of war. . . .

. . . Tonight, let us think back to the sense of unity that prevailed on 9/11. I know that it has, at times, frayed. Yet today's achievement is a testament to the greatness of our country and the determination of the American people.[16]

With the reminder that Americans "did not choose this fight," the assertion that "justice has been done," and references to a renewed national unity, Obama also conjures up the potent mythology of redemption through violence and promotes a new American exceptionalism that will once again suture values and security in the American worldview. Viewed in relation to this authoritative rhetorical frame, the *Situation Room* image promises to partially close the circuits of violence that emanated from the occurrence of 9/11. But this ideological suture is a confidence trick (and an old one), an avowal of belief in the American mission that disavows the obscene practices that make that mission possible, what Obama glosses here as "the costs of war."

This is a disavowal of the violence that has caused civilians to be brutalized or killed across the world as a result of the war on terror. Elided in Obama's rhetoric, the costs of war are the actuarial costs that have already been calculated, including those both signified and rendered acceptable

as collateral damage. Commenting on the ideological centrality of collateral damage to the promotion and conduct of the war on terror, Allen Feldman observes:

An antidemography of the discounted and misappropriated has emerged as collateral damage in Iraq, Guantanamo, Afghanistan, and now Pakistan. The doctrine of collateral damage is a calculated discounting of the wounded, the tortured and the dead. . . . What is deemed collateral damage is the trace of the enemy that is erased as that trace. The victims and ruins of collateral damage constitute the nonarrival of the enemy; they materialize a missive that has missed its mark, an illegibility gone astray, scratched out, and misaddressed. . . . The untimely dead of collateral damage are the dispatched who cannot be claimed and who have to be disaproprated and re-sent as accident and apology.[17]

Understanding collateral damage in this actuarial sense underscores its role as a necessary supplement to shock and awe as the promotion and mediation of preemptive violence as military doctrine and as an accounted cost of war. These symbolic figures of collateral damage cannot be readily historicized and so haunt the visual culture of perpetual war, exceeding the conventional evocations of empathy and compassion that attend the idea of "bearing witness" and reminding us that humanity is a differential norm in representations of war and conflict.

In chapter 4 we considered one such haunting image of collateral damage, the screaming figure of Samar Hassan, who was photographed by Chris Hondros following the killing of her parents by U.S. soldiers at a checkpoint in Tal Afar in Iraq in 2005.[18] It was one of the few images of civilian Iraqi death widely published in the United States during the course of the war, reflecting public disavowal of these particular costs—the numbers of Afghani and Iraqi dead and injured are not precisely known or reported on in the United States, as they are literally unaccounted for. Then and since, photographers have had very limited success in publishing imagery of injured Afghani or Iraqi civilians in U.S. media, though a few have developed projects to try to do so. In 2005 the Iraqi-Canadian photographer Farah Nosh undertook a project titled "Wounded Iraq" to document Iraqi amputees: "I was starting to see coverage of VA hospitals in America and the soldiers coming home. I started asking myself what the Iraqi civilian side of that was."[19] No American publications responded to Nosh's pitch of the story but she self-funded and completed it, and on her return to the United States, it was taken up by the *New York Times* in their "Week in Review" section. Taken in the homes of Iraqi amputees the images are a startling embodiment of "collateral damage" and a stark, hu-

manizing contrast to most of the visual coverage of the war. More recently, the American photographer Peter van Agtmael, who has produced an intensive documentation of the experiences of American soldiers in combat with follow-up coverage of their return to the United States, has begun to document the lives and deaths of Iraqi civilians and plans to follow their stories into the diasporas of the Middle East and Europe. Another recent example is the work of the Italian photographer Massimo Berruti, whose extensive work in Pakistan has documented the results of repression and violence on civilians, including that caused by American drone strikes.

Van Agtmael asserts a sense of responsibility about his new work: "As an American of the generation shouldering these wars, I feel a strong responsibility to document their cost. . . . I'm ready to shift my focus to the other side of the war. . . . The Iraqis and Afghans that have been most affected remain depersonalized and shadowy in our collective consciousness. We live in a self-absorbed culture—one largely unburdened by memory."[20] Such an effort to humanize may be belated, yet the work of Nosh, van Agtmael, and Berruti also signifies fresh perspectives among an emergent generation of conflict photographers, attuned to broader understandings of the costs of war and determined to document these. The reference to memory is significant in this respect as it reminds us that visual imagery plays an important role in shaping national narratives of war and conflict as these are played out within American media and popular culture over time. We recall Obama's statement that "the images of 9/11 are seared into our national memory." The Situation Room image is a particularly powerful example of how imagery can shape and serve the memory work of the state in support of its foreign policy. Yet it is also an image that must take up its meaning within a contested and volatile sphere of public memory that is haunted by images that allude to issues of state violence and human rights that have not been resolved. In this study we have encountered such images—those by Paul Watson, Kenneth Jarecke, and Chris Hondros, for example—an unsettling afterimagery of the costs of war.

The Real War

The recent history of photojournalism is marked with predictions of its demise, but these jeremiads tend too readily to conflate aims and means and lament photojournalism's loss of status as a privileged medium of national and international record. Photojournalism is only in "decline" to the degree that it is still perceived as a late modern, predigital form of image making performing to outmoded assumptions about the evidentiary

authority of the documentary image and the existence of a knowledgeable, engaged citizenry. Photojournalism is mutating in relation to the broader conditions of globalized image warfare and an expanded media sphere. The proliferation and convergence of new media technologies—satellite, the Internet, digital image production—have greatly enlarged the circulation of imagery of contemporary conflict and also increased the global capacities for visually documenting abuses and violations. The resulting instability of visual fields animates as much as it restricts contemporary photographic visualization of international conflict. At the same time, photojournalism is less clearly categorized and recognized as a distinct genre of documentary photography, its codes and conventions now more intricately linked with broader visual cultures. The current moment, a postphotographic era, is one of fresh challenges to the capacities of the medium and the practitioners to represent the realities of war.

Many in the photographic community and beyond make note of the restricted repertoires of imagery emerging from Afghanistan and Iraq, as well as a sense of exhaustion among photographers. Ashley Gilbertson remarks: "After almost ten years of war, these pictures start to meld into one. We have a responsibility to find a new way to look at these stories."[21] Fred Ritchin also remarks on the "diminished visual vocabulary" in war imagery and believes that "much of war's depiction has evolved into an unfortunately predictable spectacle, lacking the requisite nuance and depth."[22] Ritchin argues that the challenges to contemporary photojournalism are to "amplify the strategies of visual journalism" and "somehow penetrate the purview of the larger, social-networked public."[23] He continues: "If a billion persons with cellphone cameras have greater proximity to breaking news events as well as to quirkier manifestations of the human condition, the photojournalist and documentary photographer, having lost their privileged societal perch, must rethink their approaches, both destabilized and liberated by this wrenching moment of shifting paradigms."[24] There is evidence photographers *are* rethinking their approaches, devising alternative modes of visual storytelling and adopting new strategies for making and disseminating their work. These have taken many forms, from the retooling of older forms of photographic technology and practice, to engaging digital and social media as both tools and platforms.

There is considerable self-consciousness in much of this work and, not surprisingly, irony becomes a common element. In Michael Shaw's view, "The military has been so overwhelmingly effective in muting the war, and the war photographer, that—practically without notice—many of our best shooters have found themselves turning, in a disproportionate way, to the technique of irony."[25] For some, irony has become a primary

technique, a means of drawing attention to the shortcomings in viewers' perceptions of the wars in Afghanistan and Iraq. An example is the work of the young German photographer Christoph Bangert, much of it for the *New York Times*, which knowingly explores what he terms "the space between" the worlds of Iraqis and Americans.[26] The resulting imagery illustrates the surreality of military life in an alien landscape. American soldiers are constantly shown to be awkwardly searching for something always beyond their vision. As Jon Lee Anderson notes of this work, "They [the soldiers] look, but they do not see; they seem lost, but are hunting for something tangible and finite, something that will give meaning to their presence, clues to a path that, if found, might eventually lead them home again."[27] Eschewing conventional news frames or the illusion of documentary transparency, Bangert's work illuminates something of the myopia in such framings and explores the gaps between perception and reality of the American mission.

Bangert's is a sophisticated vision, attuned to the need for the new generation of war photographers to be skilled at different forms of communication and work with an inclusive sense of the media sphere. He notes that "the difference with former generations is perhaps that we take a broader view. . . . You have to have extraordinary pictures and on top of that you have to be good at communicating."[28] He plans an ambitious large-scale project in Afghanistan: "I see it in the vein of what Philip Jones Griffiths did with 'Vietnam Inc.' I don't want to make it about one soldier; I want to do something big about the whole conflict."[29] The reference to Griffiths's example is striking, reminding us how significant that work remains to younger generations of conflict photographers, yet this is now envisioned within a new paradigm of war photography that has many practitioners who explicitly eschew Griffiths's commitment to "concerned" photography. It may be that the distance from concerned photographer to ironic photographer is neither so great nor exclusive as might be assumed. We have already seen examples of irony at use in the work of Alex Webb, Susan Meiselas, Gilles Peress, Ashley Gilbertson, and others. The issue is whether the irony is proportionate to the subject under representation. However, there is a renewed debate on what remains of the tradition of concerned photography in the twenty-first century, charged by the conditions of perpetual warfare that pose particular challenges to photographers of war and conflict.

There have been some sharp attacks on the genre of concerned photography in relation to this context in recent years. One of the most widely discussed was that by the South African conceptual photographers Adam Broomberg and Oliver Chanarin, who served as judges on the 2008 World

Press Photo jury and subsequently critiqued the jury process and a number of winning images. In an essay titled "Unconcerned but Not Indifferent," they took critical aim at what they viewed as the clichés and failings of concerned photojournalism. They asked: "Do we even need to be producing these images any more. Do we need to be looking at them? . . . Does the photographic image even have a role to play anymore?"[30] More specifically, they criticized the winning World Press Photo of the Year, an image of an exhausted U.S. soldier taken by Tim Hetherington who was embedded with Second Platoon, 173rd Airborne, at Outpost Restrepo in the Korengal Valley in Afghanistan. They argue: "His is a predictable World Press winner; an amalgam of all the images of war and death that we have embedded in our memory. . . . A resemblance to the famous Vietnam images by Burrows and McCullin, is not coincidental—this image represents a nostalgia for the days of photojournalism at it's [sic] sexiest, most lucrative and effective; the days when the press image was morally significant. In order to take a photograph like this these days the photographer must be embedded with the American forces."[31] They further argue that the embedded photographer's complicity with "war-making" "nullifies the political force" of the their imagery.[32]

This is a strong critique of the aesthetics and ethos of concerned photojournalism in general and of the gatekeeping practice of the World Press Photo in particular. While it has force as polemic, the critique is skewed by the wholesale rejection of the genre and by their emphasis on Hetherington's image as exemplary of this. Hetherington rebutted their argument in an essay of his own, titled "By Any Means Necessary," in which he argues that "event-based news images—both still and moving, amateur and professional—are the primary vocabulary by which humanity interprets itself" and that photographers are adapting to "the age beyond the photograph."[33] He comments on his own strategies in this regard, including his efforts to reach the widest possible audiences using both still and moving images. More pointedly, in response to the Broomberg and Chanarin piece, he refers to his winning World Press Photo image as a strategic choice: "I'm interested in how we all carry an image-library in our heads that we can cross-reference to create layers of meaning. I believe the visual strategy I employed in Afghanistan of alluding to Vietnam worked in this respect for a predominantly U.S. audience."[34] Add to this that Hetherington eschews the title of concerned photographer (and even of photographer), with which Broomberg and Chanarin readily associate him, and it begins to seem ironic not only that they critique his work but that he won the World Press Photo in the first place. Hetherington allows that his "technique is journalistic in some ways although the output is

not. In many ways my work isn't journalism because I'm not interested in objectivity."[35] He frequently argued that photojournalism needs an intellectual and creative revival: "If you are interested in mass communication, then you have to stop thinking of yourself as a photographer. We live in a post-photographic world. If you are interested in photography, then you are interested in something—in terms of mass communication—that is past. I am interested in reaching as many people as possible. . . . But if we see ourselves merely as photographers, we are failing our duty. It isn't good enough anymore just to be a witness."[36] Hetherington was in fact highly attuned to the challenges of the postphotographic age and sought to extend the possibilities of photojournalism through his practice. It is a strong example of the ways in which photographers seek to devise answers through their work to ethical and political questions about war and violence precipitated by U.S. foreign policy.

Working as a multiplatform journalist and artist, using different distribution channels, Hetherington won awards for his video coverage of Afghanistan as well as still imagery. Before he died, he had begun to produce this more hybrid work. *Sleeping Soldiers* (2009) is a multiscreen projection, combining still images, video, and sound recorded in Afghanistan. The tightly framed portraits, bathed in warm light, convey an intimacy and sense of vulnerability and suggest the subconscious of the soldiers (fig. C.2). They are also a study of masculinity under conditions of extreme violence and what Hetherington calls "the intimacy of war," the homoerotic relationships between young men bonding in war environments. "Male bonding," he remarks, is a "huge part of the war machine."[37] In a piece coauthored with Stephen Mayes, they elaborate on this theme: "War is one of the very few places where men can express love for each other without inhibition."[38] They argue this series of images "subvert[s] by seduction. The apparent naïve honesty in [Hetherington's] imagery wraps a subtle message," producing an aura of sensuality that disarms the viewer and causes confusion about the intimacy of the scenes.[39] They further argue that "the erotic physicality of fighting flesh is an illusion part sought by the viewer and part imposed on the viewer" and that these images represent "the iconography of military fantasy," war as projections of our desires.[40]

Hetherington deploys a range of strategies in making his war imagery, what many have in common is they take us "inside" the worlds of U.S. soldiers in ways that have rarely been explored with such finesse and empathy. He embraces the embedded process as a means to develop close insights on the culture and psychology of men at war. His images function somewhat like Ashley Gilbertson's pictures of the bedrooms of deceased

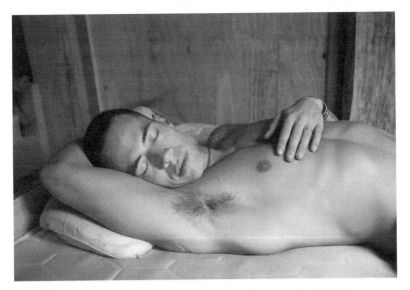

C.2 Sergeant Elliot Alcantra sleeping, Korengal Valley, Afghanistan, July 2008. (Tim Hetherington, photographer.)

soldiers, as apolitical invitations to contemplation and interpretation. Like Gilbertson's photos, they have attracted criticism, mostly from the view that they lack critical comment on the U.S. military or its presence in Afghanistan. But this can miss the nuance in Hetherington's work, which has strong intellectual and moral logic:

In America, soldiers are used by the right wing as a symbol of patriotic duty, but the truth is they are all individuals. . . . And the Left want a moral condemnation of the war. What I say is that if we have a full understanding of what the soldiers can and can't do out there, it is a good starting-point for peace-building. The heart of the war machine is in fact taking a group of young men and putting them on the side of a mountain. We need to understand that experience. Certainly if we have any hope of properly reintegrating them into society.[41]

This was the aim of much of his late work, to take the viewer to the "heart of the war machine."

Other photographers are employing visual techniques and strategies designed to make visible aspects of war that are rarely seen in mainstream media. There are now many forms of "postreportage," exploring in some detail the untold stories of war front and home front. Many of such photographers, like Hetherington, seek to move beyond established conventions of photojournalism or retool the genre in fresh ways. An example

is what has been termed "aftermath" or "late" photography, work that eschews the event of news reportage and focuses on traces of that event in the landscapes of conflict. This photography functions as a "secondary medium of evidence" that tends toward the deliberative and meditative, drawing on the potential for photography to be pensive and so open space for thought.[42] Sophie Ristelhueber, whose imagery of the ruins of Beirut in the early 1980s was cited in chapter 2, might be seen as a forerunner of the present generation of aftermath photographers, though the aesthetic and techniques are in some key respects antique, referencing the origins of photography. The work often foregrounds and troubles issues of temporality, making visible or at least apprehensible hidden relations between place and history.

The British photographer Simon Norfolk has created significant work in this vein, producing many large format landscape images of sites of conflict. These include imagery taken at Srebrenica, where more than eight thousand Bosnian Muslim civilians were killed in 1995. This work, titled *Bleed*, focuses on ice-covered bodies of water and metaphorizes the frozen topography of genocide; it is suggestive of what is concealed, frozen, in the landscape and which may yet reveal its secrets. Norfolk accentuates the beauty of the landscape elements, the better to put pressure on his viewer's expectations and response: "I'm endeavouring to set up a tension in the image between beauty and horror, two things that are normally separated in modern culture. . . these two categories are kept apart, but I think it is more realistic to collide the two together."[43] Norfolk set up this tension again when he photographed landscapes of destruction in Afghanistan, viewing them as "chronotopes," in which violent histories are layered and covered up. His images reference generations of violent interventions and colonization, traced in landscapes that are scarred yet beautiful, trying to "reconnect the evidence in the landscape to the story of this human disaster."[44]

Norfolk's interest in the less visible or tangible aspects of contemporary warfare have also led him to examine new technologies of war in more recent projects. These include a study of Echelon, a global electronic surveillance system run by the National Security Agency. One of the few places where it can be seen in physical form is Ascension Island, a small British colony in the South Atlantic where Britain and the United States co-run the surveillance program. Norfolk photographs the many antenna arrays, contrasted with the barren island landscapes, but also counterpointed with images of earlier colonial settlements by the British. Another recent project documents the "supercomputers," including IBM's BlueGene that designs the United States' nuclear weapons. They are set in sterile,

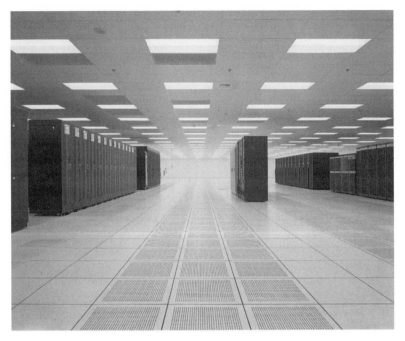

C.3 IBM BlueGene L supercomputer, California, USA. (Simon Norfolk, photographer.)

empty rooms, "nonplaces" that lack registers of affect or community yet suggest the banality of new forms of warfare (fig. C.3). They are a logical extension of his interest in landscape aesthetics and ruin, expanding our idea of what constitutes a "battlefield." With this work, Norfolk claims to be documenting an "international military sublime": "these objects are beyond: they're inscrutable, uncontrollable, beyond democracy."[45] He is forthright about the value and rationale of this work: "Warfare is becoming increasingly intangible. It is a paradox that whilst 'rolling news' and 'embedded journalists' saturate us with the showbiz of war, the really interesting developments, submarine warfare, space weapons, electronic warfare and electronic eavesdropping are essentially invisible. . . . Traditional war reporting risks irrelevance if it only concentrates on what can be seen, what can be photographed and filmed when the 'real' war is taking place elsewhere. In the 21st century, war is being visualized in the language of the 1950s and that is bad for journalism and, ultimately, bad for democracy."[46] While this veers toward polemic it is a valid indicator of the challenges facing those who wish to visualize the evolution of the military industrial complex and the broader militarizations of everyday life. There are a number of photographers involved in projects with this focus,

documenting the less visible institutions and infrastructures of power and governance that execute perpetual war.[47]

This interest in visualizing new sites and forms of warfare points up not only the intangibility of new technologies but also the emergence of new forms of violence that rarely come into focus in mainstream media. Robert Hariman comments: "The continued development of photography, in conjunction with the transformation of war from major state conflict to a shadow state of globalized violence, has refocused the image politically and morally. Images of violence are less likely to record the official 'costs' of war and more likely to document unwarranted destructiveness, inhumanity, stupidity, and sheer loss. Thus, modernity acquires a negative universality; distinctions based on progress are undercut by persistent failure and regression."[48] This "negative universality" might be said to characterize what I have termed "perpetual war," though Hariman is identifying a particular and insidious correlative of this in which the barely visible emergence of new forms of violence eludes conventional ideas of warfare. Following Ariella Azoulay, he points to the violence of the "regime-made disaster," in which "military and other state powers are used to degrade civil society in an occupied area to near the point of collapse, and keep it there."[49] The conflict between Israel and Palestine is exemplary of this violence, a situation where groups of citizens cannot "see" the disaster their regime perpetrates on others as such. Hariman also points to "untethered violence," which occurs "because of the absence of political aims, there is no check on the ferocity or longevity of some warfare."[50] An example of untethered violence is that of several African states, such as Somalia and the Congo, which draw little attention from Western media. These forms of violence test photography's potential value for illustrating both the "untethered" nature of much contemporary violence and for exposing the "permanent catastrophe" of the noncitizen.

As the nature of warfare changes so photography must shift its strategies to reflect this. I have argued throughout this study that it has been doing this for over fifty years. Indeed, while photojournalism may not be dead, it seems to thrive on a constant state of crisis and predictions of its death. As the perspectives and polemics above signify, there is a healthy, ongoing discussion about both what remains of the ethos of concerned photography and the emergent visual strategies for documenting war in a postphotographic age. Neither Norfolk nor Hetherington believe that photojournalism is adequately conceived and equipped to represent the

realities of twenty-first-century warfare. For Norfolk, the idea that there is a "real war taking place" and that it is the task of the photographer to represent it remains a compelling impetus for his work: "The point of the world is to change it," he argues.[51] Hetherington, in contrast, states: "My work's not there to make people spring into action, I'm there to inform them. . . . I'm not trying to effect change."[52] While the emphases on understanding and changing the world reflect differences in their political philosophies, they are nonetheless aligned in assuming the agency and value of the photographer as a witness to the realities of war that are unseen by general publics. Where Hetherington seeks the reality of war in sleeping soldiers, Norfolk seeks it in the abstracted spaces of high technology.

Of course, what constitutes "real" war remains a contested and relative matter, ideologically shaped by the shifting conditions of visuality, defining both what a public sees and what it does not see. Under conditions of perpetual war and amid the entropic Internet environment in which issues and images swirl, it has become both more difficult and more imperative to know where and how to look if we want to understand the realities and costs of war. Susan Sontag, looking into a postphotographic future heralded by what she viewed as the unbounded "image world" of the 1970s, famously asked for "an ecology of images," the better to arrest attention and to protect the integrity of the image as a representation of the real.[53] But we cannot staunch the flow of images, and we now inhabit a postphotographic age. As such, and more particularly, if we seek to understand the workings and transformations of American power enacted as foreign policy, we must be ever more attentive to the dialectics of blindness and insight in visual documentation of war and conflict. I believe that photography retains the potential to be a critical mirror of international affairs and that it will continue to play a significant role in giving form to the intangibilities of war by embodying abstractions and illuminating collective values and assumptions about violence, otherness, and humanity. For all the seductions and distractions of the image world, a good signpost to critical perception of international affairs remains: "Follow the Americans."

Notes

INTRODUCTION

1. Quoted in Eliza Williams, "Follow the Americans," *Creative Review*, March 30, 2007, http://www.creativereview.co.uk /cr-blog/2007/march/philip-jones-griffiths-on-vietnam.
2. The term "concerned photographer" generally refers to photographers who are actively engaged in social or political issues. It was popularized in part by Cornell Capa, a longtime member of Magnum and brother of Robert. Capa organized an exhibition in 1967 titled "The Concerned Photographer" and created the International Fund for Concerned Photography in 1966. Through both, he wanted to promote, protect, and renew the humanist tradition in photojournalism and championed "those contemporary practitioners who use their cameras as a tool of social conscience." Cornell Capa, *The Concerned Photographer* (New York: Grossman, 1968), 2.
3. In part, this is due to the political economy of the industry and its correlations with the workings of geopolitical power. As Mary Panzer notes: "For the world's photojournalists, its combat zones have steadily divided into two groups: those in which America and the other main global players are involved, that are accessible on the warring powers' strict (and self-interested) terms; and wars in the rest of the world, that are freely accessible (if dangerous) but which fall outside of the scope of the world media's interest. Photographic work in the latter category is frequently unpublished except in the pages of photojournalism magazines such as Ei8ht or as the winners of contests such as World Press Photo. Documenting America's wars independently, meanwhile, becomes the game

of only a daring few" ("Introduction," in *Things as They Are: Photojournalism in Context since 1955* [London: Chris Boot, 2005], 32).

4. Robin Andersen, "Images of War: Photojournalism, Ideology, and Central America," *Latin American Perspectives* 16, no. 2 (Spring 1989): 97.

5. Ron Haviv, "Photographer Ron Haviv's Best Shot," *Guardian*, July 14, 2010, http://www.guardian.co.uk/artanddesign/2010/jul/14/ron-haviv-best-shot. See also Denise Leith, *Bearing Witness: The Lives of War Correspondents and Photojournalists* (Milsons Point: Random House Australia, 2004), 184–85.

6. Susan Meiselas, interview by Fred Ritchin, "Susan Meiselas: The Frailty of the Frame, Work in Progress," *Aperture* 108 (Fall 1987), 33.

7. Ashley Gilbertson, quoted in Adam McCauley, "Overexposed: A Photographer's War with PTSD," *Atlantic*, December 20, 2012, http://www.theatlantic.com/health/archive/2012/12/overexposed-a-photographers-war-with-ptsd/266468/.

8. Ashley Gilbertson, interview by Dave Davies, "Ashley Gilbertson: Shooting Passionately in Iraq," *Fresh Air*, National Public Radio, June 13, 2007, http://www.npr.org/templates/story/story.php?storyId=11012130.

9. As Robert Entman has noted, "Elites tend to assume that visual images have major impacts on public opinion," but this is not based on any hard evidence and reflects uncertainty about "the problematic power of visuals" (*Projections of Power: Framing News, Public Opinion and U.S. Foreign Policy* [Chicago: University of Chicago Press, 2004], 4).

10. See Gearóid Ó. Tuathail, "Problematizing Geopolitics: Survey, Statesmanship and Strategy," *Transactions of the Institute of British Geographers* 19, no. 3 (1994): 259–72; John Agnew, *Geopolitics: Re-Visioning World Politics* (London: Routledge, 1998); and Rachel Hughes, "Through the Looking Blast: Geopolitics and Visual Culture," *Geography Compass* 1, no. 5 (2007): 976–94.

11. As David Campbell notes, "Foreign policy is a discourse of power that is global in scope yet national in its legitimation. . . . In the context of the modern nation state, foreign policy has been granted a privileged position as the discourse to which we should turn as the source of the preeminent dangers to our society and ourselves" (*Writing Security: United States Foreign Policy and the Politics of Identity* [Minneapolis: University of Minnesota Press, 1998], 70).

12. Ibid., 7

13. Susan Moeller, *Shooting War: Photography and the American Experience of Combat* (New York: Basic Books, 1989).

14. With the Spanish-American War, photojournalism become intricately tied up with the projection and representation of American's foreign policy interests. In the prelude to the war, the press supported the Cuban insurgency, presenting an image of America as the defender of freedom. As such, it conjoined the imperial and democratic impulses in America's geopolitical perspectives. By and large it did so smoothly, with huge domestic support for this imperial adventure, and photography played an important role in

linking this vision of America's growing will to power to a new landscape of international relations and communication systems. See ibid., 29–83.

15. Henry Luce, quoted in Robert T. Elson, *Time Inc.: The Intimate History of a Publishing Enterprise, 1923–1941* (New York: Atheneum, 1968), 278.

16. Via the popular picture magazines, photojournalism took on a prominent role in the representation of international affairs in the early Cold War period. It opened windows onto the world for an increasingly affluent and confident society. Photojournalism thrived on the visual richness of war and conflict but also on that of exotic international events and locations, a visual tourism of the world from the perspective of its most powerful nation. It also drew on the visual cultures of the United States and Western Europe to produce a vibrant form of visual reportage that digested and dramatized "news" and provided stimulating visual forays into a world opening up to American dominance. See Wendy Kozol, *Life's America: Family and Nation in Postwar Photojournalism* (Philadelphia: Temple University Press, 1994). With the professionalization of the industry and the emergence of new photo agencies, the photojournalist as imperial tourist-cum-celebrity emerged, exemplified by the careers of Robert Capa and David Douglas Duncan.

17. Michael Ignatieff, *Magnum Degrees* (London: Phaidon, 2000), 54.

18. This is a moral vision that springs from a distinctively Western moral imagination and Magnum's work is marked by the particularities of this imagination even as new generations of photographers have extended their visions and practices beyond the purview of the founding fathers. It is reinforced by the political economy of the photojournalism industry, producing images of difference, destruction and immiseration in "third" or "underdeveloped" worlds for "first" or "developed" world audiences. See Liam Kennedy, "Magnum's Global Enterprise," in *Reading Magnum: A Visual Archive of the Modern World*, ed. Stephen Hoelscher (Austin: University of Texas Press, 2013), 293–311.

19. The "police action" that came to be the Korean War was poorly defined in the eyes of the American public and press, who began to disapprove of management of the war, and this newfound ambivalence was reflected in the imagery of American soldiery. Perhaps the most famous series of images were those taken by David Douglas Duncan showing the U.S. marines retreating from the Changjin Reservoir in December 1950. An ex-marine himself, Duncan's photo essay functioned both to celebrate the stoicism and brotherhood of the American marines under adverse conditions and to introduce a more cautionary and reflective perspective on warfare. While still working within the aesthetic tradition of World War II combat photography, he takes the viewer ever closer to the soldier's experience and introduces a tough realism that celebrates the individual not the cause and that implicitly questions the management of the war. Duncan was instrumental in introducing a more subjective perspective into war photography, indicating changing aesthetics of the genre.

20. Robert Hariman and John Louis Lucaites, *No Caption Needed: Iconic Photographs, Public Culture, and Liberal Democracy* (Chicago: University of Chicago Press, 2007), 9.

21. See Judith Butler, *Precarious Life: The Powers of Mourning and Violence* (London: Verso, 2004), and *Frames of War: When Is Life Grievable?* (London: Verso, 2010).

22. Max Kozloff, *Lone Visions, Crowded Frames: Essays on Photography* (Albuquerque: University of New Mexico Press, 1997), 183.

CHAPTER ONE

1. David Douglas Duncan, "The Year of the Snake," *Life*, August 3, 1953, 85.

2. See Robert E. Herzstein, *Henry R. Luce, Time, and the American Crusade in Asia* (Cambridge: Cambridge University Press, 2005), 183–84.

3. See John G. Morris, *Get the Picture: A Personal History of Photojournalism* (Chicago: University of Chicago Press, 2002), 153–56.

4. David Halberstam, "U.S. Deeply Involved in the Uncertain Struggle for Vietnam," *New York Times*, October 21, 1962.

5. The frustration of dealing with misinformation seeped into much of the reporting. In 1962 Homer Bigart, in the *New York Times*, complained: "The United States information policy on Vietnam has not been marked by candor. Official secrecy has curbed reporting" (cited by Clarence R. Wyatt, *Paper Soldiers: The American Press and the Vietnam War* [Chicago: University of Chicago Press, 1993], 100). In 1964 Associated Press correspondent Malcolm Browne wrote of varied forms of "press manipulation" in the early phases of the war and noted "a high degree of skepticism in the foreign press corps about all official statements" ("Vietnam Reporting: Three Years of Crisis," *Columbia Journalism Review* [Fall 1964], 4–9).

6. Richard Nixon, quoted in Paul L. Moorcraft and Philip M. Taylor, *Shooting the Messenger: The Political Impact of War Reporting* (Washington, DC: Potomac Books, 2008), 88.

7. See Daniel Hallin, *The "Uncensored War": The Media and Vietnam* (New York: Oxford University Press, 1989).

8. Barry Zorthian, "The Tet Offensive and 'Christmas' Bombing as Case Studies," in *The Vietnam Debate: A Fresh Look at the Arguments*, ed. John Norton Moore (Lanham, MD: University Press of America, 1990), 281.

9. Browne, "Vietnam Reporting," 5.

10. Phillip Knightley, *The First Casualty: The War Correspondent as Hero and Myth-Maker from the Crimea to Iraq* (Baltimore, MD: Johns Hopkins University Press, 2004), 273.

11. See Tom Wolfe, *The New Journalism* (New York: Harper and Row, 1973). The most lauded example of this new journalism among Vietnam correspondents was the work of Michael Herr, and his book *Dispatches* (New York: Knopf, 1977) has influenced later generations of war reporters.

12. See Hallin, *The "Uncensored War."*
13. Jorge Lewinski notes: "Because of the USA's involvement in the war, the American media market—the largest in the world—of magazines, periodicals, newspapers, books and television provided the widest platform ever for the publication of pictures of the war throughout its long duration. . . . The photographer, the maker of the images, found himself in the position of being expected to comply with the demand." The result, Lewinski suggests, was a "new tendency for war photography to be undertaken to satisfy extrinsic market demands rather than for extrinsic reasons—aesthetic or documentary" (*The Camera at War: A History of War Photography from 1848 to the Present Day* [London: W. H. Allen, 1978], 197 and 201). These elements were rather more complexly entwined than Lewinski suggests, but his main point holds true.
14. Yet, they were not simply invisible; rather, like the South Vietnamese, they were rendered in distinctive ways in particular contexts and in relation to the overall direction of the war as perceived by American media. For example, in the late 1960s and early 1970s, there appeared a spate of photo stories on child victims of the war. One of the most famous was the work of *Life* photographer Larry Burrows, covered in this chapter.
15. See Oscar Patterson III, "Television's Living Room War in Print: Vietnam in the News Magazines, *Journalism Quarterly* 61 (Spring 1984): 35–39, 136; and Michael D. Sherer, "Vietnam War Photos and Public Opinion," *Journalism Quarterly* 66 (1999): 391–95.
16. Zorthian, "Tet Offensive," 285.
17. Browne, "Vietnam Reporting," 7.
18. Richard Lacayo and George Russell, *Eyewitness: 150 Years of Photojournalism* (New York: TIME Books, 1995), 129.
19. Moeller, *Shooting War*, 355.
20. David Halberstam, "Introduction," in *Larry Burrows Vietnam* (London: Jonathan Cape, 2002), 9.
21. Frank McCulloch, *Time*'s Saigon Bureau Chief, recalls: "What [Burrows] loved to do best was to study the paintings of the old masters, and then try to capture their richness and subtlety on film. And what he learned from the old masters about composition, color, contrast and human nature he applied to every picture story that he ever shot" (quoted in Larry Burrows, *Larry Burrows: Compassionate Photographer* [New York: Time-Life Books, 1972], n.p.).
22. Larry Burrows, "We Wade Deeper Into Jungle War," *Life*, January 25, 1963, 22.
23. Ibid., 29.
24. Burrows was equally adept with black and white and color but gave careful thought to his choice of film for particular assignments, gauging the conditions (light, composition, action, narrative) in making his selection. His choice of black and white for the Yankee Papa 13 story may have reflected his interest in accentuating the human elements of this narrative, rather than action material.

25. One of the most striking action shots was due to Burrows's ingenuity as he had placed a motor-driven Nikon camera outside the helicopter attached to the M60 machine gun but fixed to focus on the gunner and triggered by a remote cable held by Burrows.

26. See "Editor's Note: He Was Right up There with the Pilots," *Life*, September 9, 1966, 3. See also the comments by Milton Orshefsky, quoted in *Larry Burrows*, n.p.

27. Larry Burrows, "Vietnam: A Compassionate Vision," *Life*, February 26, 1971, 39.

28. Larry Burrows, quoted in Moeller, *Shooting War*, 408–9.

29. See Moeller, *Shooting War*, 409–10; and Patrick Hagopian, "Vietnam War Photography as a Locus of Memory," in *Locating Memory: Photographic Acts*, ed. Annette Kuhn and Kirsten McAllister (New York: Berghahn, 2006), 214–16.

30. Larry Burrows, quoted in "Editor's Note: The Way Tron Feels about Larry," *Life*, November 8, 1968, 3.

31. Images of Tron were published over a year later in *Life*, on December 12, 1969, showing her surrounded by dolls and stuffed animals sent by American readers. These images were published one week after *Life* published images of the My Lai massacre and in this context they function to sentimentalize the violence done to Vietnamese civilians by U.S. forces, reassuring American readers that the United States acts responsibly, with humanitarian intent. See Kendrick Oliver, *The My Lai Massacre in American History and Memory* (Manchester: Manchester University Press, 2006), 69.

32. *Life*'s Dan Moser recalls: "Larry became quite attached to Tron and she to him, and this worried him constantly. He realized that if she became too dependent on him, her life would be even more difficult when he left her. So he tried to maintain a certain emotional distance from her, acting like a cheerful uncle and trying—not always successfully—to mask the depth of his own feelings" (quoted in Burrows, *Larry Burrows*, n.p.). In 2000, Larry Burrows's son and granddaughter located Tron in a village called Phuoc Binh, where she was working as a tailor and medic. Claudia Dowling, "Recalled Memory," *Time Asia*, May 22, 2000, http://www.time.com/time/asia/magazine/2000 /0522/vietnam.tron.html.

33. Burrows, "Vietnam," 42.

34. The American artist Martha Rosler placed one of Burrows's photographs of Tron in a photomontage that became part of her "House Beautiful: Bringing the War Home" series (1967–72). In the photomontage, the image of Tron is placed within an image of a suburban American sitting room, taken from *House Beautiful* magazine. The juxtaposition is intended to challenge comfortable associations with the imagery of war and domesticity in the United States in this period.

35. Larry Burrows, "A Degree of Disillusion," *Life*, September 19, 1969, 67.

36. His son Russell Burrows has commented on this, asserting that Burrows's "change" in perspective "had nothing to do with the fact that the war

was wrong; he was opposed to its stupidity . . . to how the war was being waged. . . . Many people, journalists and others, radically changed their minds around 1968. Where my father was different was in his beliefs that the South Vietnamese people wanted and supported the American effort, and that they would be willing and able to shoulder that burden as the United States withdrew. It was in photographing an essay on those people that his beliefs were confronted, and the result was 'A Degree of Disillusion'" (quoted in Moeller, *Shooting War*, 354).

37. Burrows, *Larry Burrows*, n.p.
38. Larry Burrows, "The Delta: New U.S. Front in a Widening War," *Life*, January 13, 1967, 27.
39. Notably, Burrows's *Life* editors picked up on the idea of compassion in their memorial issue and in the book published in 1972, *Larry Burrows: Compassionate Photographer*. In the 1972 book, John Saar, who was *Life*'s bureau chief in Hong Kong in this period, remarks: "The more Larry Burrows saw, the more he cared. His continued involvement with the calamity of others did not harden or deaden him. In the last few months of his life, a new sense of concern for a universal humanity took a strong grip of him" (quoted in Burrows, *Larry Burrows*, n.p.). This claim is illustrated by Burrows's imagery of the devastating effects of a cyclone in the Ganges Delta in Pakistan in 1970.
40. See Richard Pyle and Horst Faas, *Lost over Laos: A True Story of Tragedy, Mystery, and Friendship* (New York: Da Capo Press, 2008).
41. Amol Rajan, "Philip Jones Griffiths: The Welshman with the 'Lazy Eye,'" *Independent*, January 21, 2008, www.independent.co.uk/news/media/philip-jones-griffiths-the-welshman-with-the-lazy-eye-771515.html.
42. Philip Jones Griffiths in Peter Howe, "The Vietnamization of Philip Jones Griffiths," *Digital Journalist*, July 2005, http://digitaljournalist.org/issue0507/griffiths.html.
43. Philip Jones Griffiths in Graham Harrison, "Philip Jones Griffiths," *Photo Histories*, 2008, http://www.photohistories.com/interviews/23/philip-jones-griffiths?pg=all.
44. Philip Jones Griffiths, quoted in Peter Howe, "The Dauntless Spirit: Philip Jones Griffiths: 1936–2008," *Digital Journalist*, April 2008, http://digitaljournalist.org/issue0804/the-dauntless-spirit-philip-jones-griffiths-1936-2008.html.
45. Philip Jones Griffiths, quoted in Donald R. Winslow, "Philip Jones Griffiths Dies in London," National Press Photographers Association, https://nppa.org/news/1463.
46. Griffiths, quoted in Howe, "The Dauntless Spirit."
47. Philip Jones Griffiths, *Vietnam Inc.* (London: Phaidon, 2001), 4.
48. Philip Jones Griffiths, quoted in Russell Miller, *Magnum: Fifty Years at the Front Line of History* (London: Pimlico, 1999), 213–14.
49. Griffiths, *Vietnam Inc.*, 174.
50. Ibid., 3.

51. Ibid., 4.
52. Ibid., 13.
53. The scene was reconstituted in the film *Apocalypse Now*.
54. Griffiths, *Vietnam Inc.*, 59.
55. See Howe, "The Dauntless Spirit."
56. Griffiths, *Vietnam Inc.*, 90.
57. Philip Jones Griffiths in Miller, *Magnum*, 214
58. Griffiths is more sanguine in his (later) comments: "The girl is not a hooker—well, she may have been a hooker, she's certainly not an innocent farm girl—but she was there dancing for the troops, and these chaps got a little out of hand" (quoted in Howe, "The Dauntless Spirit").
59. Griffiths, *Vietnam Inc.*, 164–65.
60. Ibid., 197.
61. Ibid., 198–99.
62. Griffiths later observed this was an unusual designation as "the rule in Vietnam was that anybody who had been wounded was VCS, a Vietcong suspect"; he surmises that the medic who made out the tag was "anti-war." See Howe, "The Dauntless Spirit."
63. Amanda Hopkinson, "Philip Jones Griffiths," *Guardian*, March 24, 2008, http://www.guardian.co.uk/artanddesign/2008/mar/24/photography.usa.
64. Cited on the cover of the 2001 edition of *Vietnam Inc.*
65. Ibid.
66. The book was published a week after the attacks of September 11, 2001. With the wars in Afghanistan and Iraq resurrecting interest in the imagery of the Vietnam War, Griffiths's work came in for some renewed attention, and there were several exhibitions.
67. See Howe, "The Dauntless Spirit."
68. Philip Jones Griffiths, quoted in Colin Pantall, "Agent Provocateur," *Far Eastern Economic Review*, 167, no. 5 (2004). Agent Orange is the toxic herbicide used by the American military as a defoliant during the war—it was first sprayed on crops as part of a program to force villagers into "strategic hamlets" and later, more extensively, to deny cover to Vietcong forces. More than eleven million gallons of the herbicide were sprayed over Vietnam between 1962 and 1971. Dioxin, the deadly toxin in Agent Orange, remained in the landscape causing ongoing environmental and human damage. In humans it causes hormonal and genetic changes that have disastrous effects on reproduction. The herbicide caused long-term contamination of soil and plant life in extensive areas, further affecting rural agriculture and subsistence.
69. See Marita Sturken, *Tangled Memories: The Vietnam War, the AIDS Epidemic, and the Politics of Remembering* (Berkeley: University of California Press, 1997).
70. See Allen Feldman, "The Structuring Enemy and Archival War," *PMLA* 124, no. 5 (2009): 1712.
71. Quoted on the cover of the 2001 edition of *Vietnam Inc.*

72. Philip Jones Griffiths, *Agent Orange: "Collateral Damage" in Viet Nam* (London: Trolley Books, 2004), 32.

73. Ibid., 92.

74. Eugene Smith's famous pietà image from Minamata, Japan, is explicitly recalled in a shot of sixteen-year-old Vo Van Trac who "exhibits symptoms similar to Minamata disease" and who is held by his mother in a way that echoes Smith's image. Similarly, an image of a mother with her two blind daughters has distinctive echoes of Dorothea Lange's *Migrant Mother* photograph. Griffiths, *Agent Orange*, 96 and 106–7.

75. An exhibition of the work opened at the War Remnants Museum in Saigon in November 2010, and Griffiths donated a number of the images to the museum. The museum archives an infamous collection of images of atrocities carried out by the American military during the war, including several of Griffiths's images. This siting of the *Agent Orange* work is a symbolic addition and also a marker of the different roles such imagery has in the formation of cultural and political memories in Vietnam and the United States. See Christina Schwenkel, *The American War in Contemporary Vietnam: Transnational Remembrance and National Representation* (Bloomington: Indiana University Press, 2009).

76. Griffiths, *Vietnam at Peace*, 117.

77. Ibid., 176.

78. Ibid., 220.

79. Ibid., 229.

80. "Philip Jones Griffiths Q&A—War Photography and Vietnam," Open Democracy (April 2005), http://www.opendemocracy.net/philip_jones _griffiths_q_a_war_photography_and_vietnam_0.

81. Fred Ritchin, "Parsing the Wound," in *Under Fire: Great Photographers and Writers in Vietnam*, Catherine Leroy (New York: Random House, 2005), 160.

82. Rajan, "Philip Jones Griffiths."

83. In the closing text of the *Agent Orange*, Griffiths argues the need for further research on dioxin and proposes that Vietnam offers "the ultimate laboratory where the clues to dioxin's murderous progression can be discovered" (174). He further points out that Vietnam offers a relatively clear control study, as South Vietnam was heavily sprayed while North Vietnam was not. This conclusion to his book is suggestive of some of the tensions underlying the admixture of compassion and accusation in *Agent Orange*.

CHAPTER TWO

1. In the early 1980s, Georgetown University ran a series of meetings that brought together policy makers and media personnel to discuss U.S. media coverage of conflicts in Lebanon and Central America—the timing and the yoking together of these topics is indicative of the growing consciousness about the tensions surrounding media coverage of these volatile and strategi-

cally important territories. See Landrum R. Bolling, ed., *Reporters under Fire: U.S. Media Coverage of Conflicts in Lebanon and Central America* (Boulder, CO: Westview Press, 1985).

2. Roger Morris, "Beirut and the Press under Siege," *Columbia Journalism Review* 21, no. 4 (November–December 1982): 23.

3. Landrum R. Bolling, "Questions on Media Coverage of Recent Wars," in *Reporters under Fire*, ed. Bolling, 9.

4. Ben Wattenberg, quoted in *Reporters under Fire*, ed. Bolling, 22.

5. Robert Pledge, who was manager of Gamma in the United States and then founder of Contact Press Images, comments on the initiative and drive of the new agencies: "The agencies were coming up with the ideas, initiating the coverage, sending people out there, getting there faster because they were journalists—hungry photographers dying to get out there. Being highly competitive, they wouldn't even wait until an assignment or a financial commitment was made by anybody" (quoted in Marianne Fulton, *Eyes of Time: Photojournalism in America* [New York: New York Graphic Society, 1988], 189).

6. Andy Grundberg, "Photojournalism Lays Claim to the Realm of Esthetics," *New York Times*, April 12, 1987, http://www.nytimes.com/1987/04/12/arts /art-photojournalism-lays-claim-to-the-realm-of-esthetics.html?pagewanted =all&src=pm.

7. See Susan Sontag, *On Photography* (London: Penguin, 1979).

8. See Sontag, "The Image World," in ibid., 153–80.

9. Martha Rosler, in "Get the Picture: Photojournalism or Art," Minneapolis Institute of Arts, http://www.artsmia.org/get-the-picture/peress /photojournalism.html.

10. The term "new photojournalism" was used on a few occasions during the period, though never clearly focused or analyzed. It echoes, of course, the term "new journalism," a category associated with literary news reporting that was widely taken up by practitioners and critics. Indeed, the new journalism has by now been canonized as a significant literary movement, influencing later generations of writers in the United States and globally. See Tom Wolfe, *The New Journalism* (New York: Harper and Row, 1973).

11. For the writers, this foregrounding is also an assertion of subjectivity as a register of the reality of the event; as Tom Wolfe points out, a key allure of the first-person reportage is the sensation of presence. See Wolfe, *The New Journalism*. The photographers, too, want to underscore the reality effects of their work, precisely by drawing attention to its workings. For photographers, of course, the role of witness has particular connotations that pertain to the visual schemas of recognition and identification that are so important to the conventions of photojournalism.

12. Raymond Depardon, *Notes* (Paris: Arfuyen, 1979).

13. Alex Webb, quoted in Adam D. Weinberg, *On the Line: The New Color Photojournalism* (Minneapolis: Walker Art Center, 1986), 29.

14. Sophie Ristelhueber, *West Bank* (London: Thames and Hudson, 2005), n.p.

15. Some critics were dubious about what this portended for the genre. Andy Grundberg, writing in the *New York Times* in 1985, opined: "The arena of art photography, which first seized center stage from photojournalism and now seems ready to cede it back, remains in control. For the shows and books we will be seeing are not photojournalistic in conception and design, but rather view photojournalism as a wellspring of artistic imagery. . . . In short, photojournalism is not displacing art photography. It is being incorporated into the fine art fold, joining fashion, advertising and topographic survey photography as subjects for scholarship and delectation" ("Photojournalism Makes a Comeback," *New York Times*, September 8, 1985, http://www.nytimes.com/1985/09/08/arts/photojournalism-makes-a-comeback.html). Later, in 1987, Grundberg writes: "Taken off the page and folded into the museum, the New Photojournalism becomes simply another genre in the realm of art, dysfunctional but beautiful" ("Photojournalism Lays Claim").

16. Weinberg, *On the Line*, 20. Weinberg's curatorial perspective—much of the catalog serves as a rationale for the selection of the photographers—privileges formal aspects of their work and promotes aesthetic frames and codes in viewing the work. This approach is echoed in the hanging of the exhibition. See Donna Schwartz, "On the Line: Crossing Institutional Boundaries between Photojournalism and Photographic Art," *Visual Sociology Review* 5, no. 2 (1990): 22–29.

17. In the exhibition catalog, Susan Meiselas reflects on these tensions: "Art in a way . . . gives you a license to free yourself from the confines of a magazine, the confines of a story, the confines of having to do things in certain ways. In a way it gives you the edge to be able to free yourself from all of that, but if you end up too much in the art world, then you get drawn into the box of being an artist." Susan Meiselas, quoted in Weinberg, *On the Line*, 30. This tension is, as we shall see, evident in Meiselas's work in Nicaragua and El Salvador.

18. Max Kozloff, "Photography: The Coming of Age of Colour," *Artforum* 13, no. 5 (January 1975): 34. This was a view that also reflected the preference among documentary photographers to use black and white for imaging subjects of social concern. Philip Jones Griffiths and David Douglas Duncan were equally forthright in their rejection of color. Duncan: "I've never made a combat picture in colour—ever. And I never will. It violates too many of the human decencies and the great privacy of the battlefield" (quoted in Kozloff, "Photography," 34).

19. Susan Meiselas, quoted in Weinberg, *On the Line,* 43.

20. Alex Webb, quoted in Weinberg, *On the Line,* 43.

21. Esther Prada, quoted in Max Kozloff, *Lone Visions, Crowded Frames: Essays on Photography* (Albuquerque: University of New Mexico Press, 1994), 188.

22. Kozloff, *Lone Visions*, 188.

23. Ibid., 189.

24. Ibid., 190–91.

25. Ibid., 191.

26. Abbas, quoted in Diane Smyth, "Revolution in Iran," *British Journal of Photography*, April 1, 2009, http://www.bjp-online.com/british-journal-of -photography/report/1646861/revolution-iran.

27. See Ellen Goodman, "And That's the Way It Is—or Is It?" *Washington Post*, June 17, 1980, http://articles.washingtonpost.com/2009-07-17/opinions /36918801_1_walter-cronkite-sanford-socolow-american-hostages.

28. David Harris, quoted in Jordan Michael Smith, "Contra Iran," *Columbia Journalism Review*, November 4, 2009, http://www.cjr.org/behind_the_news /contra_iran.php?page=all.

29. Some commentators charged that this was due in part to the lack of interest among U.S. media (and public) in Iran and the region, reflected by the lack of media bureaus there. No major American news organization maintained a Tehran bureau (though the *New York Times* had one briefly in the mid-1970s) and they relied on stringers and wire services. See Edward Said, "Islam, Orientalism and the West: An Attack on Learned Ignorance," *Time*, April 16, 1979, 54, and "Iran and the Press: Whose Holy War?" *Columbia Journalism Review*, March–April 1980, 20.

30. "Blackmailing the U.S.," *Time*, November 19, 1979. *Newsweek* also used the photograph on its front cover during the course of the crisis, on February 25, 1980, and again on January 26, 1981.

31. Reza Deghati worked for Sipa and *Newsweek* during the revolution, though he did not use his real name. See Betty Blair, "In Pursuit of Freedom and Justice: Through the Eyes of a Photojournalist—Reza," *Azerbaijan International*, Spring 1998, 38–41.

32. "Blackmailing the U.S.," 14.

33. David Burnett, *44 Days: Iran and the Remaking of the World* (Washington, DC: National Geographic, 2009), 113.

34. As Abbas records: "During the revolution, photography became important in Iran as a form of expression. The hostage crisis furthered the careers of several Iranian photojournalists, since their foreign counterparts found it harder to work in Iran after this" (quoted in Sonali Pahwa, "Shifting Visions,'" *Al-Ahram Weekly*, January 1–7, 2004, http://weekly.ahram.org.eg /2004/671/cu1.htm).

35. Abbas, quoted in Smyth, "Revolution in Iran."

36. Abbas: "It was my country, my people, my revolution, but at the same time it didn't mean that I could lose my critical sense. My duty was, of course, to the revolution, but my foremost duty was to my trade, my craft. I was a journalist" (quoted in Shiva Balaghi, "Abbas's Photographs of Iran," *Middle East Report*, 34 (2004), http://www.merip.org/mer/mer233/abbass-photographs -iran).

37. Abbas, *Allah O Akbar: A Journey through Militant Islam* (London: Phaidon, 1994), 12–13.

38. Ibid., 17.

39. Ibid.
40. Abbas, quoted in Shiva Balaghi, "Writing with Light: Abbas's Photographs of the Iranian Revolution of 1979," in *Picturing Iran: Art, Society and Revolution*, ed. Lynn Gumpert and Shiva Balaghi (London: I. B. Tauris, 2002), 110.
41. Abbas, *Allah O Akbar*, 17.
42. Burnett, *44 Days*, 119 and 121.
43. ibid., 51.
44. Ibid., 183.
45. Ibid., 200.
46. Ibid.
47. Ibid., 165.
48. Ibid., 219.
49. Cornell Capa, cover quote, Gilles Peress, *Telex Iran: In the Name of the Revolution* (Millerton, NY: Aperture, 1983).
50. Gary Knight, quoted in Holly Stuart Hughes, "Capturing Chaos: Gary Knight on Gilles Peress," *Photo District News*, November 1, 2002, 184.
51. Fred Ritchin, "What Is Magnum?" in *In Our Time: The World as Seen by Magnum Photographers* (London: Andre Deutsch, 1989), 439.
52. The editors, in Gilles Peress, *Telex Iran: In the Name of Revolution* (Zurich: Scalo, 1997), 2.
53. Carole Kismaric, "Gilles Peress," *BOMB*, vol. 59 (Spring 1997), http://bombsite .com/issues/59/articles/2033.
54. Max Kozloff's comments on Peress's use of space in his coverage of the Northern Irish conflict are just as pertinent for his imagery of the Iranian revolution: "This imagery overflows with, and opens up precipitous ideas about space, yielding an endless repertoire of dislocations" ("Gilles Peress and the Politics of Space," in *Lone Visions*, 176).
55. Gholam-Hossein Sa'edi, essay in Peress, *Telex Iran*, 100.
56. Peress, *Telex Iran*, 3.
57. It also refers us to the purported value of Western journalism, to "tell the truth"—as such, it is in part a reminder of what Peress is implicitly tasked to do as a professional photojournalist.
58. Peress, *Telex Iran*, 44.
59. Ibid., 20–21.
60. Ibid., 52.
61. Ibid., 66.
62. Ibid., 88.
63. Peress, *Telex Iran*, n.p.
64. Fred Ritchin, "The Photography of Conflict," *Aperture* 97 (1984): 26.
65. Miriam Horn, "Eyes behind the Camera, Then and Now," *U.S. News and World Report*, November 9, 1987, 88.
66. Horn, "Eyes behind the Camera," 88.
67. Greg Grandin, *Empire's Workshop: Latin America, the United States, and the Rise of the New Imperialism* (New York: Metropolitan Books, 2006).

68. For the U.S. military, Grandin observes, Latin America served as a "laboratory for counter-insurgency," becoming "a school where the United States studied how to execute imperial violence through proxies. . . . By the end of the Cold War, Latin American security forces trained, funded, equipped, and incited by Washington had executed a reign of bloody terror—hundreds of thousands killed, an equal number tortured, millions driven into exile" (*Empire's Workshop*, 4).

69. See Bolling, *Reporters under Fire*, 95–118. A prominent critique was that put forward by the journalist Shirley Christian, based on her study of *Washington Post*, *New York Times*, and CBS coverage of Nicaragua from January 1978 to July 1979, when the Sandinistas came to power. Christian charged that American journalists were myopic in their coverage of the Nicaraguan revolution, failing to underscore the Marxist nature of the rebels and fixating on the corruptions and cruelties of the Somoza regime. In conclusion, she writes that "the press got on the Sandinistas' bandwagon and the story that reporters told—with a mixture of delight and guilt—was the ending of an era in which the United States had once again been proved wrong" (Christian, quoted in Bolling, *Reporters under Fire*, 130).

70. Robin Andersen, "Images of War: Photojournalism, Ideology, and Central America," *Latin American Perspectives* 16, no. 2 (Spring 1989): 101.

71. Ibid., 101–2, 112.

72. Joan Didion, *Salvador* (1983; repr., London: Granta, 2006), 13.

73. Ibid., 35–36.

74. While some journalists were critical of Didion's perspective and of her relatively brief sojourn in the country as the basis for a book publication, most reviews in the U.S. media were impressed or sympathetic. Writing in the *Washington Post*, Joanne Omang argued that the book was "less about the bloody civil war than it is a meditation on the place as conqueror of all attempts at description. Hundreds of 'straight' reporters groping through El Salvador last year dimly felt the way she did, I am convinced from my own experience there, but we were unable to make it known, constrained by the conventions of our media, which demand conclusions, and by our own tied tongues. Didion does it for us" ("El Salvador and the Topography of Terror," Book World, *Washington Post*, March 13, 1983, 1). The lack of "conclusions"—of a clear, explanatory narrative—was widely perceived as a dilemma among U.S. journalists, an aporia for the "concerned" reporter that foregrounded the role of the journalist as witness. Gene Lyons, in a highly critical review of Salvador in *Newsweek*, nonetheless echoed the dilemma: "Can we, or should we, do nothing but avert our eyes?" ("Slouching through Salvador," *Newsweek*, March 28, 1983, 69).

75. Richard Cross, quoted in David Levi Strauss, *Between the Eyes: Essays on Photography and Politics* (New York: Aperture, 2003), 20.

76. Cross, quoted in ibid., 20–21

77. Susan Meiselas, "Central America and Human Rights," in *Witness in Our Time*, ed. Ken Light (Washington, DC: Smithsonian Books, 2000), 106.

78. Ibid., 102.

79. Susan Meiselas, "An Interview with Susan Meiselas," by Kristen Lubben, in *Susan Meiselas: In History*, ed. Kristen Lubben (New York: International Center of Photography; Gottingen: Steidl, 2008), 115–16.

80. Susan Meiselas, "Voyages," in *Susan Meiselas*, ed. Lubben, 225–26.

81. Of course, these intensive reflections also become a form of framing, inserting a critical interpretation on her work—a self-consciousness about photojournalism as a practice of framing that presumes a knowledge that is created by the frame.

82. Meiselas, "Voyages," 226.

83. Ibid., 225.

84. Susan Meiselas, "Body on a Hillside," in *Picturing Atrocity: Photography in Crisis*, ed. Geoffrey Batchen, Mick Gidley, Nancy K. Miller, and Jay Prosser (London: Reaktion, 2012), 118.

85. Ibid., 118.

86. Susan Meiselas, "Some Thoughts on Appropriations and the Use of Documentary Photographs," *Exposure* 24, no. 4 (1989): 11.

87. Alan Riding, "National Mutiny in Nicaragua," *New York Times Magazine*, July 30, 1978.

88. Meiselas, "Some Thoughts," 12.

89. Ibid., 12.

90. Meiselas, "Voyages," 225.

91. Richard Elman, "Nicaragua: A People Aflame," *Geo* 1 (1979): 58.

92. The Catholic Church appropriated it in advertising in Nicaragua, and much to Meiselas's disgust, the U.S.-backed Contras used it for recruitment posters. It was widely reproduced on murals in Nicaragua and also on merchandise, from stamps to t-shirts. See Lubben, *Susan Meiselas*, 170–73, for the images discussed in the text.

93. The production experience was a frustrating one for Meiselas as she did not have editorial control, but she was pleased that a Spanish edition was published at moderate cost and was widely circulated throughout Central America.

94. Susan Meiselas, quoted in Fred Ritchin, "Susan Meiselas: The Frailty of the Frame," *Aperture* 108 (Fall 1987): 108.

95. Robert Stone, "Witness at El Playon," *Harper's*, December 1983, 72.

96. Meiselas, quoted in *Susan Meiselas*, ed. Lubben, 158.

97. Andy Grundberg, "Pictures of Change," *New York Times*, June 14, 1981, http://www.nytimes.com/1981/06/14/books/pictures-of-change.html.

98. John Leonard, "Cocktails at Somoza's," *New York Times*, June 2, 1981, http://www.nytimes.com/1981/06/02/books/books-of-the-times-140500.html.

99. Max Kozloff, review of *Nicaragua*, by Susan Meiselas, *Art Forum*, November 1981, 77.

100. John Berger, "Restoring Dignity," *New Society*, November 5, 1981, 244.

101. Ibid., 244.

102. Lucy Lippard, "Susan Meiselas: An Artist Called," in *Susan Meiselas*, ed. Lubben, 215.

103. Martha Rosler, "A Revolution in Living Color: The Photojournalism of Susan Meiselas," *In These Times*, June 17–30, 1981, 20.

104. Ibid., 20.

105. Rosler would later reprint this essay, with a revisionary prefatory note stating her admiration for Meiselas's work and wondering if "the shock caused by war photos in color is no longer quite such an important issue." In the reprint, Rosler restored text that was edited out of the original publication and notes: "It restores my criticism of publishers that the newspaper was reluctant to print, which led to editing that appeared to lay too much responsibility for the book's format . . . at Meiselas's feet" ("Wars and Metaphors," in *Decoys and Disruptions: Selected Writings, 1975–2001*, October Books (Cambridge, MA: MIT Press, 2006), 245–46.

106. "I was certainly questioning my role as an 'outsider' throughout the process of working in Nicaragua, El Salvador, and Chile" (Susan Meiselas, in Joanna Heatwole and Mariola Mourelo, "Extending the Frame: An Interview with Susan Meiselas," *Afterimage*, March–April 2006, 18).

107. See Diana Taylor, "Past Performing Future: Susan Meiselas's *Reframing History*," in *Susan Meiselas*, ed. Lubben, 232–36.

108. Quoted in Denise Leith, *Bearing Witness: The Lives of War Correspondents and Photojournalists* (Sydney: Random House, 2004), 239.

109. Caroline Brothers, "Susan Meiselas: Photographs from the Edge," *New York Times*, August 1, 2007, http://www.nytimes.com/2007/08/01/arts/01iht -magnum.4.6936425.html?pagewanted=all&_r=0.

110. Meiselas, "An Interview with Susan Meiselas," 116.

111. In December 1981, Bonner and Guillermoprieto had been separately invited by guerillas to enter Morazan but then cancelled the trip. The invitations were extended again in early January. Arriving in Honduras on January 3, 1982, Bonner and Meiselas hiked for three days with rebels to the sites of the massacre. See Mark Danner, *The Massacre at El Mozote: A Parable of the Cold War* (New York: Vintage, 1994).

112. Susan Meiselas, quoted in Leith, *Bearing Witness*, 237.

113. See Danner, *Massacre at El Mozote*.

114. Meiselas, "An Interview with Susan Meiselas," 120.

115. Meiselas, quoted in Ritchin, "Susan Meiselas," 33.

116. In 1990 she helped to edit a book of images by Chilean photographers covering conflicts in that country, *Chile from Within, 1973–1988*, stating that she "felt it was important that the world see Chile through *their* eyes, rather than those of us who come from afar" (in Heatwole and Mourelo, "Extending the Frame," 18).

117. The book was published by Writer and Readers Press and distributed by W. W. Norton. The first print of 12,500 copies sold out within a year.

118. In 2005, the images were exhibited again, at the International Center for Photography in New York and at University of Texas in Austin, to which the archive was donated. In this later version, the accompanying text drew attention both to the ongoing upheavals in El Salvador and to the wars in Afghanistan and Iraq—the latter reference was picked up by many reviewers. See Bill Van Auken, "Images of El Salvador Carnage Reprised in Light of Iraq War," World Socialist Web Site (October 25, 2005), http://www.wsws.org/en /articles/2005/10/salv-o28.html.

119. In 2007, Meiselas contested the use of the *Molotov Man* image by an American artist. In doing so, she argued the need to "reclaim the context" of an image: "We owe this debt of specificity not just to one another but to our subjects, with whom we have an implicit contract" (in Joy Garnett and Susan Meiselas, "On the Rights of Molotov Man: Appropriation and the Art of Context," *Harper's Magazine*, February 2007, 53–58).

120. This usage further reflects the contexts of different countries in which they have taken on meanings. As Kristen Lubben points out, these countries "are in different places in their histories, and the uses to which [Meiselas'] photos are put—from commemoration to prosecution—reflect that" (Lubben, "An Interview with Susan Meiselas," in *Susan Meiselas*, ed. Lubben, 121).

CHAPTER THREE

1. In 1990, then secretary of state James Baker stated: "Beyond containment lies democracy. The time of sweeping away the old dictators is passing fast; the time of building up the new democracies has arrived. That is why President Bush has defined our new mission to be the promotion and consolidation of democracy. It is a task that fulfills both American ideals and American interests." Quoted in Samuel P. Huntington, *The Third Wave: Democratization in the Late Twentieth Century* (Norman: Oklahoma University Press, 1991), 284.

2. See Karin von Hippel, *Democracy by Force: US Military Intervention in the Post-Cold War World* (Cambridge: Cambridge University Press, 2000).

3. Jean Baudrillard, *The Gulf War Did Not Take Place* (Bloomington: Indiana University Press, 1995), 30.

4. See Philip Hammond, *Media, War, and Postmodernity* (London: Routledge, 2007).

5. How the media reported global conflicts and American interests in those conflicts was reshaped by the breakdown of the Cold War paradigm. As Robert Entman observes, this breakdown "betokens the growth of ambiguity in foreign policy events, issues, and actors as habitual schemas laid down and continually reinforced during the Cold War fell into disuse" (*Projections of Power: Framing News, Public Opinion and US Foreign Policy* [Chicago: University of Chicago Press, 2004], 95).

6. See Michael Ignatieff, *Virtual War: Kosovo and Beyond* (New York: Vintage, 2001), 164.

7. Ibid., 163.

8. Ibid.

9. See Piers Robinson, *The CNN Effect: The Myth of News, Foreign Policy and Intervention* (London: Routledge, 2002).

10. Within human rights discourse, the "mobilization of shame" depends on visual exposure. As Thomas Keenan notes, it is a "pervasive axiom of the human rights movement that those agents whose behavior it wishes to affect—governments, armies, businesses, and militias—are exposed in some significant way to the force of public opinion. . . . Shame is thought of as a primordial force that articulates or links knowledge with action, a feeling or a sensation brought on not by physical contact but by knowledge or consciousness alone. And it signifies involvement in a social network, exposure to others and susceptibility to their gaze" ("Mobilizing Shame," *South Atlantic Quarterly* 103, nos. 2–3 [Spring–Summer 2004], 435–36).

11. David B. Stockwell, "Press Coverage in Somalia: A Case for Media Relations to Be a Principle of Operations Other Than War," GlobalSecurity.org, April 18, 1995, http://www.globalsecurity.org/military/library/report/1995/SDB.htm.

12. See David Perlmutter, "When Icons Collide: Somalia, 1992–1993," in *Photojournalism and Foreign Policy: Icons of Outrage in International Crises* (Westport, CT: Praeger, 1998), 91–124.

13. George Bush, "Address to the Nation on the Situation in Somalia," December 4, 1992, The American Presidency Project, http://www.presidency.ucsb.edu/ws/?pid=21758.

14. *Time* ran a photo essay titled "Landscape of Horrors: The Images That Moved the World" (December 14, 1992).

15. George J. Church, "Somalia: Anatomy of a Disaster," *Time*, October 18, 1993, http://www.time.com/time/magazine/article/0,9171,979399,00.html?xid=rss-mostpopular.

16. B. Drummond Ayres Jr., "The Somalia Mission: Voices; a Common Cry across the U.S.: It's Time to Exit," *New York Times*, October 9, 1993, http://www.nytimes.com/1993/10/09/us/the-somalia-mission-voices-a-common-cry-across-the-us-it-s-time-to-exit.html.

17. Joseph Nye, "Redefining National Interest," *Foreign Affairs* 78, no. 4 (July–August 1999): 22.

18. See Perlmutter, "When Icons Collide," 103–7.

19. See Entman, *Projections of Power*, 107.

20. As Thomas Keenan argues, "The point of Somalia was the pictures, the transmission and archiving of a new image for a military-aesthetic complex recently deprived of the only enemy it could remember knowing" ("Mobilizing Shame," 440). Somalis, too, were recording events, including the filming of the captured pilot Durant. In this respect, the Somalia conflict evidenced the heightened mediation of conflict outlined above.

21. Paul Watson, *Where War Lives: A Journey into the Heart of War* (New York: Rodale, 2008), 23.
22. Ibid., 24.
23. Ibid., 6, 37.
24. Ibid., 24.
25. Ibid., 37.
26. Jacqueline E. Sharkey, "When Pictures Drive Foreign Policy," *American Journalism Review*, December 1993, http://www.ajr.org/article.asp?id=1579.
27. The corpses of Somalis were not shown in U.S. media.
28. Steve Wilson, in Sharkey, "When Pictures."
29. Marvin Kalb, quoted in Sharkey, "When Pictures."
30. Perlmutter, *Photojournalism and Foreign Policy*, 12.
31. The image has come to exemplify the risks of interventionism, and some have argued it thereby contributed to U.S. reluctance to intervene in African crises, most notably the failure to do so in Rwanda the following year. The *New York Times* stated this clearly in a 1994 editorial: "Somalia provides ample warning against plunging open-endedly into a 'humanitarian' mission" (April 23, 1994, http://www.nytimes.com/1994/04/23/opinion/cold-choices-in-rwanda.html).
32. Osama bin Laden, quoted in Barry Rubin and Judith Colp Rubin, eds., *Anti-American Terrorism and the Middle East: A Documentary Reader* (Oxford: Oxford University Press, 2002), 140.
33. Watson, *Where War Lives*, 36.
34. Ibid., 37.
35. See Judith Butler, *Precarious Life: The Powers of Mourning and Violence* (London: Verso, 2004), and *Frames of War: When Is Life Grievable?* (London: Verso, 2010).
36. Phil Gramm, in "Foreign Policy: In, or Out, or What?" *Economist*, October 9, 1993, 22.
37. After the war, then defense secretary Dick Cheney made clear his view that the press needed to be contained: "Frankly I looked on it as a problem to be managed. . . . The information function was extraordinarily important. I did not have a lot of confidence that I could leave that to the press" (quoted in Patrick J. Sloyan, "What Bodies?" *Digital Journalist*, November 2002, http://digitaljournalist.org/issue0211/sloyan.html).
38. Malcolm Browne, "The Military vs. the Press," *New York Times Magazine*, March 3, 1991, http://www.nytimes.com/1991/03/03/magazine/the-military-vs-the-press.html?pagewanted=all&src=pm.
39. Ibid.
40. Elihu Katz, "The End of Journalism? Notes on Watching the War," *Journal of Communication* 4, no. 3 (1992): 8.
41. Michael Griffin and J. S. Lee, "Picturing the Gulf War: Constructing Images of War in *Time*, *Newsweek*, and *U.S. News & World Report*," *Journalism and Mass Communication Quarterly* 72, no. 4 (1995): 813–25.

42. David Turnley, "Picture Power: Casualties of War," BBC News, October 3, 2005, http://news.bbc.co.uk/1/hi/4290906.stm.

43. Ibid.

44. Paul Martin Lester, "Military Censorship of Photographs," in *Media Ethics: Issues and Cases*, ed. Philip Patterson and Lee Wilkins (Madison: WCB Brown and Benchmark, 1994), 215.

45. George Bush, quoted in Tim Graham, "The Picture of the Cost of War," *Buffalo News*, June 24, 2012, http://www.buffalonews.com/apps/pbcs.dll /article?aid=/20120624/cityandregion/120629986/1079.

46. Turnley, "Picture Power."

47. It has many precedents, including the famous Yankee Papa 13 images produced by Larry Burrows in 1965.

48. Also, this was a conventional picture of the hero-warrior, a figure otherwise absent from the visualization of this war. Turnley was concerned that the war denied representation to the realities of "heroism." As with many such images, the subject's subsequent life was revisited by the media and found to sharply contrast with the heroic image. When Kozakiewicz was interviewed by the *Buffalo News* in 2012, he expressed "survivor's guilt and bitterness towards the government," related his postwar experiences of "panic attacks and dark depression," and remarked that he looked at the photograph "only reluctantly." Graham, "The Picture of the Cost of War."

49. Turnley, "Picture Power." Michael Ignatieff and others argue sacrifice has become "implausible or ironic," an empty sign, in the era of virtual war. See Ignatieff, *Virtual War.*

50. John Dumiak reports on the Sygma coverage: "The photographers planned ahead and fitted themselves carefully into the Mideast military environment. Before leaving Britain for the front lines, Mr. Hudson envisioned a still-photography team organized to compete against television. First, color negative film would be processed on the spot. Second, satellite picture transmission would carry still images out to a picture-hungry world. He found that battery-powered portable phones and satellite transmitters were sold in Saudi Arabia. Mr. Hudson said he took a Honda gasoline-powered generator to Saudi Arabia after learning about the inconsistencies in electrical power there" ("Camera," *New York Times*, September 1, 1991, http://www.nytimes .com/1991/09/01/news/camera.html).

51. Sygma Photo News, Inc., *In the Eye of Desert Storm: Photographers of the Gulf War* (New York: Harry N. Abrams, 1991).

52. Ibid., 84.

53. Ibid., 94.

54. Sloyan, "What Bodies?"

55. The launch of ground war on February 24 had involved a ferocious tank battle in the neutral zone between Iraq and Saudi Arabia. When war correspondent Leon Daniel arrived the next day he wondered what had happened to the estimated six thousand Iraqi defenders who had vanished. "Where the

hell are all the bodies?" Daniel finally asked the First Division's public affairs officer, an army major. "'What bodies?' the officer replied." They later discovered that "thousands of Iraqi soldiers, some of them alive and firing their weapons from World War I–style trenches, were buried by plows mounted on Abrams main battle tanks." Sloyan, "What Bodies?"

56. Peter Turnley, "The Unseen Gulf War," *Digital Journalist*, December 2002, http://digitaljournalist.org/issue0212/pt_intro.html.

57. Peter Turnley, in "Blood in the Sand: The Unpublished Photographs That Reveal the True Horror of the Gulf War," *Guardian*, February 14, 2003, 7.

58. See Andrew Hoskins and Ben O'Loughlin, *War and Media: The Emergence of Diffused War* (Cambridge: Polity, 2010), 99.

59. Turnley, "The Unseen Gulf War."

60. John Taylor, *Body Horror: Photojournalism, Catastrophe and War* (London: Routledge, 1998), 181.

61. Kenneth Jarecke, "Picture Power: Death of an Iraqi Soldier," BBC News, May 9, 2005, http://news.bbc.co.uk/1/hi/world/middle_east/4528745.stm.

62. Harold Evans, "Facing a Grim Reality," *American Photographer*, July–August 1991, 48.

63. Ibid.

64. Taylor, *Body Horror*, 183.

65. Kenneth Jarecke, quoted in Turnley, "Blood in the Sand," 13.

66. Turnley, "Blood in the Sand."

67. Susan Sontag: "Let the atrocious images haunt us. Even if they are only tokens, and cannot possibly encompass most of the reality to which they refer, they still perform a vital function. The images say: This is what human beings are capable of doing—may volunteer to do, enthusiastically, self-righteously. Don't forget" (*Regarding the Pain of Others* [New York: Farrar, Straus and Giroux, 2003], 115). The *Guardian* used this quote to preface "Blood in the Sand."

68. See David Campbell, "Cultural Governance and Pictorial Resistance: Reflections on the Imaging of War," *Review of International Studies* 29 (2003): 73. Secretary of Defense Dick Cheney described the Gulf War as a "catharsis . . . that sort of lifted the burden that the country had borne, almost without being aware of it, since the war in Vietnam" (quoted in Hammond, *Media, War and Postmodernity*, 52).

69. Martin Shaw, *Civil Society and Media in Global Crises* (London: Pinter, 1996), 178. Shaw further argues, "In the Kurdish crisis, there was a clear interdependence of television news journalism with the transnationally-oriented humanitarian organisations, in advocacy of globalist concepts of responsibility for victims. Kurdish political movements were not able to represent their goals effectively in the global mass media, but when Kurdish civilians were transformed into the pure victims of the Saddam regime, and indirectly of Western non-intervention, Western journalists engaged in powerful representation of their plight" ("Crystallizations of Media in the Global Revolu-

tion: News Coverage and Power from Kurdistan to Kosovo," http://www
.sussex.ac.uk/Users/hafa3/crystal.htm).

70. Les Stone of Sygma produced one of the most striking images, of the arrival
of a U.S. Sikorsky "green giant" helicopter with relief supplies in the moun-
tainous border area. The arrival "causes a stampede of famished Kurdish refu-
gees. An eight year old girl was trampled to death in the melee." Les Stone, in
In the Eye of Desert Storm, 168.

71. One of the most sustained photographic documentations of the experiences
of the Kurds was that of Susan Meiselas. Meiselas was drawn to the plight of
the Kurds as she followed news reports about the Iraqi military's "Anfal cam-
paign" to destroy whole communities in Kurdistan in 1990 yet noted there
was little visual documentation of this. Working in tandem with Middle
East Watch and Human Rights Watch, which were collecting testimony from
refugees, she set about visually documenting the destroyed villages, mass
graves, and any markers of violence that could provide evidence of what
caused their displacement. Meiselas also put together a book and a website
that documented the history of the Kurds via numerous different visual and
documentary sources. The resulting book, *Kurdistan: In the Shadow of History*
(Chicago: University of Chicago Press, 1997), and website akaKurdistan.com,
constitute a "usable archive" that has become a significant reference point
for Kurds across the world. The website is an open-ended construct that
invites Kurds to contribute images and comments, collectively excavating a
buried archive of belonging in the diasporic circuits of a stateless people. It
is a potent example of the role of photography in the creation of imagined
community. Within the history of photojournalism's commitment to docu-
mentation of the lives of stateless subjects, it represents a radical rethinking
of the role of the photographer as witness.

72. Fred Ritchin, "The End of Photography as We Have Known It," in *Photovideo:
Photography in the Age of the Computer*, ed. P. Wombell (London: Rivers Oram
Press, 1991), 11.

73. David Levi Strauss, *Between the Eyes: Essays on Photography and Politics* (New
York: Aperture, 2003), 78.

74. Oleg Klimov, quoted in Dirck Halstead, "The End of History and Photojour-
nalism," *Digital Journalist*, November 1999, http://digitaljournalist.org
/issue9910/editorial.htm.

75. Media coverage of the massacre at Srebrenica in 1995 prompted the United
Nations to authorize "safe areas" in endangered Bosnian towns.

76. Carol Williams, quoted in Sherry Ricchiardi, "Confused Images: How the
Media Fueled the Balkans War," *Journal of the International Institute*, vol. 3,
no. 2 (Winter 1996), http://quod.lib.umich.edu/cgi/t/text/text-idx?c
=jii;view=text;rgn=main;idno=4750978.0003.215.

77. Paul Whyte, quoted in Ricchiardi, "Confused Images."

78. Raznatovic recognized Haviv, who had photographed him holding a pet tiger
in front of a tank and a group of his soldiers, an image that had boosted the

militia leader's fame in the region. Ron Haviv said of the incident: "I went to him and appealed to his sense of vanity and asked him to let me photograph his troops liberating the Serbian people. Thinking he was smarter than me and the media, he said, 'Of course.' I was then able to document the first instances of ethnic cleansing in Bosnia as his troops killed a number of elderly people. After the photographs were published, Arkan never let any journalist travel with him again" ("Horror and Humanity: Photographing War," usnews.com, July 11, 2001, http://www.usnews.com/usnews/doubleissue /photography/chat.htm).

79. Ron Haviv, quoted in "Basically We're Alone. Left Up to Our Own Wits," Nieman Reports, Fall 2000, http://www.nieman.harvard.edu/reports /article/101848/Basically-Were-Alone-Left-Up-to-Our-Own-Wits.aspx.

80. Chuck Sudetic, quoted in Ron Haviv, *Blood and Honey: A Balkan War Journal* (New York: TV Books, 2000).

81. Ron Haviv, quoted in "Basically We're Alone."

82. David Rieff, quoted in Haviv, *Blood and Honey*, 22.

83. J. F. O. McAlister, "Atrocity and Outrage," *Time*, August 17, 1992, http://www .time.com/time/magazine/article/0,9171,976238,00.html.

84. Russell Watson, "Ethnic Cleansing," *Newsweek*, August 17, 1992, 16. See Susan Moeller, *Compassion Fatigue: How the Media Sell Disease, Famine, War and Death* (London: Routledge, 1999), 231.

85. See Barbie Zelizer, *Remembering to Forget: Holocaust Memory through the Camera's Eye* (Chicago: University of Chicago Press, 1998).

86. This reflected the determination of the Bush administration not to be pressured to intervene; as Mark Danner observes, "The pictures from the camps . . . confronted Bush officials with the challenge not of how to deal with the re-emergence of concentration camps in Europe but rather how to withstand the political pressures from the televised images of them" ("America and the Bosnian Genocide," *New York Review of Books*, December 4, 1997, http://www.nybooks.com/articles/archives/1997/dec/04/america-and -the-bosnia-genocide/?pagination=false).

87. Roger Cohen, "In Bosnia, the War That Can't Be Seen," *New York Times*, December 25, 1994, http://www.nytimes.com/1994/12/25/weekinreview /ideas-trends-in-bosnia-the-war-that-can-t-be-seen.html.

88. Dan Rather, quoted in Moeller, *Compassion Fatigue*, 259–60.

89. Ibid., 279.

90. Susan Sontag, "'There' and 'Here': A Lament," *Nation*, December 25, 1995, 819.

91. Zelizer, *Remembering to Forget*, 206.

92. Roy Gutman, quoted in Leith, *Bearing Witness*, 162

93. Roy Gutman and David Rieff, *Crimes of War: What the Public Should Know* (New York: W. W. Norton, 1999).

94. In a 1997 interview, Peress remarks: "With the end of the Cold War comes the end of a major dialectical relationship in our world" and the inauguration of "a Nietzchian world, a world where it's each man for himself, a world

based on a bipolar dialectic—similitude and difference, with no mediating terms. . . . It has caused in me an urgency to look at reality. As it is" (Carole Kismaric, "Gilles Peress," *BOMB* 59 [Spring 1997]: 23, http://bombsite.com /issues/59/articles/2033).

95. These include articles, photographic books, and an innovative digital publication with the *New York Times*. His books—*The Silence* (New York: Distributed Art Publishers, 1995), which photographs the wake of the genocide in Rwanda, and *The Graves: Srebrenica and Vukovar* (Zurich: Scalo, 1998), which documents the painstaking search for human remains in mass graves in the former Yugoslavia—are at once eloquent and harrowing in their indictment and illustration of crimes against humanity.

96. Gilles Peress, "I Don't Care That Much Anymore about 'Good Photography,'" *U.S. News and World Report*, October 6, 1997, 6.

97. Ibid.

98. Gilles Peress, quoted in Paul Lowe, "The Forensic Turn: Bearing Witness and the Thingness of the Photograph," in *The Violence of the Image: Photography and International Conflict*, ed. Liam Kennedy and Caitlin Patrick (London: I. B. Tauris, 2014), 221.

99. Gilles Peress, *Farewell to Bosnia* (Zurich: Scalo, 1994).

100. Gilles Peress, quoted in "Get the Picture: Gilles Peress," Minneapolis Institute of Arts, http://www.artsmia.org/get-the-picture/peress/frame05.html.

101. Gilles Peress, quoted in Abigail Foerstner, "Images Document Human Devastation in Bosnian War," *Chicago Tribune*, July 8, 1994, http://articles .chicagotribune.com/1994-07-08/entertainment/9407080075_1_gilles -peress-bosnian-war-civil-war.

102. Peress, *Farewell to Bosnia*.

103. This included an exhibition, first staged at the Corcoran Gallery of Art in Washington, DC, in April 1994. It represented the rawness and oppressive nature of the imagery by hanging over eighty photographs in poster size, without frames, that "surround the viewer like giant contact sheets and generate a kaleidoscopic composite of human suffering." Foerstner, "Images Document Human Devastation in Bosnian War."

104. Such interactive forms of online presentation of conflict photography would become common, but this was the first major example. See Fred Ritchin, *After Photography* (New York: W. W. Norton, 2009), 101–9.

105. Gilles Peress, "Bosnia: Uncertain Paths to Peace," Pixel Press, http://www .pixelpress.org/bosnia/intro.html.

106. Ibid.

107. Carroll Bogert, "Journalism and Human Rights," A Village Destroyed, May 14, 1999, http://avillagedestroyed.org/printer_onmethod.html.

108. Bogert (ibid.) notes: "The war in Kosovo was a turning point for Human Rights Watch. . . . For the first time, over the many weeks of the NATO bombing campaign, human rights researchers were sending out fast dispatches based on refugee accounts and sources inside Kosovo—applying the same

painstaking methodology of traditional human rights work, but at a break-neck pace. Modern technology, of course, made this possible."

109. Gary Knight, quoted in Lowe, "The Forensic Turn," 219.

110. Anthony Lloyd, quoted in Gary Knight and Anthony Lloyd, *Evidence* (Millbrook, NY: De. MO, 2002), 6.

111. Ibid.

112. Knight, quoted in Lowe, "The Forensic Turn," 219.

113. Roy Gutman, quoted in Leith, *Bearing Witness*, 169.

114. Haviv, *Blood and Honey*, 184.

115. Ibid., 183.

116. Haviv, "Horror and Humanity." Haviv adds: "I think this is quite important now as we have entered a new historical phase with the arrest of President Milosevic. The current case against him with Kosovo, as well as those that will follow, are all backed up photographically by myself and my colleagues. Not only does the work accuse Mr. Milosevic but in my opinion holds responsible the politicians of the world who saw these images in the media as the war went on, and often did too little and too late to help" ("Horror and Humanity").

117. Bill Clinton, "Remarks at the Legislative Convention of the American Federation of State, County, and Municipal Employees," March 23, 1999, http://www.presidency.ucsb.edu/ws/?pid=57294.

118. Ignatieff, *Virtual War*, 203

119. See Moeller, *Compassion Fatigue*.

CHAPTER FOUR

1. The concept of "perpetual war" has been taken up by diverse constituencies. For a range of perspectives, see Tariq Ali, "Perpetual War: Grand Strategy after 9/11," *CounterPunch*, September 7, 2011, www.counterpunch.org/2011/09/07/perpetual-war/; David A. Love, "A State of Perpetual War," *Huffington Post*, January 14, 2010, www.huffingtonpost.com/david-a-love/a-state-of-perpetual-war_b_422616.html; Greg Grandin, "Building a Perfect Machine of Perpetual War," *Nation*, February 11, 2011, www.thenation.com/blog/158492/building-perfect-machine-perpetual-war-mexico-colombia-security-corridor-advances; and James Joyner, "How Perpetual War Became U.S. Ideology," *Atlantic*, May 11, 2011, www.theatlantic.com/international/archive/2011/05/how-perpetual-war-became-us-ideology/238600/.

2. On "hauntology," see Jacques Derrida, *Specters of Marx: The State of the Debt, the Work of Mourning, and the New International* (New York: Routledge, 2006).

3. Thomas Hoepker, quoted in David Friend, *Watching the World Change: The Stories behind the Images of 9/11* (New York: Picador, 2007), 91.

4. Frank Rich, "Whatever Happened to the America of 9/12?" *New York Times*, September 10, 2006, http://select.nytimes.com/2006/09/10/opinion/10rich.html?_r=1.

5. Thomas Hoepker, "I Took That 9/11 Photo," *Slate*, September 14, 2006, http://www.slate.com/articles/arts/culturebox/2006/09/i_took_that_911_photo.html.

6. See the Poynter Institute's *September 11, 2001: A Collection of Newspaper Front Pages Selected by the Poynter Institute* (New York: Andrews McMeel, 2001); and John Taylor, "This Is This," *Source* 29 (Winter 2001): 4–6.

7. See Susan Sontag, *On Photography* (London: Penguin, 1979); Jay Ruby, *Secure the Shadow: Death and Photography in America* (Cambridge, MA: MIT Press, 1995).

8. Marianne Hirsch, "The Day Time Stopped," *Chronicle of Higher Education*, January 25, 2002, 6.

9. Brian Wallis, "Aftermath: Photography in the Wake of September 11," International Center of Photography, http://www.icp.org/exhibitions/aftermath.

10. Ingrid Sischy, "Lasting Images," *Sunday Morning*, Radio National, http://www.abc.net.au/rn/arts/sunmorn/stories/s487406.htm.

11. Blake Eskin, "Getting the Big Picture," *ARTnews*, February 2002, 101.

12. Andy Grundberg, "Photography," *New York Times Book Review*, December 2, 2001, 35.

13. David Harvey, "Cracks in the Edifice of the Empire State," in *After the World Trade Center: Rethinking New York City*, ed. Michael Sorkin and Sharon Zukin (London: Routledge, 2002), 57.

14. Michael Griffin, "Picturing America's 'War on Terrorism' in Afghanistan and Iraq," *Journalism* 5, no. 4 (2004): 383.

15. Bryan Whitman, quoted in D. O'Regan, "Embedded Journalism," *Knot Magazine*, February 5, 2003, www.knotmag.com/?article=639.

16. O'Regan, "Embedded Journalism."

17. Vincent Laforet, "Photographer Worried about 'Glorifying War,'" *Editor and Publisher*, April 23, 2003, http://www.editorandpublisher.com/PrintArticle/Photographer-Worried-About-Glorifying-War-.

18. Rita Leistner, quoted in Catherine Komp, "Witness to War: Unembedded Photojournalism in Iraq," *Clamor Magazine*, Spring 2006, http://clamormagazine.org/issue/spring-2006.

19. Judith Butler, "Photography, War, Outrage," *PMLA* 120, no. 3 (2005): 823.

20. Moises Saman, "US: Double Standards for War Photographs," *The Editor's Weblog*, July 20, 2005 http://wef.blogs.com/editors/2005/07/us_ethical_doub_2.html.

21. Michael Kamber and Tim Arango, "4,000 U.S. Deaths, and a Handful of Images," *New York Times*, July 26, 2008, http://www.nytimes.com/2008/07/26/world/middleeast/26censor.html?pagewanted=all.

22. Ashley Gilbertson, *Whiskey Tango Foxtrot: A Photographer's Chronicle of the Iraq War* (Chicago: University of Chicago Press, 2007), 10.

23. Dexter Filkins, introduction to ibid., 2.

24. Ashley Gilbertson, quoted in Rachel Wells, "Live from Fallujah," *Age*, Au-

gust 30, 2005, http://www.theage.com.au/news/entertainment/live-from
-fallujah/2005/08/29/1125302504555.html.

25. Gilbertson, *Whiskey Tango Foxtrot*, 239.

26. Michael Shaw, "WTF," *Bag News*, September 28, 2007, http://www
.bagnewsnotes.com/2007/09/wtf/.

27. Gilbertson, *Whiskey Tango Foxtrot*, 193.

28. Ibid., 234.

29. Ibid., 193.

30. Ashley Gilbertson, interview by Dave Davies, "Ashley Gilbertson: Shooting
Passionately in Iraq," *Fresh Air*, National Public Radio, June 13, 2007, http://
www.npr.org/templates/story/story.php?storyId=11012130.

31. As Allen Feldman observes, "geographies of alterity are linked to their
authentication in geographies of violence"; "a buried truth is located in the
alien body sited in the postcolonial peripheries" and must be brought up to
the surface in modes of exposure and display ("Memory Theatres, Virtual
Witnessing, and the Trauma-Aesthetic," *Biography* 27, no. 1 [Winter 2004]:
163–202). Documentary photography is one such mode of creating this dis-
play, which is to say this photograph works off a long history of photojour-
nalistic imagery of violent conflict, using a frame and conventions common
to the genre.

32. Alain Badiou, *Polemics* (London: Verso, 2006), 28.

33. Ibid., 29.

34. Is this a scene of care or a scene of domination? Part of the difficulty in mak-
ing a judgment about this is that the postures of care and domination draw
on the same foundation, the primal scene of human vulnerability. See Judith
Butler, *Precarious Life: The Power of Mourning and Violence* (London: Verso,
2006).

35. Dexter Filkins, introduction to Gilbertson, *Whiskey Tango Foxtrot*, 7.

36. Ashley Gilbertson: "I think you need to be very conscious of what you're
doing when you're embedding. I mean I feel that I've embedded with pretty
much every one of my subjects over the years. . . . Our goal as photojournal-
ists is to spend as much time with a subject as humanly possible. We are
living and breathing and eating and sleeping with them. You gain so much
trust that way, and you actually start seeing more intimate moments of
people's lives. So I don't think it's anything different from what we normally
do. The reason to embed is for that reason, for the access, for that intimacy,
to see what they see and to feel what they feel, although the Pentagon has
put rules on what we do and how we work" ("Julian Stallabrass and Ash-
ley Gilbertson—in Conversation," Brighton Photo Biennial 2008, Octo-
ber 2008, www.courtauld.ac.uk/people/ . . . /Ashley%20Gilbertson
%20interview.doc).

37. The Editors, *CJR*, "Chris Hondros: How He Got That Picture," *Columbia Jour-
nalism Review*, April 21, 2011, www.cjr.org/campaign_desk/chris_hondros
_how_he_got_that_picture.php.

38. This is how the images are sequenced in an online slideshow maintained by *Newsweek*. See www.msnbc.msn.com/id/6871483.

39. Under media pressure, the U.S. military issued a formal statement in which officials extended their condolences for "this unfortunate incident." The unit's chaplain, Captain Ed Willis, said there was no reason for the soldiers involved to feel guilt: "If you kill someone on the battlefield, whether it's another soldier or collateral damage, that doesn't fit under 'Thou shalt not kill'" (quoted in Owen Matthews, "Orphans of Tal Afar," *Newsweek*, March 28, 2005, www.newsweek.com/2005/03/27/orphans-of-tall-afar .html).

40. Ibid.

41. See Allen Feldman, "The Structuring Enemy and Archival War," *PMLA* 124, no. 5 (2009): 1704–13.

42. There are numerous examples. More often than not, they are framed as comments on the caring mission of the soldier or/and they emphasize the contrast of innocence and experience. At times, the framing is more ambiguous, hinting at violation and subjugation. A compelling example of the latter is the image by Philip Jones Griffiths of a GI with a young Vietnamese girl on his knee, taken in Vietnam in 1967, and one of the first images in Griffiths's book *Vietnam Inc.* Their implacable togetherness is disturbing and indicative of Griffiths's intention to question "misplaced confidence in the universal goodness of American values" (*Vietnam Inc.* [London: Phaidon Press, 2001], 4).

43. Jason Christopher Hartley, in his blog *Just Another Soldier*, occasionally provides tentative thoughts about the violent action of his colleagues. Following the killing of a civilian Iraqi family by U.S. forces, who mistook them for insurgents, Hartley reflects on his inchoate feelings about such killings: "I've been painstakingly mulling over in my mind the things these insurgents do and the things we, the U.S. Army do and the unintuitive peculiarity of how the *drive* to be violent seems to precede the *purpose* to be violent and how rampant it is to meaninglessly develop one's identity through injury, but frankly I don't feel I've figured it all out well enough yet to even kludge together a coherent line of thought." Along with his commentary Hartley posts a photograph of one of the dead civilians. It is discretely composed, showing a bloodied torso lying beside what appears to be the door of a vehicle. The head of the body is not visible, possibly due to respect for the dead individual but as likely due to security regulations. Although he does not comment on the image, it appears to supplement his desire to act as witness to an event he was not present at. He notes that he "didn't see any of this first-hand" and adds "I wish I had been there, to bear witness I suppose. So tell me, why would I wish for this? ("I ♥ Dead Civilians," *Just Another Soldier* [blog], April 24, 2004, http://www.justanothersoldier.com/?p=30). Hartley's commentary is a troubled and troubling reflection on the compulsion to visually document such experiences as a form of "bearing witness."

44. Jay Romano, quoted in "A Soldier's Pictures of Iraq," Lightstalkers (posted August 13, 2007), http://www.lightstalkers.org/posts/a_soldier_s_pictures _of_iraq.

45. Jay Romano, 2009, http://www.flickr.com/photos/70355737@N00/.

46. Ibid.

47. Ibid.

48. Quoted in ibid.

49. Ibid.

50. Tim O'Brien, *The Things They Carried* (New York: Barnes and Noble, 1990).

51. Nina Berman, in David Schonaeur, "America's Homeland Insecurity: A Q & A with Photojournalist Nina Berman," *Popular Photography*, December 16, 2008, http://www.popphoto.com/Features/America-s-Homeland-Insecurity.

52. Nina Berman, "Purple Hearts: Back from Iraq," *Open Democracy*, March 22, 2005, http://www.opendemocracy.net/author/nina-berman.

53. Concurrent with the *Purple Hearts* project, Berman undertook a commission for *People* magazine during which she took a series of photographs of the recovery and marriage of a wounded Marine sergeant, Ty Ziegel. One of these images quickly became iconic. It depicts Ziegel and his fiancée Renee Kline posing for studio photographs in an Illinois farm town in 2006. Ziegel was very severely wounded when a car bomb exploded his truck in Iraq; the resulting explosion melted his face, blinded him in one eye, cost him his left arm and three fingers on his right hand. After a long rehabilitation, the couple, who had been teenage lovers, decided to wed. The photograph was judged World Press Photo portrait of the Year in 2007 and was widely republished. See Lindsay Beyerstein, "The Face of War," *Salon.com*, March 10, 2007, http://www.salon.com/life/feature/2007/03/10/berman_photo.

54. Berman, "Purple Hearts."

55. Nina Berman, *Homeland* (London: Trolley, 2008).

56. Ibid.

57. Berman, quoted in Schonaeur, "America's Homeland Insecurity."

58. Berman, *Homeland*.

59. Anthony Suau, "Fear This: A Nation at War," *Open Democracy*, October 6, 2004, http://www.opendemocracy.net/democracy-photography/article _2140.jsp.

60. Anthony Suau, "When I Took This Picture I Knew It Was the One," *British Journal of Photography*, February 13, 2009, http://www.bjp-online.com /public/showPage.html?page=840011.

61. Ashley Gilbertson, quoted in Adam McCauley, "Overexposed: A Photographer's War with PTSD," *Atlantic*, December 20, 2012, http://www.theatlantic .com/health/archive/2012/12/overexposed-a-photographers-war-with-ptsd /266468/.

62. Ashley Gilbertson, quoted in Adam McCauley, "Ashley Gilbertson," Aesop, http://www.aesop.com/fr/stories/ashley-gilbertson/.

63. Ashley Gilbertson, in Rachel Nolan, "A Conversation with Photographer

Ashley Gilbertson," *New York Times Magazine*, May 17, 2011, http://6thfloor
.blogs.nytimes.com/2011/05/17/a-conversation-with-photographer-ashley
-gilbertson/?_r=0.

64. Gilbertson, quoted in McCauley, "Ashley Gilbertson." In another interview
Gilbertson comments: "Death has been something I've been obsessed with
[ever] since Miller died . . . I began looking for a way to humanise him. I
didn't really know him, but I began looking for a way to tell people his story
[and that of] anybody who dies in these places" (quoted in David Tacon,
"Bringing Home the Tragedy of War," *Age*, August 6, 2011, http://www.theage
.com.au/national/bringing-home-the-tragedy-of-war-20110805-1if93.html
?skin=text-only).

65. Ashley Gilbertson, "The Shrine Down the Hall," *New York Times Maga-
zine*, March 18, 2010, http://www.nytimes.com/interactive/2010/03/21
/magazine/20100321-soliders-bedrooms-slideshow.html. The photo essay
won a National Magazine Award.

66. Ashley Gilbertson, in "Interview: Ashley Gilbertson's 'Bedrooms of the
Fallen,'" boywithgrenade.org, May 18, 2011, http://boywithgrenade.org
/2011/05/18/interview-ashley-gilbertsons-bedrooms-of-the-fallen/.

67. Ashley Gilbertson, in "Ashley Gilbertson's Bedrooms of the Fallen," inter-
view by Ochberg Society, November 16, 2012, http://www.ochbergsociety
.org/ashley-gilbertsons-bedrooms-of-the-fallen/.

68. In this respect his work complements but is also in competition with projects
such as the *New York Times*' "Faces of the Dead."

69. Mark Danner, "Frozen Scandal," *New York Review of Books*, December 4, 2008,
http://www.nybooks.com/articles/22117.

70. Nina Berman, in Catherine Clyne, "Coming Home: The *Satya* Interview with
Nina Berman," *Satya*, June–July 2006, http://www.satyamag.com/jun06
/berman.html.

CONCLUSION

1. With relation to photojournalism, the concept of a "postphotographic" era
has been most fully and influentially discussed by Fred Ritchin in his books
After Photography (New York: Norton, 2008) and *Bending the Frame: Photojour-
nalism, Documentary, and the Citizen* (New York: Aperture, 2013).

2. Susan Meiselas, interview by Fred Ritchin, "Susan Meiselas: The Frailty of the
Frame, Work in Progress," *Aperture* 108 (Fall 1987): 33.

3. A related burden is that created by critics who place the ills of modern
society on the "image world" sustained by photography, pace Susan Sontag
and Jean Baudrillard. See Susan Sontag, *On Photography* (London: Penguin,
1979); and Jean Baudrillard, *Simulacra and Simulation* (Ann Arbor: University
of Michigan Press, 1995).

4. I am grateful to Robert Hariman for sharing his thoughts on these points.

5. Henry Luce, quoted in Robert T. Elson, *Time Inc.: The Intimate History of a Publishing Enterprise, 1923–1941* (New York: Atheneum, 1968), 278.

6. Harold Evans, *Eyewitness: 25 Years through World Press Photos* (New York: William Morrow, 1981), 9, 24.

7. Errol Morris, "Not Every Picture Tells a Story," *New York Times*, November 20, 2004, http://www.nytimes.com/2004/11/20/opinion/20morris.html.

8. Robert Hariman makes a similar argument: "I think the basic problem is that people, at least collectively, decide to know. It is not the case that we know and then act. We decide when we will know, and then we are more likely to act. You can have the truth staring you in the face, but it doesn't matter until you decide to suspend all the habits of amnesia, distraction, rationalization, and denial that are otherwise in place and reproduced continuously. Once we decide, we can look back and see that there was plenty of information there all along. But we have to make that decision" ("When We Decide to Know," *No Caption Needed* [blog],October 25, 2010, http://www .nocaptionneeded.com/2010/10/when-we-decide-to-know/).

9. See www.flickr.com/photos/whitehouse/5680724572/. I want to be precise about this initial framing as there has been a huge amount of speculation about what this photograph depicts. First media reports, supported by White House spin, stated that the president and his team were watching live footage of the killing of Osama bin Laden. Under media scrutiny this story quickly swerved as it was admitted that only a small portion of the video viewed was live at the scene, most was focused on CIA chief Leon Panetta, who was commenting on what was being communicated to him. For a fuller commentary on the image, see Liam Kennedy, "Seeing and Believing: On Photography and the War on Terror," *Public Culture* 24, no. 2 (2012): 261–81.

10. See, for example, "The Situation Room," Know Your Meme, http:// knowyourmeme.com/memes/the-situation-room. A less playful manipulation of the image occurred with its publication in *Der Tzitung*, a Brooklyn-based Hasidic newspaper, which erased the two women in the photograph— Hillary Clinton and Audrey Tomasen, a counterterrorism analyst—stating this was due to religious "laws of modesty." See "Hilary Clinton Removed from Situation Room Photo by Der Tzitung, Hasidic Newspaper," *Huffington Post*, May 9, 2011, www.huffingtonpost.com/2011/05/09/hillary-clinton -der-tzitung-removed-situation-room_n_859254.html.

11. There are many online commentators claiming the image is "fake." For a careful commentary on the need to distinguish between claims of faking and staging this image, see David Campbell, "Thinking Images v.16: Osama bin Laden and the Pictorial Staging of Politics," www.david-campbell.org/2011 /05/06/thinking-images-v-16-bin-laden-and-pictorial-staging-of-politics/.

12. This was a common reading of the image in the national media. In the *Washington Post*, Joel Achenbach remarked: "Protocol fell away. They were all, in that moment, spectators to an historic event—and they didn't know which

way it was going to go" ("That Situation Room Photo," *Achenblog* [blog], *Washington Post*, May 4, 2011, http://www.washingtonpost.com/blogs /achenblog/post/that-situation-room-photo/2011/05/04/AFrx7KmF_blog .html).

13. The Situation Room (actually a warren of rooms) is in the basement of the West Wing, just below the Oval Office. It was created in the spring of 1961, under the auspices of President Kennedy's national security adviser McGeorge Bundy, who sought to create a command center within the White House. The impetus was the failed Bay of Pigs invasion and Bundy's belief that this was partly due to the lack of real-time intelligence available to the president and his advisers. The creation of the Situation Room resulted in a significant empowerment of the president within the national security apparatus, at the center of command and control. According to the White House's website, it "serves as a conference facility, a processing center for secure communications, a hub of intelligence gathering, and a center for emergency operations" ("Inside the Situation Room," *The White House Blog*, The White House, December 18, 2009, https://www.whitehouse.gov/blog/2009/12/18 /inside-situation-room). More precisely (though not mentioned on the website), it is designated a Sensitive Compartmented Information Facility (SCIF), one of several throughout the higher reaches of government and the military. These spaces have enhanced protections against surveillance and are often linked to communications feeds from Predator drones and other unmanned aerial vehicles. The Situation Room is, in other words, a key node in the networks of military and political power that prosecute the doctrine of preemptive violence.

14. See Lisa Parks, *Cultures in Orbit: Satellites and the Televisual* (Durham, NC: Duke University Press, 2005); Chad Harris, "The Omniscient Eye: Satellite Imagery, 'Battlespace Awareness,' and the Structures of the Imperial Gaze," *Surveillance and Society* 4 (2006): 101–22; and Stephen Graham, "Robowar Dreams: US Military Technophilia and Global South Urbanization," *City* 12, no. 1 (April 2008): 25–49.

15. "Obama's Remarks on Bin Laden's Killing," *New York Times*, May 2, 2011, www.nytimes.com/2011/05/02/world/middleeast/02obama-text.html ?pagewanted=all.

16. Ibid.

17. Allen Feldman, "The Structuring Enemy and Archival War," *PMLA* 124, no. 5 (2009): 1712.

18. On May 7, 2011, five days after the publication of the Situation Room image, the *New York Times* published an interview with Samar Hassan. The correspondent, Tim Arango, sought out Samar and presented her with Hondros's images. An accompanying photograph depicts her looking for the first time at these images, as Arango indicates in the opening line of the article: "Until the past week, Samar Hassan had never glimpsed the photograph of her that millions had seen, never knew it had become one of the most famous images

of the Iraq war" ("Face That Screamed War's Pain Looks Back, 6 Hard Years Later," *New York Times*, May 7, 2011, www.nytimes.com/2011/05/07/world /middleeast/07photo.html?pagewanted=all). While the journalist may have wanted to honor Hondros and remind readers of the horrors Samar bore witness to, the image nonetheless turns her act of witnessing into a moment of obscene voyeurism. Readers are treated to her response to viewing her younger self, a self-spectatorship that is more in line with the genre and ethics of reality television than photographic journalism. The anger and compassion elicited by Hondros's photograph now dissolve into curiosity and pity, and a privatized trauma, as signified by the domestic setting, displaces Samar's original role as witness to a national trauma in Iraq.

19. Farah Nosh, quoted in interview in Michael Kamber, *Photojournalists on War: The Untold Stories from Iraq* (Austin: University of Texas Press, 2013), 203.

20. Peter van Agtmael, quoted in Vaughan Wallace, "Peter van Agtmael Receives the 2012 W. Eugene Smith Grant in Humanistic Photography," *Time Lightbox*, October 17, 2012, http://lightbox.time.com/2012/10/17/peter -van-agtmael-receives-the-2012-w-eugene-smith-grant-in-humanistic -photography/#1.

21. Ashley Gilbertson, "The Consequences of War: A Photographer's Perspective," *Need to Know*, PBS, June 6, 2011, http://www.pbs.org/wnet/need-to -know/culture/the-consequences-of-war-a-photographers-perspective /9675/.

22. Ritchin, *Bending the Frame*, 21, 61.

23. Ibid., 30, 39.

24. Ibid., 48.

25. Michael Shaw, "4,000 U.S. Combat Deaths, and Just a Handful of Images," *BagNews*, August 19, 2013, http://www.bagnewsnotes.com/2008/07/4000 -u-s-combat-deaths-and-just-a-handful-of-images/.

26. Christoph Bangert, *Iraq: The Space Between* (New York: Powerhouse Books, 2007).

27. Jon Lee Anderson, quoted in ibid., 7.

28. Christoph Bangert, quoted in Gert Van Langendonck, "Christoph Bangert: Nobody Is Trying to Get Rich Here," emphas.is, http://blog.emphas.is/?p=461.

29. Bangert, quoted in ibid.

30. Adam Broomberg and Oliver Chanarin, "Unconcerned but Not Indifferent," March 5, 2008, Fot08, http://www.foto8.com/live/unconcerned-but-not -indifferent/.

31. Ibid.

32. Ibid.

33. Tim Hetherington, "By Any Means Necessary," May 9, 2008, Fot08, http:// www.foto8.com/live/by-any-means-necessary/.

34. Ibid.

35. Tim Hetherington, in Jon Levy, "Respect: Tim Hetherington Speaks to Jon Levy," *Professional Photographer*, January 4, 2011, http://www.professional

photographer.co.uk/Magazine/Photographer-Profiles/Tim-Hetherington
-speaks-to-Jon-Levy#sthash.lpQFqcoz.dpuf.

36. Tim Hetherington, interview by Michael Kamber, "'Restrepo' and the Imagery of War," *Lens* (blog), *New York Times*, June 22, 2010, http://lens.blogs.
nytimes.com/2010/06/22/behind-44/.

37. Ibid.

38. Stephen Mayes and Tim Hetherington, "The Theatre of War, or 'La Petite
Mort,'" David-Campbell.org, http://www.david-campbell.org/wp-content
/documents/The_Theatre_of_War.pdf. In some respects, this is a continuation of his work in Liberia, where he had embedded with the rebel forces and
photographed their more intimate lives. See Tim Hetherington, *Long Story Bit
by Bit: Liberia Retold* (New York: Umbrage, 2009).

39. Mayes and Hetherington, "The Theatre of War."

40. Ibid.

41. Tim Hetherington, quoted in Rob Sharp, "Combat Fatigue: Tim Hetherington's Intimate Portraits of US Soldiers at Rest Reveal the Other Side of
Afghanistan," *Independent*, September 11, 2010, http://www.independent
.co.uk/arts-entertainment/art/features/combat-fatigue-tim-hetheringtons
-intimate-portraits-of-us-soldiers-at-rest-reveal-the-other-side-of
-afghanistan-2073877.html.

42. David Campany, "Safety in Numbness: Some Remarks on Problems of 'Late
Photography,'" in *Where Is the Photograph?* ed. David Green (Maidstone:
Photoforum; Brighton: Photoworks, 2003), 123–33. See David Campbell,
"Cultural Governance and Pictorial Resistance: Reflections on the Imaging of
War," *Review of International Studies* 29 (2003): 72–73.

43. Simon Norfolk, in Paul Lowe, "The Forensic Turn: Bearing Witness and the
'Thingness' of the Photograph," in *The Violence of the Image: Photography and
International Conflict*, ed. Liam Kennedy and Caitlin Patrick (London: I. B.
Tauris, 2014), 225.

44. Simon Norfolk, *Afghanistan: Chronotopia* (Stockport: Dewi Lewis Publishing,
2010).

45. Simon Norfolk, in Geoff Manaugh, "War/Photography: An Interview with
Simon Norfolk," *bldgblog*, November 30, 2006, http://bldgblog.blogspot
.co.uk/2006/11/warphotography-interview-with-simon.html.

46. Simon Norfolk, "Ascension Island: The Panopticon," http://www
.simonnorfolk.com/pop.html.

47. Trevor Paglen has been documenting the "black world" of secret U.S. military
and intelligence activities. See Trevor Paglen, *Invisible: Covert Operations and
Classified Landscapes* (New York: Aperture, 2010). Mishka Henner has made
use of found documents and imagery on the Internet to locate and image
overt and covert U.S. military sites across the globe. See Mishka Henner,
"Fifty-One U.S. Military Outposts," http://www.mishkahenner.com
/Fifty-One-US-Military-Outposts.

48. Robert Hariman, "Watching War Evolve: Photojournalism and New Forms of Violence," in *The Violence of the Image*, ed. Kennedy and Patrick, 155.

49. Ibid.

50. Ibid. Hariman borrows the term "untethered violence" from Susie Linfield, *The Cruel Radiance: Photography and Political Violence* (Chicago: University of Chicago Press, 2010).

51. Norfolk, quoted in Manaugh, "War/Photography."

52. Tim Hetherington in conversation with Ronit Novak, "NYPH09: Tim Hetherington Interview," *HMAb* (blog), Heather Morton Art Buyer, http://www.heathermorton.ca/blog/?p=2054.

53. Susan Sontag, *On Photography* (London: Penguin, 1979).

Index